PERSPECTIVE!

FOR COMIC BOOK ARTISTS

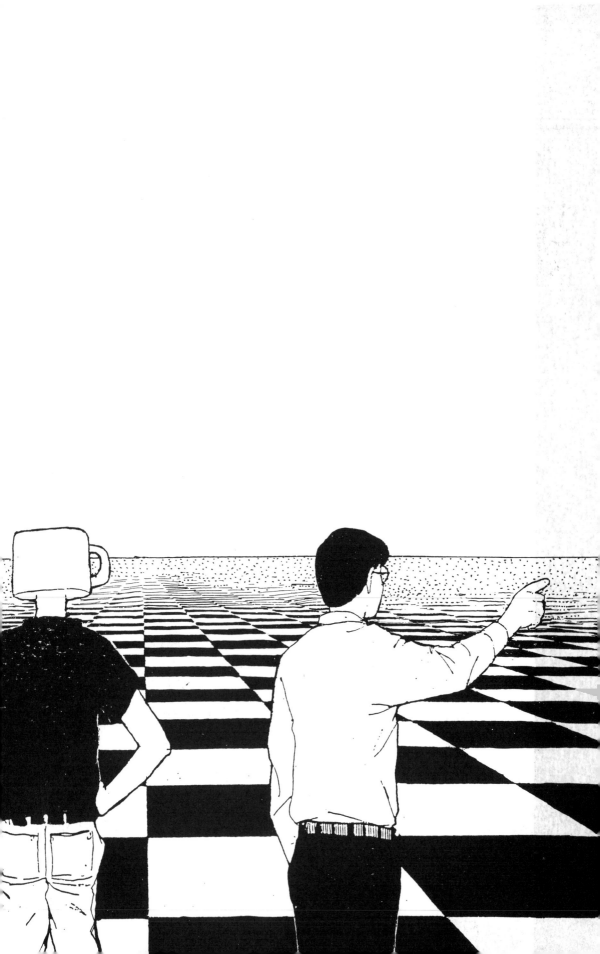

PERSPECTIVE!

FOR COMIC BOOK ARTISTS

HOW TO ACHIEVE A PROFESSIONAL LOOK
IN YOUR ARTWORK

DAVID CHELSEA

WATSON-GUPTILL PUBLICATIONS/NEW YORK

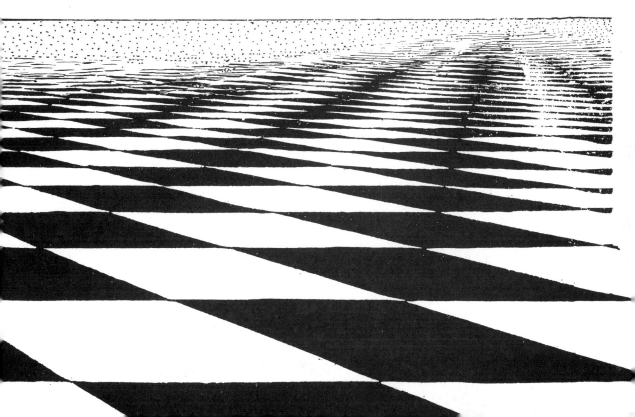

For Eve, and our son Benjamin, who has brought us a
whole new sense of perspective.

Senior Editor: Candace Raney
Edited by Joy Aquilino
Designed by Jay Anning
Graphic production by Hector Campbell

First published in 1997 by Watson-Guptill Publications, an imprint of the
Crown Publishing Group, a division of Random House, Inc., New York
www.crownpublishing.com
www.watsonguptill.com

Library of Congress Cataloging-in-Publication Data
Chelsea, David.
 Perspective! for comic book artists: how to achieve a
professional look in your artwork/David Chelsea.
 p. cm.
 Includes index.
 ISBN 0-8230-0567-4 (paper)
 1. Comic books, strips, etc.—Technique. 2. Perspective.
I. Title.
NC1764.c49 1997
741.5—dc21 97-28757
 CIP

Manufactured in the United States of America

First printing, 1997

14 15 / 14

CONTENTS

Acknowledgments

This book owes a large debt to Gary Faigin, the cofounder, with his wife Pamela Belyea, of the Academy of Realist Art. Gary taught me perspective nearly 15 years ago and has remained a friend and guide since then. His comments and criticisms did much to transform my sprawling and ungainly early drafts into the present, more streamlined version. Candace Raney and Joy Aquilino, given the unfamiliar task of editing a long, long comic book, took to it with patience and enthusiasm; likewise, designer Jay Anning and production manager Hector Campbell did their utmost to give the book the best look possible. Many friends and colleagues were kind enough to give the work in progress a critical eye; I would like to thank in particular mathematician and puzzle designer Adam Alexander for helping me through the tricky geometry in the "Circles in Perspective" chapter.

It is a dirty little secret in the comics business that much of the background detail is actually drawn by assistants while the big-name artist takes all the credit, and I humbly admit that even this book, where the background takes center stage, is no exception. I had the indispensable help of three assistants over the course of this project: David Kidd, Milan Erceg, and Tod Herman; much, or most, of the meticulous perspective detail in the book is theirs. I would also like to thank Stacie Dolan, who assisted me on an early version of the first chapter, which was my book proposal. You can always count on your family in a crisis, and I thank my mother, Lolita, for an eleventh-hour inking job on the perspective grids in the last chapter, and my sister Teresa, who faced the unenviable task of putting my scrawled notes for the text on disk. The text font, which is based on handlettering by the 1920s cartoonist J. Norman Lynd, was put on disk for me by Sean Tejaratchi, a talented designer and editor of *Craphound,* an anthology of bizarre, forgotten spot illustrations. Thanks also to Arlen Schumer for drawing "Mugg's" Captain Bombast™ sequence; and to my neighbor, Talbot V. Ridgway, who lent me his 1931 Fleet biplane for the cover illustration.

Most profound thanks go to my wife, Eve. By an unplanned coincidence, the original deadline for this book and the due date for the arrival of our first child were exactly the same—but Benjamin missed *his* deadline by only a day, while the book consumed an additional three months of near-constant work, making me a preoccupied if not absentee husband and father during his first demanding months, an excess of bad timing that Eve handled with nearly unflagging understanding and humor. And it was *worth it,* too—right, Eve?

PREFACE

You have in your hands the first book on perspective written specifically for the comic book illustrator, though I believe all illustrators and, indeed, artists in general will find it useful. While there have been a few perspective books tailored to the needs of illustrators, most fall into one of two other categories: Either they are geared toward fine artists, in which case the artist is presumed to be working from life and therefore to need only a general awareness of perspective to bolster his own observations; or they are extremely technical manuals directed at architectural renderers and far too difficult for the general reader. Working illustrators, especially those working in the comics field, differ from both of these types of artists in that they can rarely work from life, and must fabricate convincing scenes without even an architect's floorplan to guide them. For many illustrators, this means a time-consuming hunt for photo reference, and for comic book illustrators, who are faced with the job of filling frame after frame, usually in a hurry, it often means resorting to one's imagination. This book therefore includes a section on working from photographs, developing the perspective cues within the photograph, and extending them to include invented material. Since comic book artists often use unorthodox "bird's-eye" and "worm's-eye" views, this book also contains an entire chapter on three-point perspective, which is used to construct those views. This book also contains a section of perspective grids for tracing, to aid artists who don't have the time to construct their own perspective.

This is also the first book on perspective in comic book form. I was inspired by Scott McCloud's pioneering *Understanding Comics,* a long essay on the art of comics done in comics form. Scott's book showed me how even very complex theory could be put across with clarity using comics, and I believe that in this case, the form of comics and the subject of perspective were made for each other. In this book, the reader is guided through confusing material one panel at a time, the text always in lockstep with the images. Never are you asked to turn to diagram 45A on page 87. In short, I have tried to produce the most user-friendly perspective book available, without skirting any of the complexities.

CHAPTER ONE

INTRODUCTION TO PERSPECTIVE

Why bother to learn perspective at all? Many illustrators and cartoonists, of course, never do, but I believe that those who do save themselves a lot of headaches down the line. It is true that people, fruit, and puppies can be drawn without knowledge of perspective, but it becomes invaluable when one needs to draw chairs, fruit bowls, and doghouses. Without an understanding of perspective, each object we attempt to draw becomes a unique new problem, to be solved either by finding a reference photo taken from precisely the right angle, or by laborious trial and error. With a firm grasp of perspective, however, we learn to see the common boxy structure underlying most man-made objects, and to master drawing one is to master drawing them all. There are, of course, styles of drawing that depend on deliberately violating the rules of perspective for their expressive power. But in most cases, the background is meant to be a subordinate element, and since the eye is unconsciously accustomed to correct perspective, a background that is quietly in perspective will attract less attention than one that is jarringly out of it, the way a man who has bathed will attract less attention at a party than one who hasn't.

Perspective is worth the effort. With it under your belt, you will be able to draw a consistent and believable world that evokes three dimensions on paper, incorporating observation, photo reference, and your own invented elements into a seamless whole.

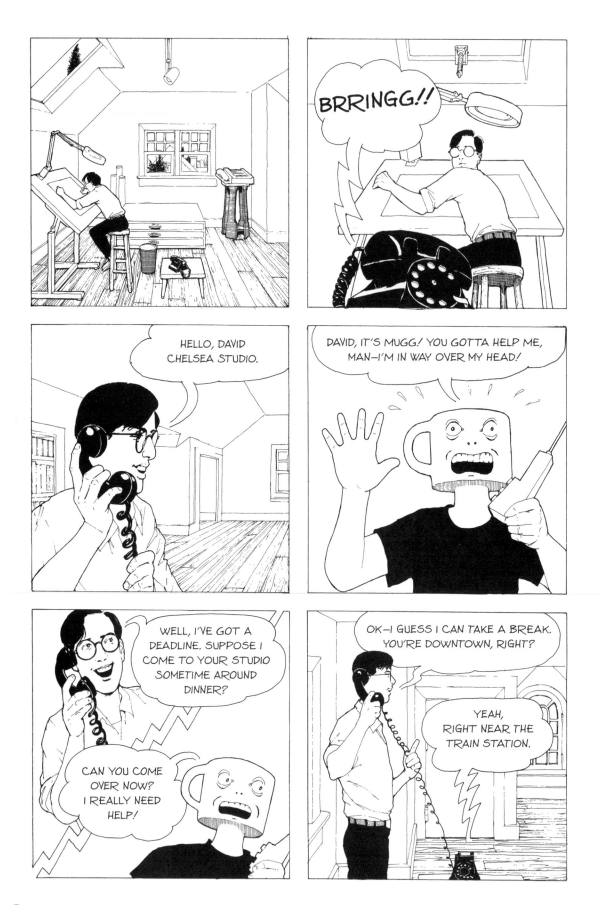

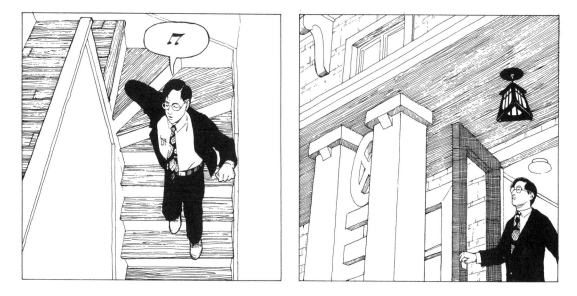

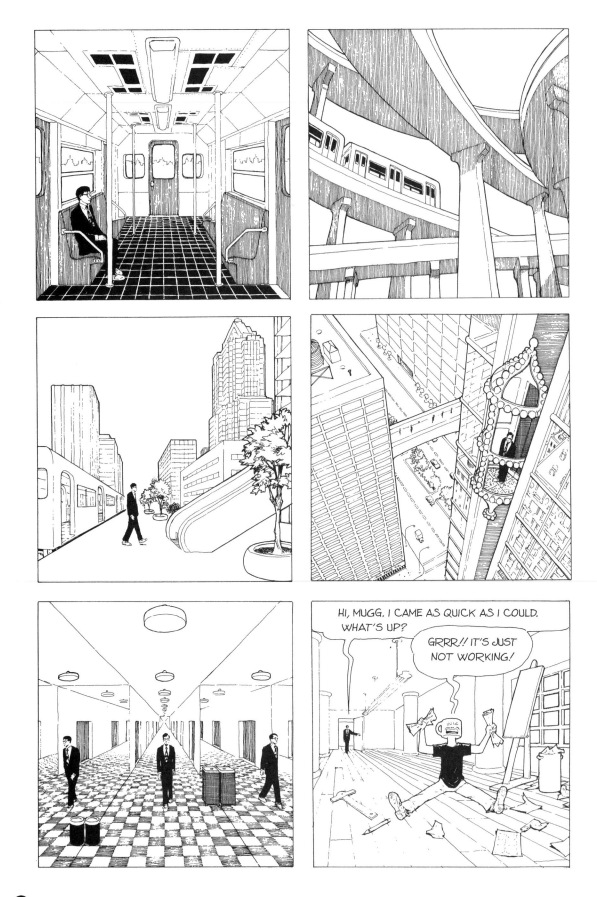

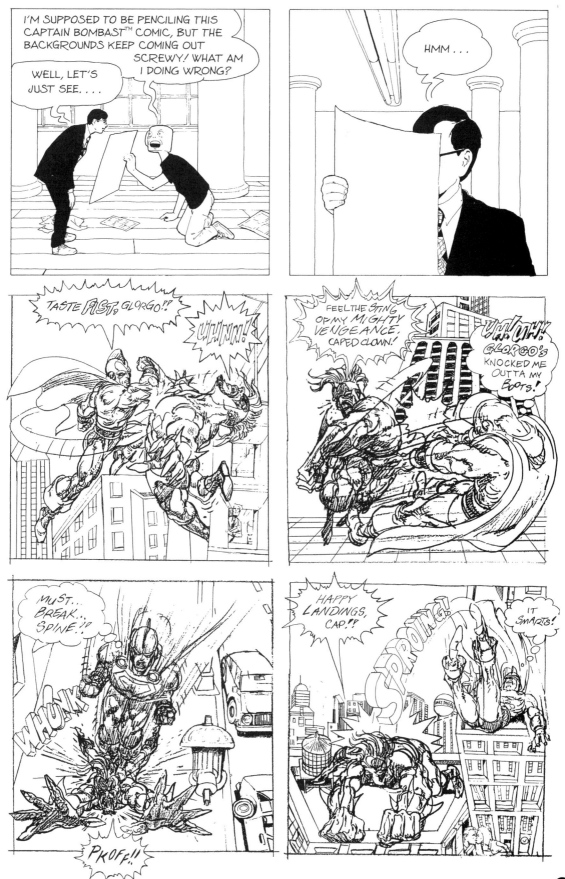

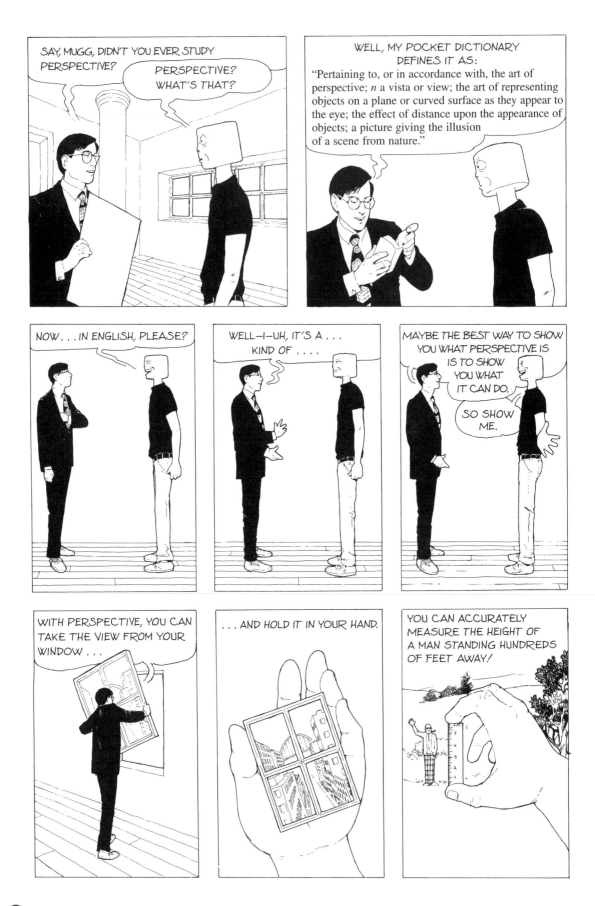

YOU CAN FOOL WILD BEASTS INTO RUNNING SMACK INTO A BRICK WALL . . .

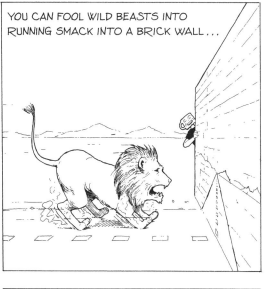

. . . AND YOU CAN MAKE A GRINNING SKULL SEEM TO FLOAT OFF ANOTHER WALL.

YOU CAN USE PERSPECTIVE TO TELL YOU HOW TO LAND A PLANE . . .

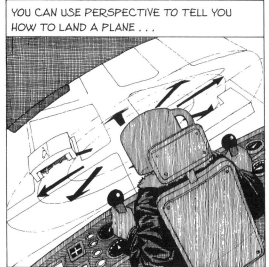

. . . OR MANEUVER THROUGH OUTER SPACE.

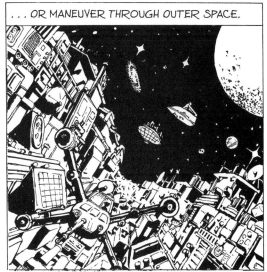

IN THE MOVIES, YOU CAN SEEM TO BE HAVING A CONVERSATION WITH A 50-FOOT WOMAN . . .

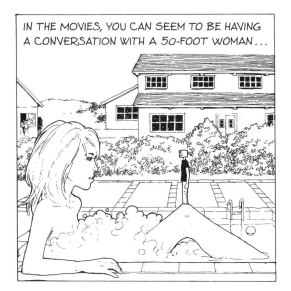

. . . WHEN ALL THE TIME, YOU'RE ACTUALLY A HUNDRED FEET AWAY!

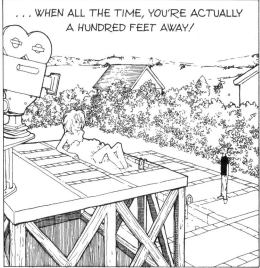

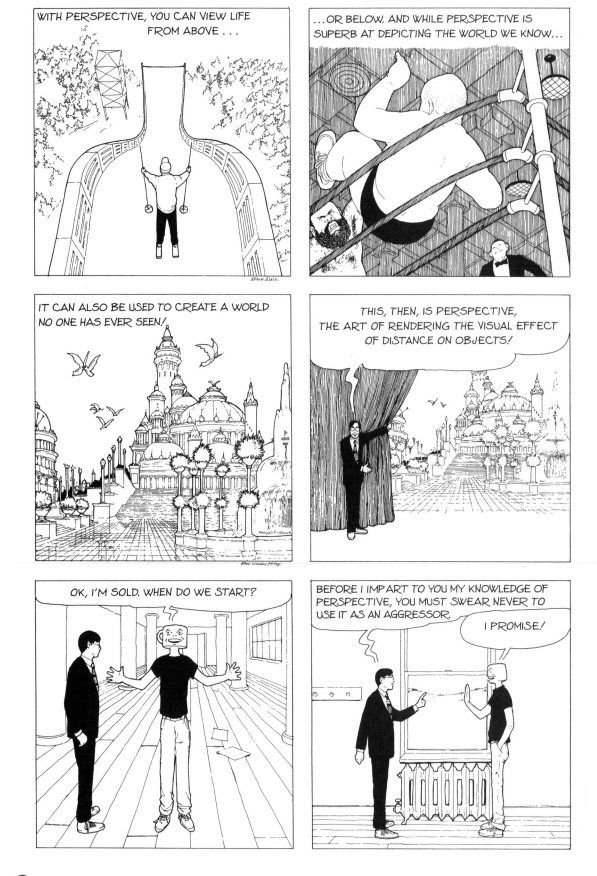

CHAPTER TWO

DEPTH CUES

Upon hearing the word "perspective," most people immediately think of parallel lines meeting at a vanishing point. True, that is one aspect of perspective, and one that I spend much of the book explaining. However, other effects are used to simulate the third dimension that may seem so obvious as to be overlooked. They are known as *depth cues,* and in this chapter we will look at them.

Pretty much all artists, apart from pure abstractionists, use at least some depth cues in their work, often unconsciously. Anyone who draws a foreground figure larger than one in the background is using the effect of *diminution.* The very idea of "foreground" and "background" presupposes that the former overlaps the latter, and that cannot happen without depth. Overlap is such an obvious effect that most of us take it for granted, yet I can recall the hours of effort it took me as a child, crayon clutched in hand, before I managed to draw Fred Flintstone standing in front of his car.

If this book spends most of its time on the "parallel lines" aspect of perspective, it is only because it is more susceptible to hard-and-fast rules. The more elusive depth cues in this chapter can be mastered only by observation, intuition, and practice, and those cannot be taught in a book.

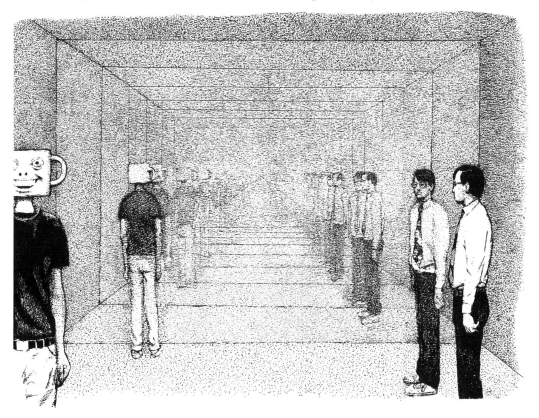

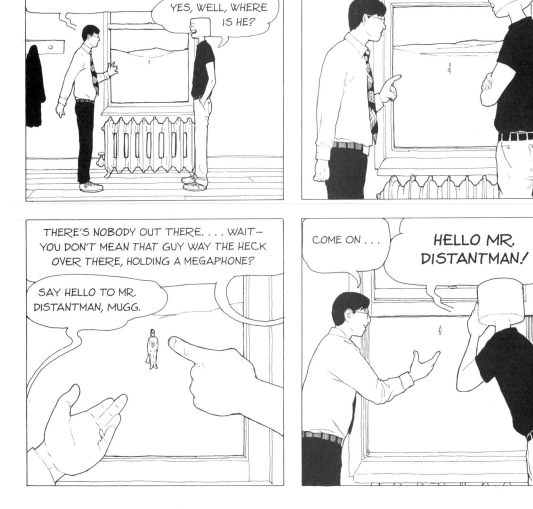

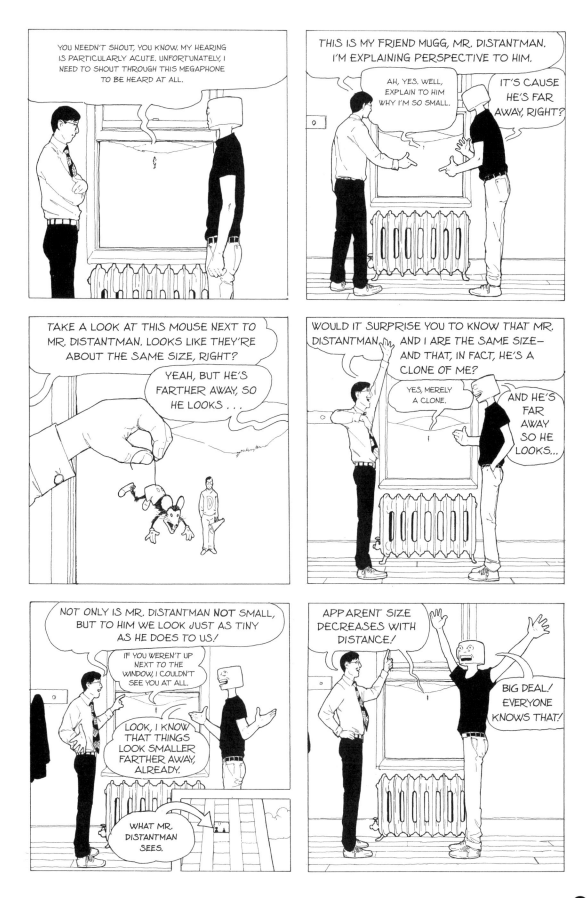

EVERYONE?? DID YOU SAY **EVERYONE** KNOWS THAT? LET ME TELL YOU A STORY, FRIEND!

MEET HUK YUK BUK, A DEMITASSE INDIAN TRIBESMAN FROM THE AMAZON RAINFOREST IN SOUTH AMERICA.

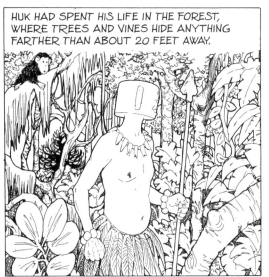

HUK HAD SPENT HIS LIFE IN THE FOREST, WHERE TREES AND VINES HIDE ANYTHING FARTHER THAN ABOUT 20 FEET AWAY.

ONE DAY, A VISITING CULTURAL ANTHROPOLOGIST OFFERED HIM A RIDE IN HIS JEEP.

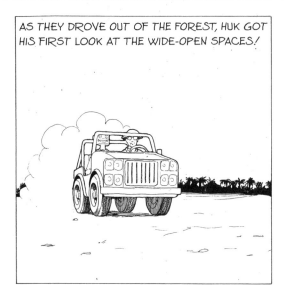

AS THEY DROVE OUT OF THE FOREST, HUK GOT HIS FIRST LOOK AT THE WIDE-OPEN SPACES!

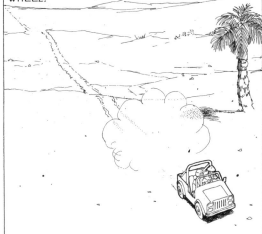

HE WAS SO EXCITED BY THIS THAT HE BEGGED THE ANTHROPOLOGIST TO LET HIM TAKE THE WHEEL.

ZIPPING HAPPILY THROUGH THE LANDSCAPE, HUK NOTICED WHAT LOOKED LIKE A COLONY OF BLACK-AND-WHITE ANTS OFF IN THE DISTANCE.

DRIVING CLOSER FOR A BETTER LOOK, HUK WAS SURPRISED TO SEE THE ANTS BECOME GIANT, FOUR-LEGGED ANIMALS!

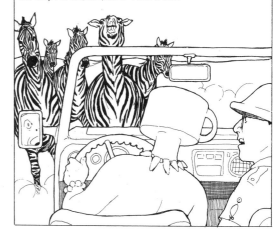

THEY TRIED TO TURN AROUND, BUT IT WAS TOO LATE—HUK, THE ANTHROPOLOGIST, AND THE JEEP WERE ALL TRAMPLED FLAT BY A HERD OF STAMPEDING ZEBRAS.

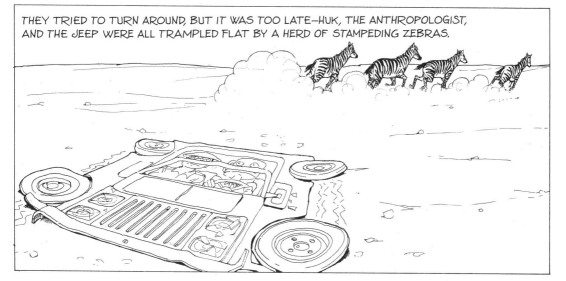

IF ONLY HE'D STUDIED PERSPECTIVE, THAT STORY COULD'VE HAD A HAPPY ENDING.

WHAT IS A HERD OF ZEBRAS DOING IN SOUTH AMERICA, ANYWAY?

THAT'S NOT THE POINT, MUGG. THE EFFECT OF DISTANT OBJECTS APPEARING SMALLER THAN NEAR ONES IS CALLED **DIMINUTION**, AND IT SHOULDN'T BE TAKEN FOR GRANTED!

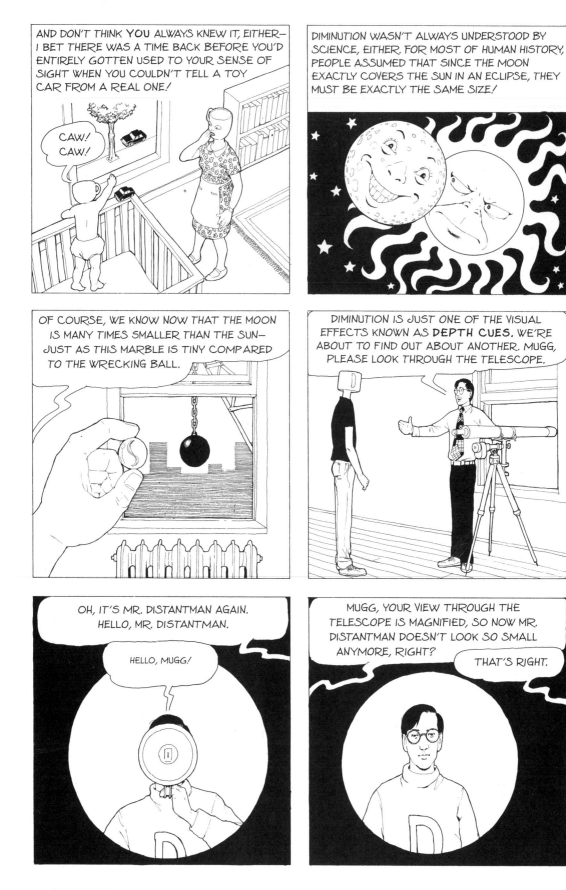

AND DON'T THINK **YOU** ALWAYS KNEW IT, EITHER—I BET THERE WAS A TIME BACK BEFORE YOU'D ENTIRELY GOTTEN USED TO YOUR SENSE OF SIGHT WHEN YOU COULDN'T TELL A TOY CAR FROM A REAL ONE!

CAW! CAW!

DIMINUTION WASN'T ALWAYS UNDERSTOOD BY SCIENCE, EITHER. FOR MOST OF HUMAN HISTORY, PEOPLE ASSUMED THAT SINCE THE MOON EXACTLY COVERS THE SUN IN AN ECLIPSE, THEY MUST BE EXACTLY THE SAME SIZE!

OF COURSE, WE KNOW NOW THAT THE MOON IS MANY TIMES SMALLER THAN THE SUN—JUST AS THIS MARBLE IS TINY COMPARED TO THE WRECKING BALL.

DIMINUTION IS JUST ONE OF THE VISUAL EFFECTS KNOWN AS **DEPTH CUES**. WE'RE ABOUT TO FIND OUT ABOUT ANOTHER. MUGG, PLEASE LOOK THROUGH THE TELESCOPE.

OH, IT'S MR. DISTANTMAN AGAIN. HELLO, MR. DISTANTMAN.

HELLO, MUGG!

MUGG, YOUR VIEW THROUGH THE TELESCOPE IS MAGNIFIED, SO NOW MR. DISTANTMAN DOESN'T LOOK SO SMALL ANYMORE, RIGHT?

THAT'S RIGHT.

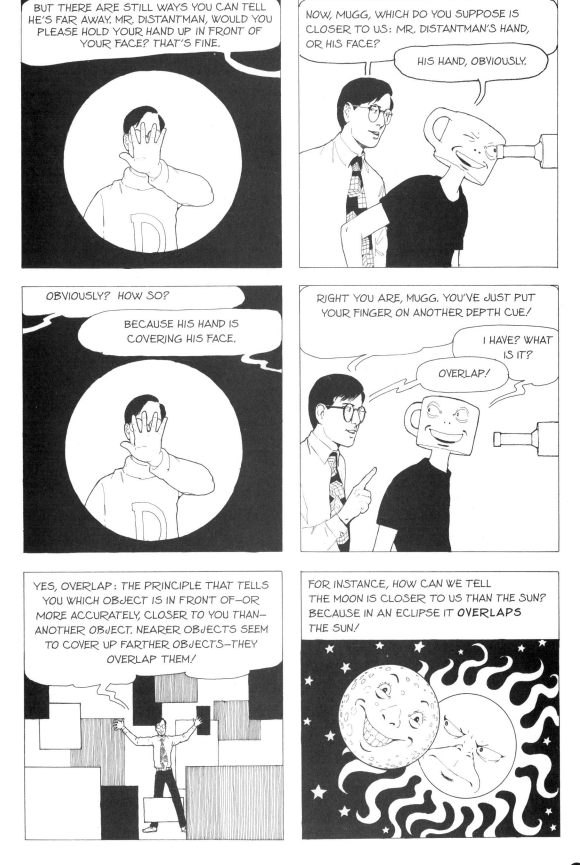

I'LL DEMONSTRATE WITH THIS MR. DISTANTMAN ACTION FIGURE HUNG ON A FISHING LINE. TAKE A LOOK AT IT THROUGH THE TELESCOPE, MUGG.

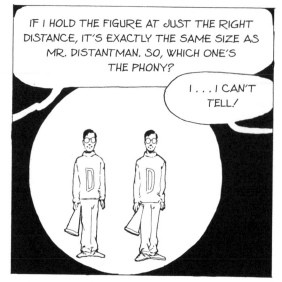

IF I HOLD THE FIGURE AT JUST THE RIGHT DISTANCE, IT'S EXACTLY THE SAME SIZE AS MR. DISTANTMAN. SO, WHICH ONE'S THE PHONY?

I . . . I CAN'T TELL!

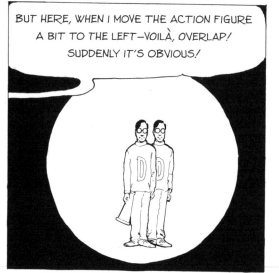

BUT HERE, WHEN I MOVE THE ACTION FIGURE A BIT TO THE LEFT—VOILÀ, OVERLAP! SUDDENLY IT'S OBVIOUS!

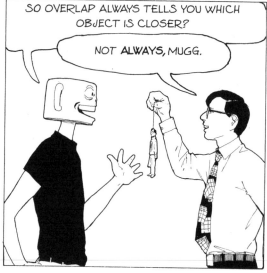

SO OVERLAP ALWAYS TELLS YOU WHICH OBJECT IS CLOSER?

NOT **ALWAYS**, MUGG.

ON THE PLANET KWONK, EVERYTHING IS TRANSPARENT, SO EVEN THOUGH OBJECTS OVERLAP YOU CAN'T TELL WHAT'S IN FRONT OF WHAT! PEOPLE ARE ALWAYS BUMPING INTO THINGS, PLUS, THEY'VE GOT NO PRIVACY!

EEGHAH! GLAD I DON'T LIVE THERE!

BUT ENOUGH ABOUT OVERLAP—TAKE ANOTHER LOOK THROUGH THE TELESCOPE AND TELL ME WHAT MR. DISTANTMAN IS DOING.

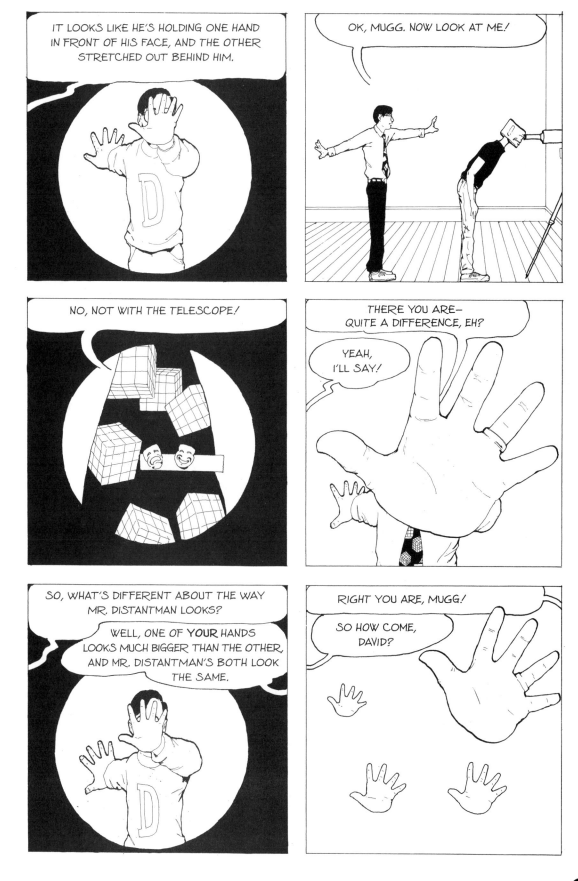

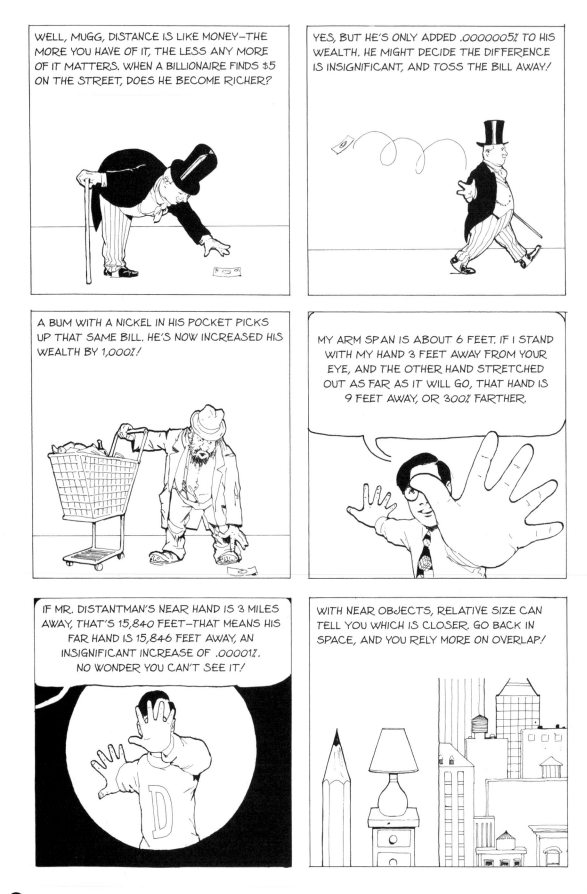

WELL, MUGG, DISTANCE IS LIKE MONEY—THE MORE YOU HAVE OF IT, THE LESS ANY MORE OF IT MATTERS. WHEN A BILLIONAIRE FINDS $5 ON THE STREET, DOES HE BECOME RICHER?

YES, BUT HE'S ONLY ADDED .0000005% TO HIS WEALTH. HE MIGHT DECIDE THE DIFFERENCE IS INSIGNIFICANT, AND TOSS THE BILL AWAY!

A BUM WITH A NICKEL IN HIS POCKET PICKS UP THAT SAME BILL. HE'S NOW INCREASED HIS WEALTH BY 1,000%!

MY ARM SPAN IS ABOUT 6 FEET. IF I STAND WITH MY HAND 3 FEET AWAY FROM YOUR EYE, AND THE OTHER HAND STRETCHED OUT AS FAR AS IT WILL GO, THAT HAND IS 9 FEET AWAY, OR 300% FARTHER.

IF MR. DISTANTMAN'S NEAR HAND IS 3 MILES AWAY, THAT'S 15,840 FEET—THAT MEANS HIS FAR HAND IS 15,846 FEET AWAY, AN INSIGNIFICANT INCREASE OF .00001%. NO WONDER YOU CAN'T SEE IT!

WITH NEAR OBJECTS, RELATIVE SIZE CAN TELL YOU WHICH IS CLOSER. GO BACK IN SPACE, AND YOU RELY MORE ON OVERLAP!

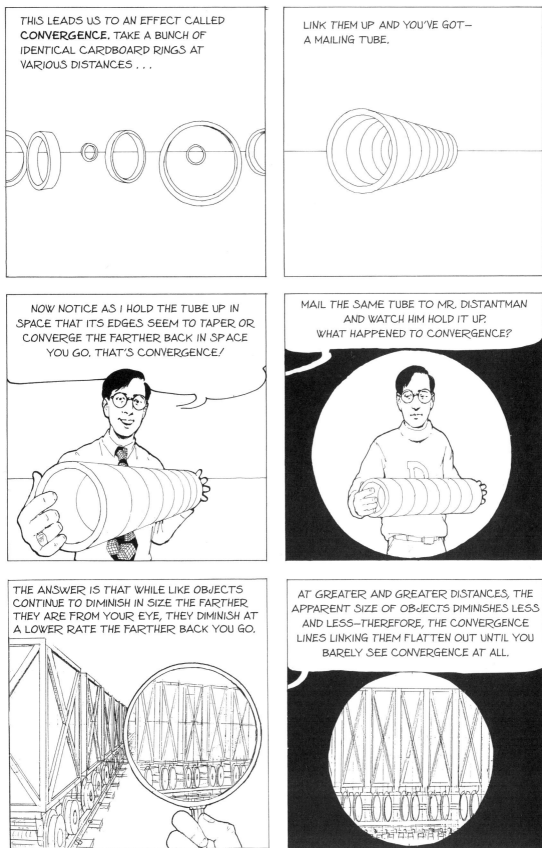

THIS LEADS US TO AN EFFECT CALLED **CONVERGENCE.** TAKE A BUNCH OF IDENTICAL CARDBOARD RINGS AT VARIOUS DISTANCES . . .

LINK THEM UP AND YOU'VE GOT— A MAILING TUBE.

NOW NOTICE AS I HOLD THE TUBE UP IN SPACE THAT ITS EDGES SEEM TO TAPER OR CONVERGE THE FARTHER BACK IN SPACE YOU GO, THAT'S CONVERGENCE!

MAIL THE SAME TUBE TO MR. DISTANTMAN AND WATCH HIM HOLD IT UP. WHAT HAPPENED TO CONVERGENCE?

THE ANSWER IS THAT WHILE LIKE OBJECTS CONTINUE TO DIMINISH IN SIZE THE FARTHER THEY ARE FROM YOUR EYE, THEY DIMINISH AT A LOWER RATE THE FARTHER BACK YOU GO.

AT GREATER AND GREATER DISTANCES, THE APPARENT SIZE OF OBJECTS DIMINISHES LESS AND LESS—THEREFORE, THE CONVERGENCE LINES LINKING THEM FLATTEN OUT UNTIL YOU BARELY SEE CONVERGENCE AT ALL.

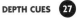

NOW, LET'S EXAMINE AN EFFECT THAT IS LINKED TO CONVERGENCE—**FORESHORTENING!** FIRST, HERE'S THE MAILING TUBE, SEEN DIRECTLY FROM THE SIDE.

WATCH WHAT HAPPENS AS MR. DISTANTMAN ROTATES IT IN SPACE—THE WIDTH OF THE TUBE NARROWS AND THE LITTLE SECTIONS GET CLOSER TOGETHER.

ROTATE IT SOME MORE, AND THE TUBE SEEMS TO FLATTEN OUT MORE, AND THE LITTLE SECTIONS NARROW AND SQUEEZE DOWN UNTIL . . .

. . . THE TUBE FLATTENS OUT TO A CIRCLE AND YOU CAN'T SEE ANY DEPTH AT ALL! AS THE APPARENT WIDTH OF THE TUBE SHRINKS, THE TUBE IS SAID TO **FORESHORTEN.**

CLOSER UP, FORESHORTENING AND CONVERGENCE APPEAR TOGETHER. AS THE EDGES SEEM TO CONVERGE, THE FORESHORTENED SECTIONS GET NARROWER AND MORE SQUISHED THE FARTHER BACK YOU GO!

FORESHORTENING IS EASIEST TO OBSERVE IN OBJECTS WITH REGULAR DIVISIONS.

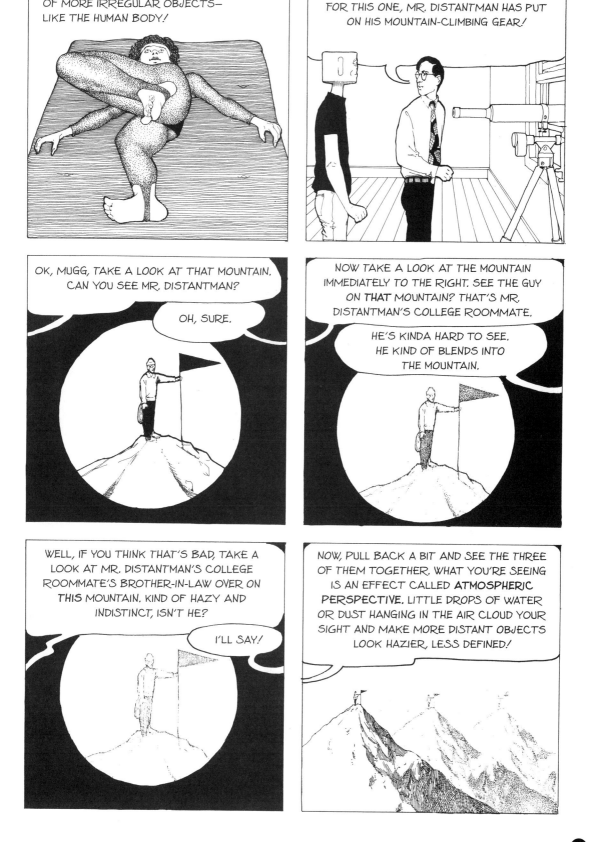

BUT IT CAN ALSO BE SEEN IN ALL KINDS OF MORE IRREGULAR OBJECTS— LIKE THE HUMAN BODY!

NOW, LET'S MOVE ON TO ANOTHER DEPTH CUE. FOR THIS ONE, MR. DISTANTMAN HAS PUT ON HIS MOUNTAIN-CLIMBING GEAR!

OK, MUGG, TAKE A LOOK AT THAT MOUNTAIN. CAN YOU SEE MR. DISTANTMAN?

OH, SURE.

NOW TAKE A LOOK AT THE MOUNTAIN IMMEDIATELY TO THE RIGHT. SEE THE GUY ON **THAT** MOUNTAIN? THAT'S MR. DISTANTMAN'S COLLEGE ROOMMATE.

HE'S KINDA HARD TO SEE. HE KIND OF BLENDS INTO THE MOUNTAIN.

WELL, IF YOU THINK THAT'S BAD, TAKE A LOOK AT MR. DISTANTMAN'S COLLEGE ROOMMATE'S BROTHER-IN-LAW OVER ON **THIS** MOUNTAIN, KIND OF HAZY AND INDISTINCT, ISN'T HE?

I'LL SAY!

NOW, PULL BACK A BIT AND SEE THE THREE OF THEM TOGETHER. WHAT YOU'RE SEEING IS AN EFFECT CALLED **ATMOSPHERIC PERSPECTIVE.** LITTLE DROPS OF WATER OR DUST HANGING IN THE AIR CLOUD YOUR SIGHT AND MAKE MORE DISTANT OBJECTS LOOK HAZIER, LESS DEFINED!

IT'S A LESS EXTREME CASE OF WHAT YOU SEE ON A VERY, VERY FOGGY DAY. . . OR IN A SMOKY ROOM. ACTUALLY, IT'S A FORM OF OVERLAP. THOSE LITTLE PARTICLES HANG IN THE AIR, OVERLAPPING OBJECTS AND PARTLY HIDING THEM!

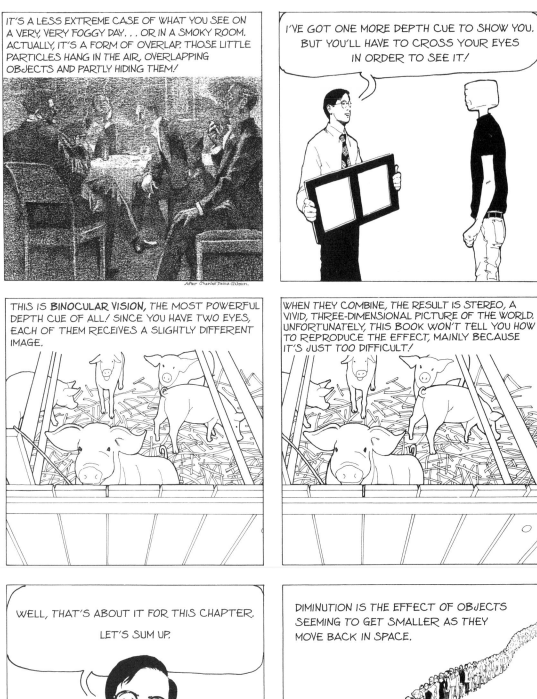

After Charles Dana Gibson.

I'VE GOT ONE MORE DEPTH CUE TO SHOW YOU. BUT YOU'LL HAVE TO CROSS YOUR EYES IN ORDER TO SEE IT!

THIS IS **BINOCULAR VISION**, THE MOST POWERFUL DEPTH CUE OF ALL! SINCE YOU HAVE TWO EYES, EACH OF THEM RECEIVES A SLIGHTLY DIFFERENT IMAGE.

WHEN THEY COMBINE, THE RESULT IS STEREO, A VIVID, THREE-DIMENSIONAL PICTURE OF THE WORLD. UNFORTUNATELY, THIS BOOK WON'T TELL YOU HOW TO REPRODUCE THE EFFECT, MAINLY BECAUSE IT'S JUST TOO DIFFICULT!

WELL, THAT'S ABOUT IT FOR THIS CHAPTER. LET'S SUM UP.

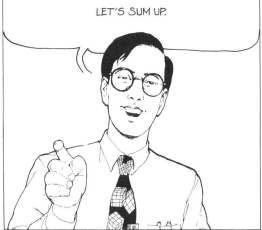

DIMINUTION IS THE EFFECT OF OBJECTS SEEMING TO GET SMALLER AS THEY MOVE BACK IN SPACE.

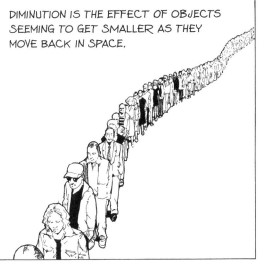

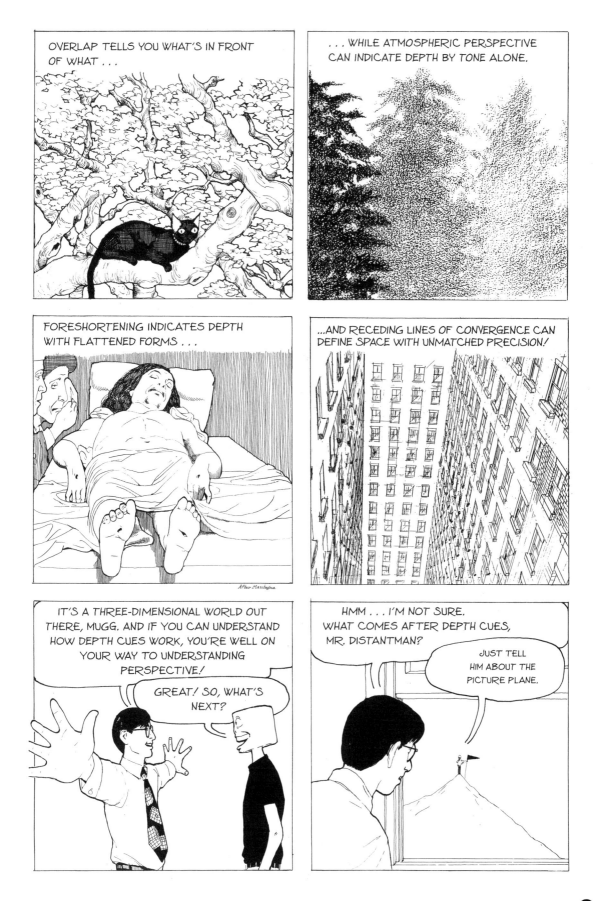

OVERLAP TELLS YOU WHAT'S IN FRONT OF WHAT . . .

. . . WHILE ATMOSPHERIC PERSPECTIVE CAN INDICATE DEPTH BY TONE ALONE.

FORESHORTENING INDICATES DEPTH WITH FLATTENED FORMS . . .

After Mantegna.

...AND RECEDING LINES OF CONVERGENCE CAN DEFINE SPACE WITH UNMATCHED PRECISION!

IT'S A THREE-DIMENSIONAL WORLD OUT THERE, MUGG. AND IF YOU CAN UNDERSTAND HOW DEPTH CUES WORK, YOU'RE WELL ON YOUR WAY TO UNDERSTANDING PERSPECTIVE!

GREAT! SO, WHAT'S NEXT?

HMM . . . I'M NOT SURE. WHAT COMES AFTER DEPTH CUES, MR. DISTANTMAN?

JUST TELL HIM ABOUT THE PICTURE PLANE.

CHAPTER THREE

THE PICTURE PLANE

The *picture plane* is the imaginary window through which we view a scene. If you set yourself up in front of an actual window and attempt to trace the scene outside on the glass with a felt-tipped pen, you will soon realize that the exercise only works so long as you keep your eye rigidly fixed. Move your head, or swing open the window, and the scene outside and lines you've drawn will shift out of alignment.

Walk into a room with a divided window. One half of the window opens onto the view outside, and the other half has been replaced by a picture of that view. From most parts of the room, it will be obvious to you which half of the window is the real scene and which is the flat picture. But from one exact point in space, the two window views will line up exactly, and you won't be able to tell where the real scene ends and the picture begins.

In perspective, you reproduce this situation on paper using an imaginary window, an imaginary scene, and an imaginary point in space to view it from. The window is the picture plane.

After Rene Magritte

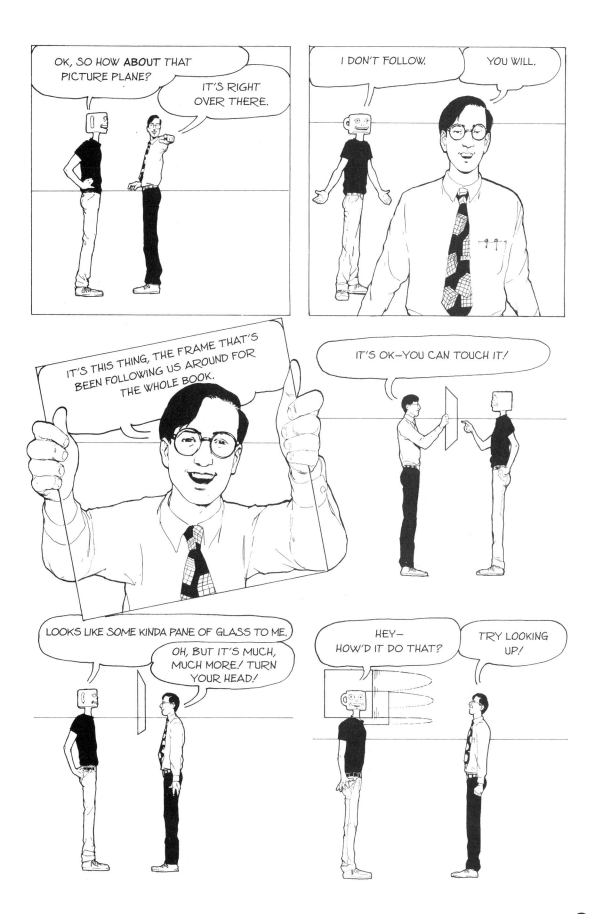

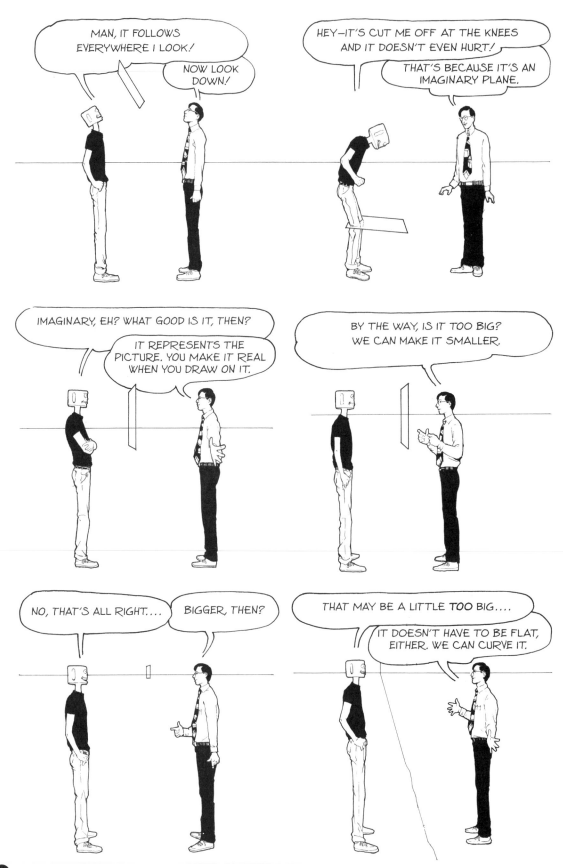

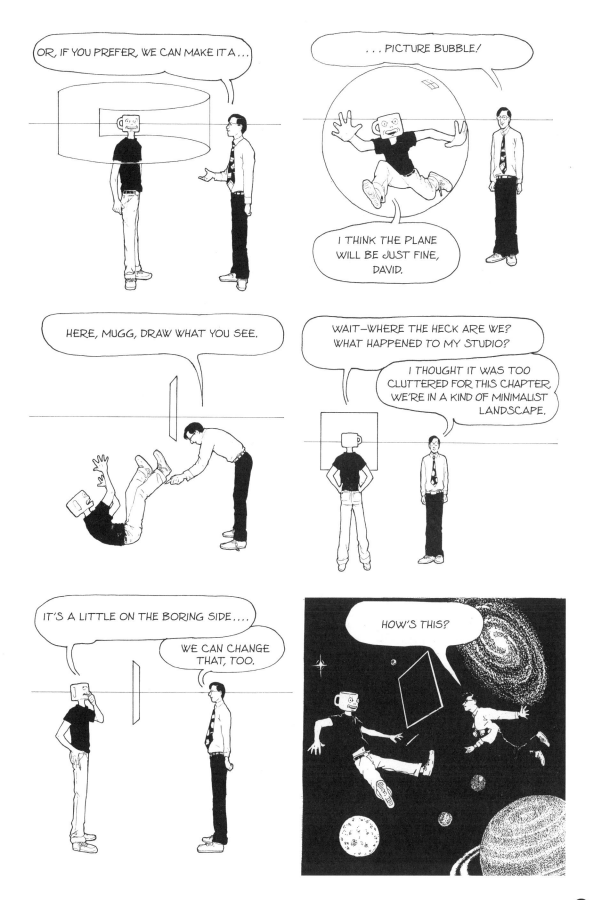

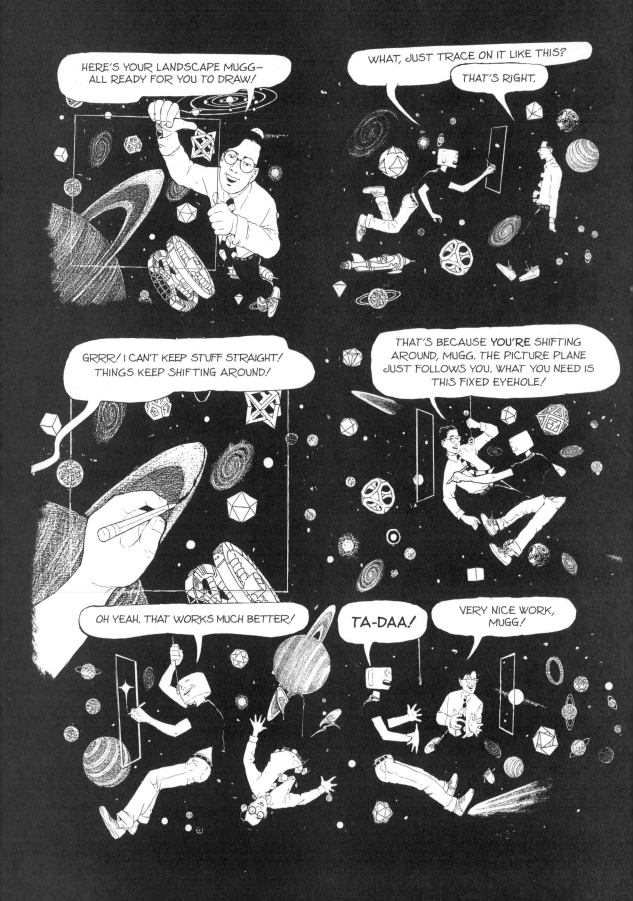

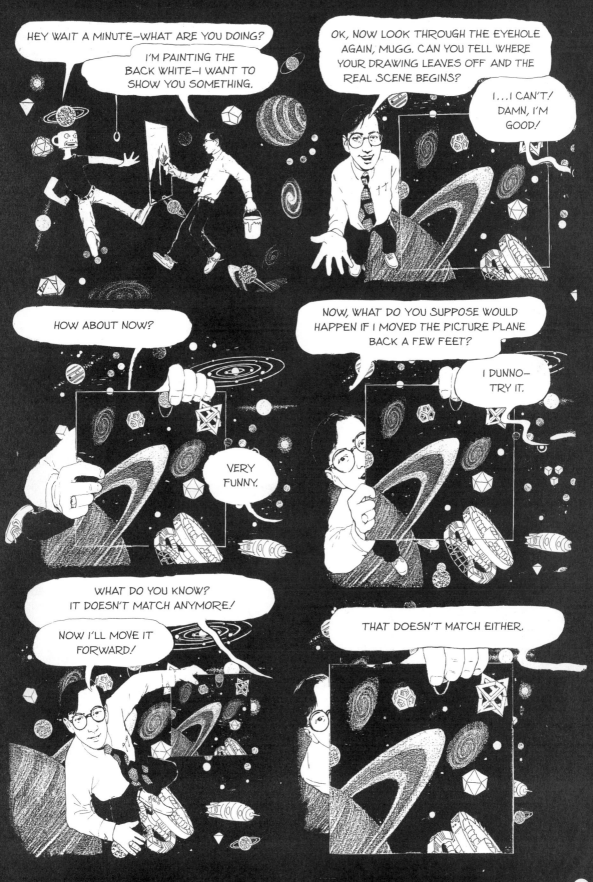

SO WHAT HAVE YOU LEARNED FROM THIS LITTLE EXPERIMENT, MUGG?

IS THAT SO? LET'S TRY SETTING UP ANOTHER PICTURE PLANE FARTHER AWAY.

THAT PERSPECTIVE ONLY WORKS WHEN THE PICTURE PLANE IS THE CORRECT DISTANCE AWAY. SO TELL ME WHAT THAT DISTANCE IS— I WANT TO WRITE IT DOWN.

NOW DRAW ON IT WITH THIS EXTRA-LONG PENCIL!

OK, OK, GOOD! GOOD!

PAINT THE BACK WHITE AGAIN, AND PRESTO!

ONCE MORE, WE HAVE A DRAWING THAT MATCHES THE SCENE EXACTLY JUST LIKE THE FIRST ONE!

WHEN I HOLD THE FIRST PICTURE NEXT TO THE SECOND ONE, YOU CAN SEE HOW MUCH SMALLER IT LOOKS—THAT'S BECAUSE IT'S MADE TO BE SEEN FROM MUCH CLOSER.

BUT WITH BOTH PICTURES AT THE PROPER VIEWING DISTANCE, THEY LOOK IDENTICAL!

THERE IS NO SINGLE PROPER DISTANCE FOR THE PICTURE PLANE—IT CAN BE LOCATED ANYWHERE YOUR EYE CAN SEE, FROM THE SURFACE OF YOUR EYE OUT ALL THE WAY TO INFINITY—AND EACH PLANE IS EQUALLY CORRECT!

YEAH, BUT HAPPENS IF YOU MOVE THE EYEHOLE?

GOOD QUESTION, MUGG. LET'S TRY IT.

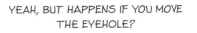

DOES THE PICTURE LINE UP WITH THE LANDSCAPE NOW?

NO.

HOW ABOUT IF I MOVE THE PICTURE FORWARD A BIT?

NOPE.

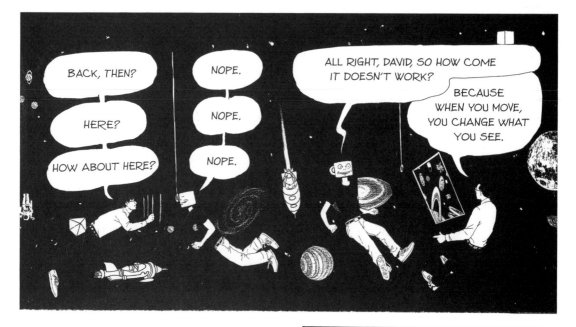

CRUISE AROUND WITH A FRAME OUT AT ARM'S LENGTH FOR A BIT AND NOTICE HOW YOUR VIEW CHANGES. A DRAWING ON THE PICTURE PLANE IS A STILL PICTURE, SO IT CAN'T CHANGE! IT WILL ONLY CORRESPOND WITH THE VIEW FROM ONE PARTICULAR POINT IN SPACE!

HERE'S A FOR INSTANCE: SUPPOSE YOU WERE BEING CHASED BY A HUNGRY LION.

YOU MIGHT WANT TO TRY AND OUTSMART HIM BY PAINTING A PERSPECTIVE SCENE ONTO A PANE OF PLATE GLASS, SO HE RUNS RIGHT INTO IT AND KNOCKS HIMSELF COLD! (DON'T FORGET TO PAINT THE BACK WHITE.)

BUT DON'T FORGET THAT THE LION'S VIEW CHANGES AS HE RUNS. AT A GREAT DISTANCE, THE PAINTING WON'T MATCH THE SCENE—IT WILL LOOK LIKE THIS.

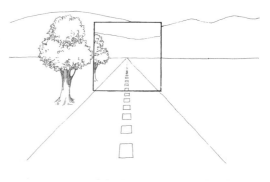

AS HE GETS CLOSER, THE PAINTING WILL BEGIN TO MATCH THE SURROUNDING LANDSCAPE, UNTIL HE REACHES THE **STATION POINT**, WHERE IT COINCIDES EXACTLY.

BUT THEN AS HE GETS CLOSER AND CLOSER, IT BECOMES OBVIOUS THAT THIS PAINTING WAS MADE TO BE SEEN FROM FARTHER AWAY!

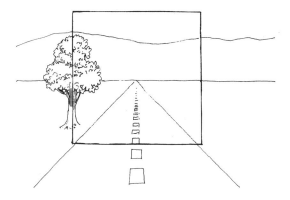 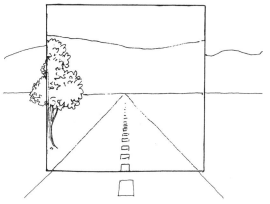

AND IF HE GETS OFF THE ROAD AND VIEWS IT FROM THE SIDE, THE DECEPTION WILL BE EVEN MORE OBVIOUS!

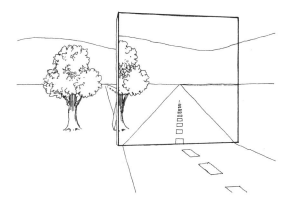

UNLESS YOUR LION IS A TOTAL DUMMY, HE'S GOING TO GIVE THE GLASS A MISS AND KEEP ON CHASING YOU!

HEY! IN THE FIRST CHAPTER YOU SAID THAT PLAN WOULD WORK!

I LIED.

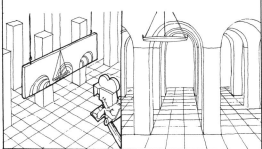

SO, DOES EVERY PICTURE IN PERSPECTIVE NEED TO BE SEEN FROM THE STATION POINT TO WORK?

NOT REALLY.

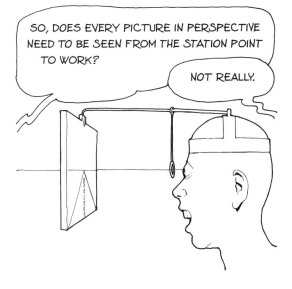

IT DEPENDS ON WHETHER YOUR AIM IS REALLY TO FOOL THE EYE OR NOT. IF YOU'RE PAINTING ON GLASS FOR A MOVIE, THEN IT HAS TO BE MOUNTED IN EXACTLY THE RIGHT SPOT OR IT WON'T MATCH THE SCENE.

BUT HARDLY ANYONE MINDS THAT A BACKDROP IN THE THEATER DOESN'T LINE UP WITH THE REST OF THE SCENERY.

A PICTURE PAINTED IN PERSPECTIVE HAS SUCH A STRONG AND PLEASING ILLUSION OF DEPTH THAT IT LOOKS GOOD AT ANY DISTANCE.

MOST PICTURES PRINTED IN BOOKS ARE SHRUNK WAY DOWN—TO VIEW THEM CORRECTLY FROM THE STATION POINT MIGHT CAUSE EYESTRAIN.

AND WHEN A MOVIE IS PROJECTED IN A THEATER, USUALLY THE ONLY PERSON WHO HAS A VIEW FROM THE STATION POINT IS THE PROJECTIONIST!

THIS BRINGS US TO OUR NEXT LESSON ABOUT THE PICTURE PLANE, AND THAT HAS TO DO WITH IMAGE SIZE.

YOUR EYE IS LIKE A MOVIE PROJECTOR IN REVERSE: INSTEAD OF PROJECTING AN IMAGE ONTO A SCREEN, IT PROJECTS AN IMAGE FROM THE REAL WORLD THROUGH THE PICTURE PLANE WHILE THE HAND TRACES THE OUTLINES.

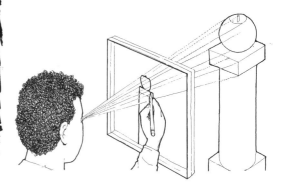

WHEN YOUR EYE SEES SOMETHING, IT LOCKS ONTO IT AND PULLS AN IMAGE BACK TO THE SURFACE OF THE RETINA, USING A KIND OF SHRINKING RAY—THE CLOSER TO THE EYE, THE SMALLER THE IMAGE.

A PICTURE PLANE HELD UP IN FRONT OF YOUR EYE CAN BLOCK THAT VIEW, BUT IF THE IMAGE ON THE PICTURE EXACTLY COINCIDES WITH A SLICE OF THIS VISUAL CONE, YOU WON'T NOTICE THE DIFFERENCE!

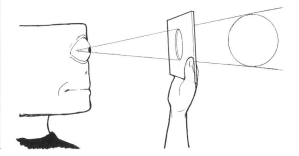

WHICH LION IS LONGER?

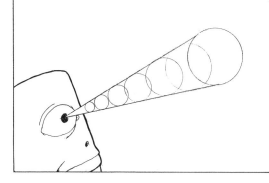

A SLIGHTLY DIFFERENT VIEW MAKES THE ANSWER OBVIOUS!

OBJECTS BEHIND THE PICTURE PLANE HAVE TO BE DRAWN SMALLER THAN ACTUAL SIZE, DEPENDING ON DISTANCE, WHILE—GET THIS!—OBJECTS IN FRONT NEED TO BE DRAWN LARGER!

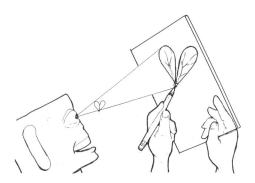

SO WHAT HAPPENS IF AN OBJECT IS EXACTLY THE SAME DISTANCE FROM YOUR EYE AS THE PICTURE PLANE? THE OUTLINE IS EXACTLY THE SIZE OF THE OBJECT!

SUCH AN OBJECT IS SAID TO BE "ON THE PICTURE PLANE" AND IS DRAWN ACTUAL SIZE— IT CAN EVEN BE TRACED DIRECTLY.

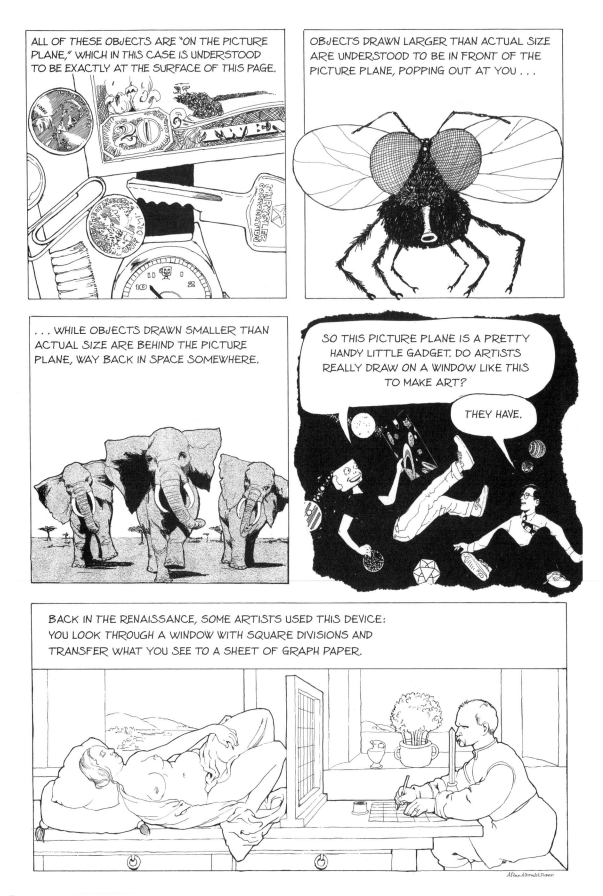

ALL OF THESE OBJECTS ARE "ON THE PICTURE PLANE," WHICH IN THIS CASE IS UNDERSTOOD TO BE EXACTLY AT THE SURFACE OF THIS PAGE.

OBJECTS DRAWN LARGER THAN ACTUAL SIZE ARE UNDERSTOOD TO BE IN FRONT OF THE PICTURE PLANE, POPPING OUT AT YOU . . .

. . . WHILE OBJECTS DRAWN SMALLER THAN ACTUAL SIZE ARE BEHIND THE PICTURE PLANE, WAY BACK IN SPACE SOMEWHERE.

SO THIS PICTURE PLANE IS A PRETTY HANDY LITTLE GADGET. DO ARTISTS REALLY DRAW ON A WINDOW LIKE THIS TO MAKE ART?

THEY HAVE.

BACK IN THE RENAISSANCE, SOME ARTISTS USED THIS DEVICE: YOU LOOK THROUGH A WINDOW WITH SQUARE DIVISIONS AND TRANSFER WHAT YOU SEE TO A SHEET OF GRAPH PAPER.

After Albrecht Dürer.

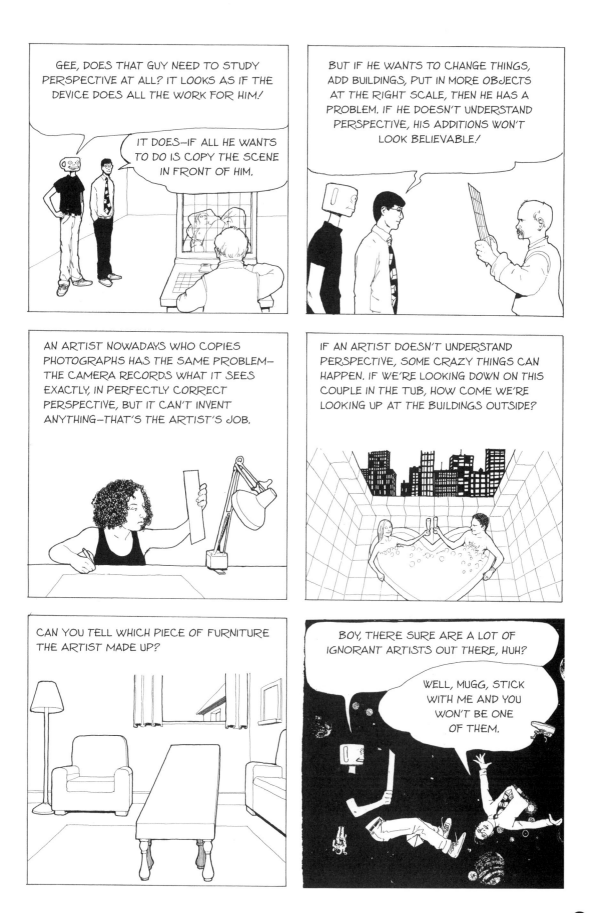

CHAPTER FOUR

THE HORIZON AND THE VANISHING POINT

Two of the most fundamental concepts of perspective are the horizon and the vanishing point. Many readers, of course, are already familiar with these concepts and may feel that they are self-evident and obvious, but it took many centuries for artists to realize that they exist.

Early writers on optics observed that lines in a room seemed to slope upward from the floor and downward from the ceiling, and observant artists from antiquity up to the Renaissance included the effect in their paintings. But what they failed to grasp was that these same lines, if extended far into the distance, would all appear to meet at a single point on the horizon. Eventually the discovery was made during the Renaissance by the painter-architect Brunelleschi, and soon artists all over Europe were using it in their art.

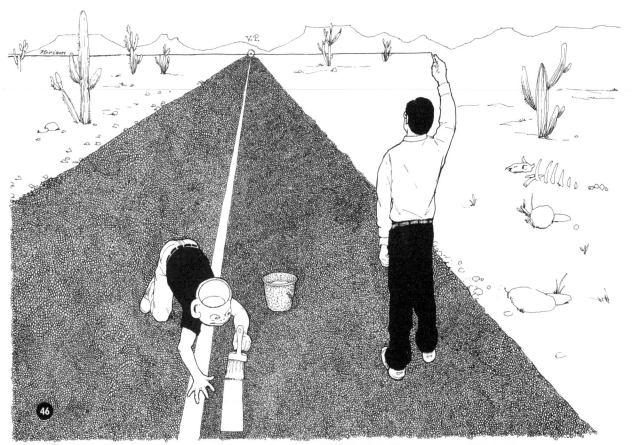

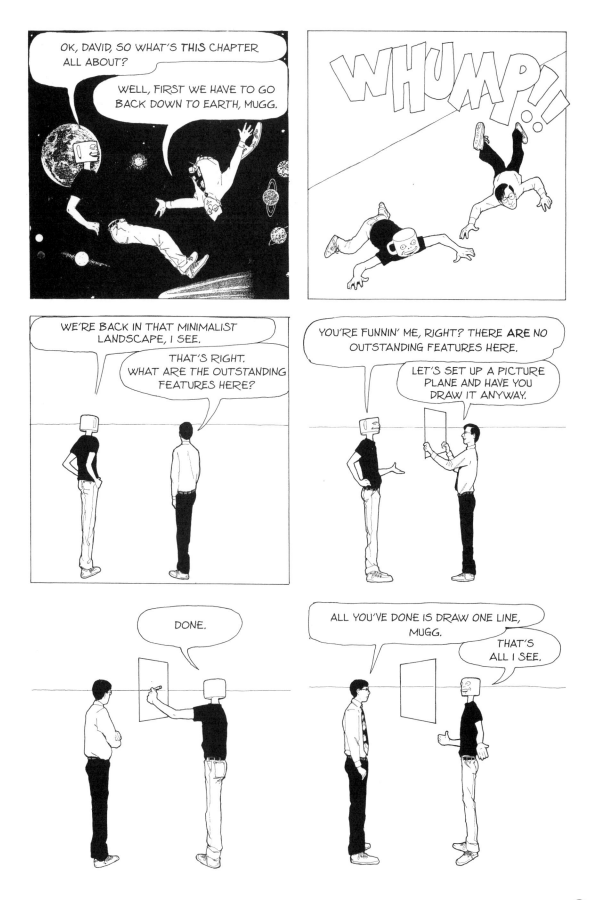

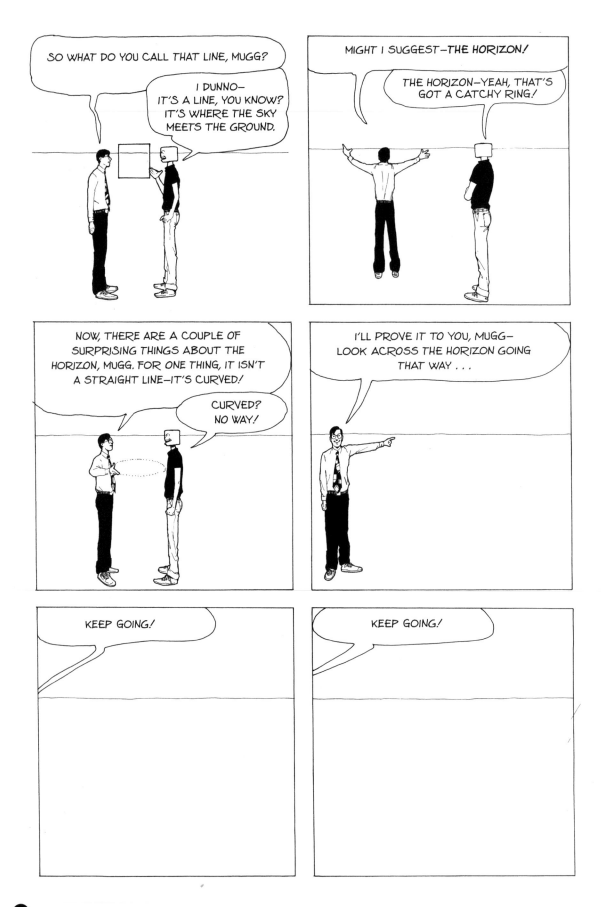

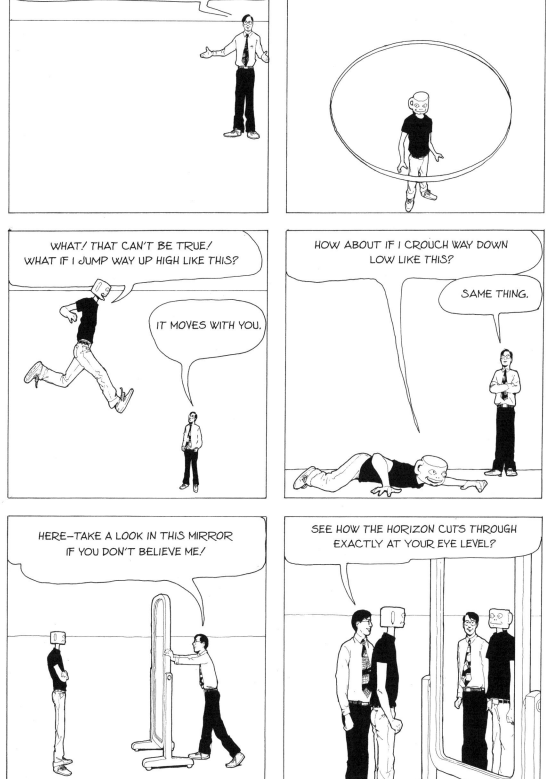

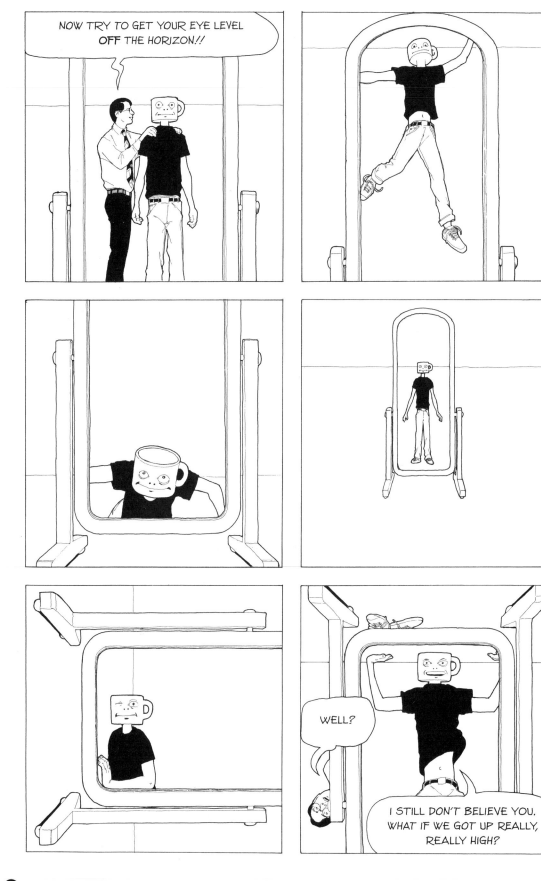

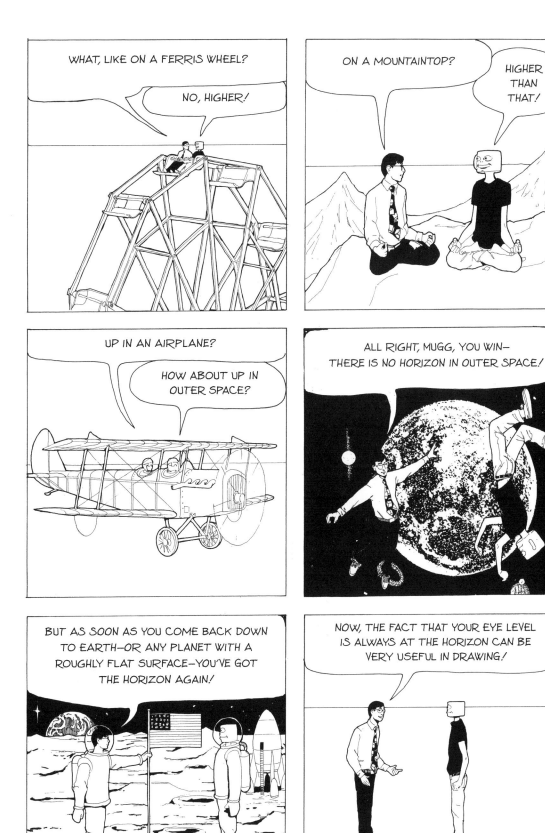

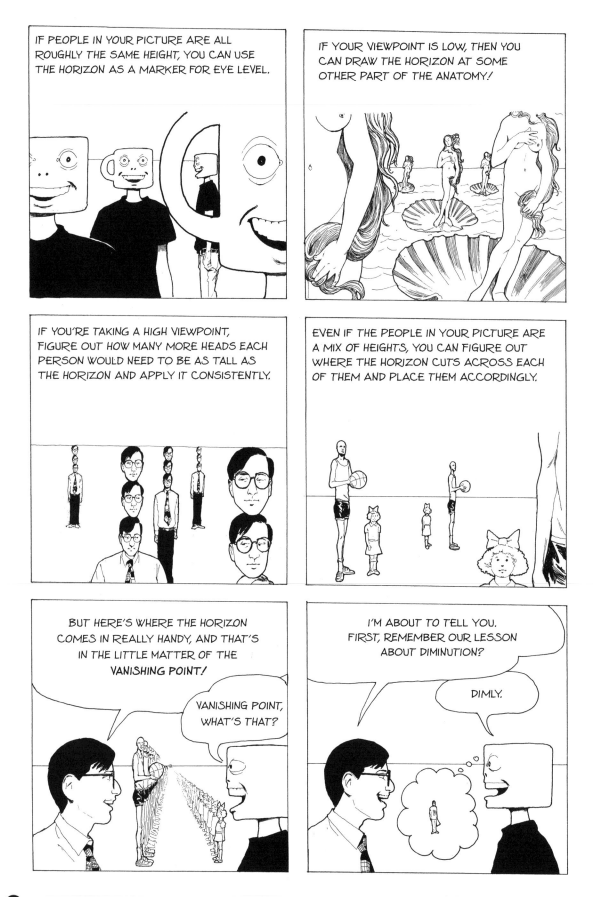

IF PEOPLE IN YOUR PICTURE ARE ALL ROUGHLY THE SAME HEIGHT, YOU CAN USE THE HORIZON AS A MARKER FOR EYE LEVEL.

IF YOUR VIEWPOINT IS LOW, THEN YOU CAN DRAW THE HORIZON AT SOME OTHER PART OF THE ANATOMY!

IF YOU'RE TAKING A HIGH VIEWPOINT, FIGURE OUT HOW MANY MORE HEADS EACH PERSON WOULD NEED TO BE AS TALL AS THE HORIZON AND APPLY IT CONSISTENTLY.

EVEN IF THE PEOPLE IN YOUR PICTURE ARE A MIX OF HEIGHTS, YOU CAN FIGURE OUT WHERE THE HORIZON CUTS ACROSS EACH OF THEM AND PLACE THEM ACCORDINGLY.

BUT HERE'S WHERE THE HORIZON COMES IN REALLY HANDY, AND THAT'S IN THE LITTLE MATTER OF THE VANISHING POINT!

VANISHING POINT, WHAT'S THAT?

I'M ABOUT TO TELL YOU. FIRST, REMEMBER OUR LESSON ABOUT DIMINUTION?

DIMLY.

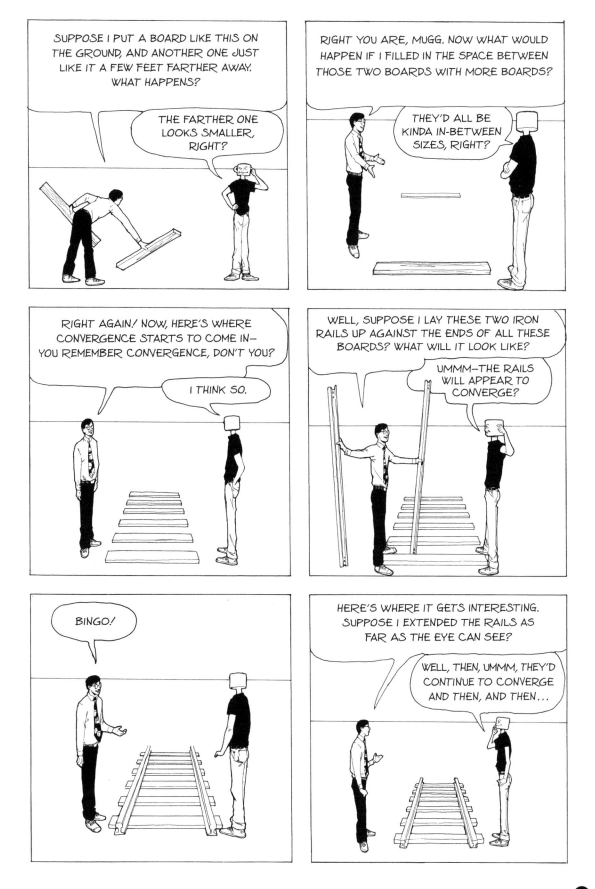

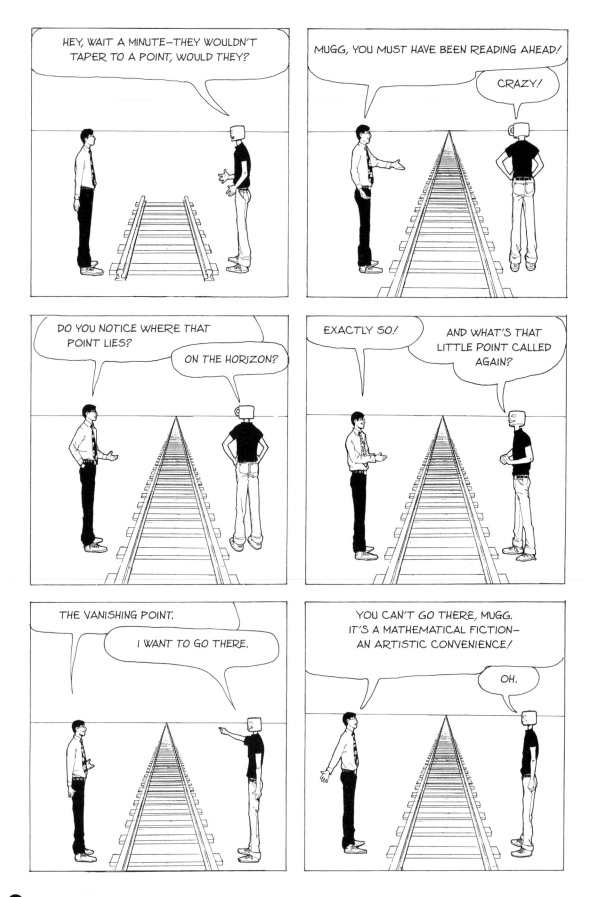

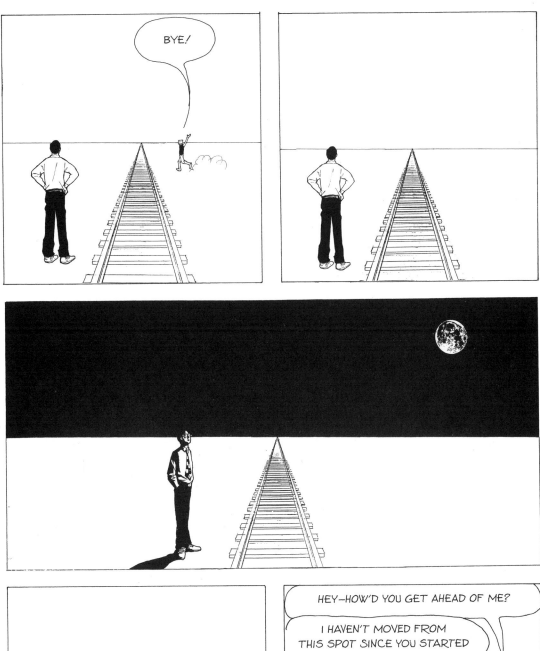

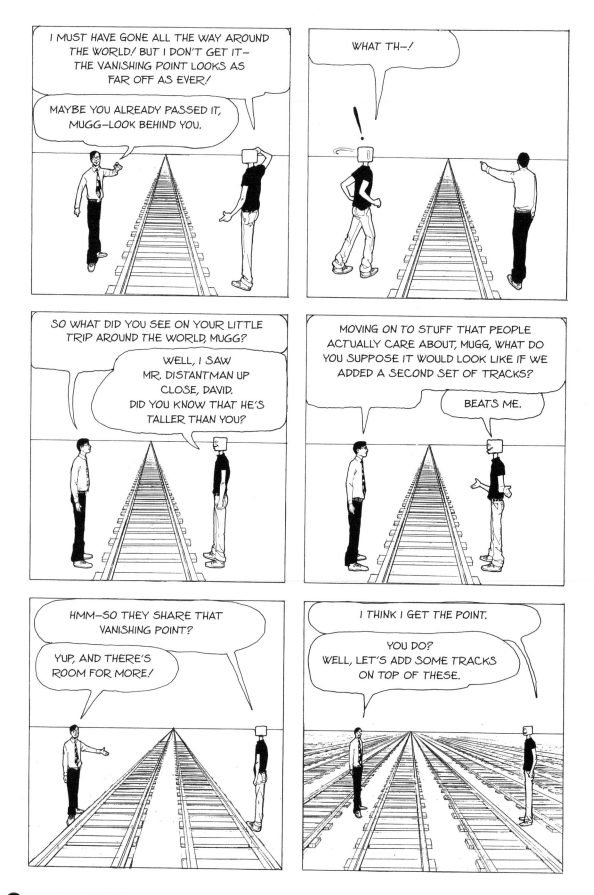

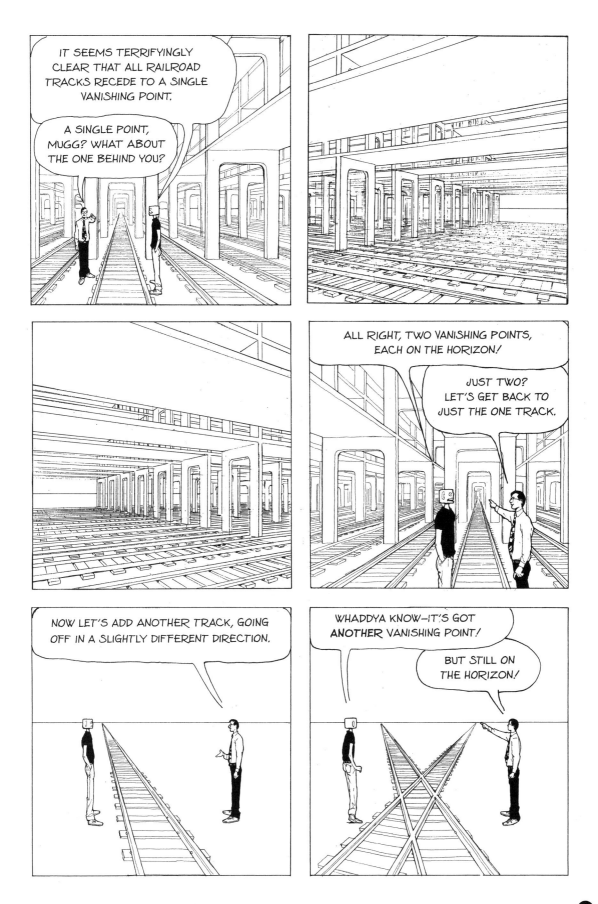

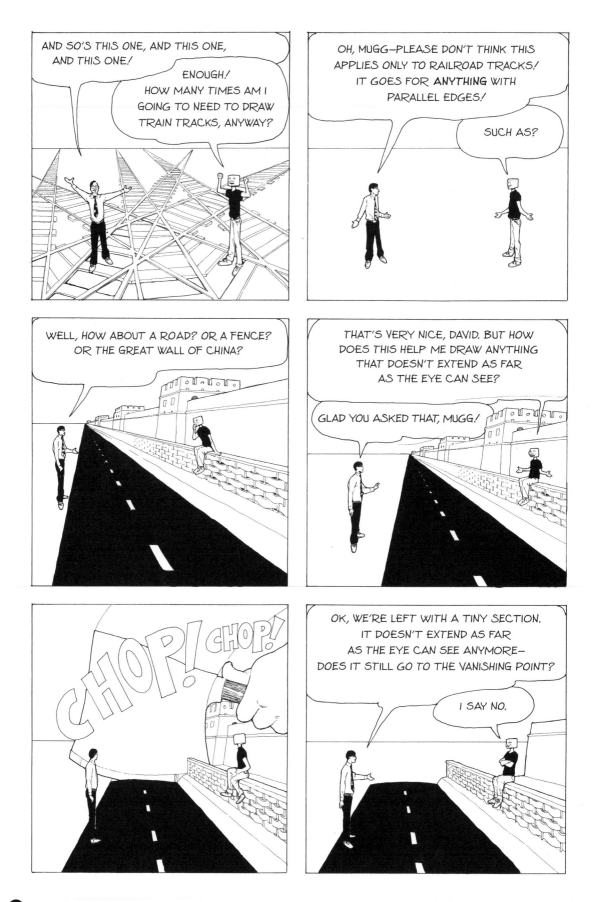

LOOK AGAIN.

WOW!
A SECOND
COLOR!

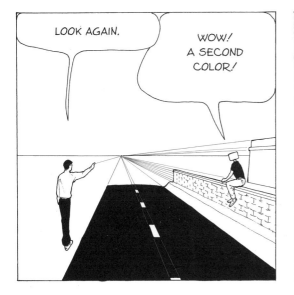

WELL, IT **WAS** EXPENSIVE, BUT I JUST WANTED TO SHOW YOU THAT WHAT'S TRUE OF THE WHOLE IS TRUE OF ANY PART—THOSE RECEDING LINES ALWAYS CONVERGE TOWARD A VANISHING POINT, WHETHER THEY REACH ALL THE WAY OR NOT!

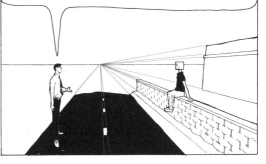

ALSO, THIS IS TRUE OF ANY OBJECT CONTAINING PARALLEL LINES— WHEN THOSE LINES RECEDE, THEY RECEDE TO A VANISHING POINT!

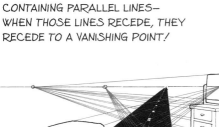

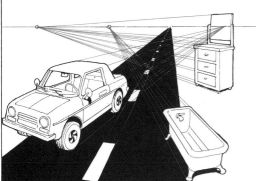

AND AS LONG AS THOSE RECEDING LINES ARE EITHER ON THE GROUND OR PARALLEL TO IT, THEY MEET AT THE HORIZON.

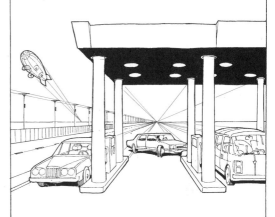

IT'S A GOOD IDEA TO DRAW IN A HORIZON, EVEN IF IT'S NOT VISIBLE. IT'LL HELP ENSURE THAT YOUR PERSPECTIVE IS CORRECT, AND YOU CAN ALWAYS ERASE IT LATER.

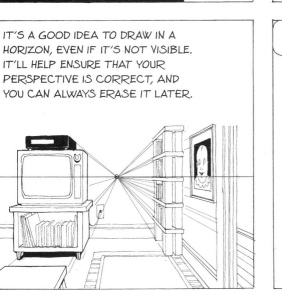

SO, TO CONCLUDE . . .

HEY, DAVID, I JUST THOUGHT OF SOMETHING! I KNOW WHY I DIDN'T REACH THE VANISHING POINT!

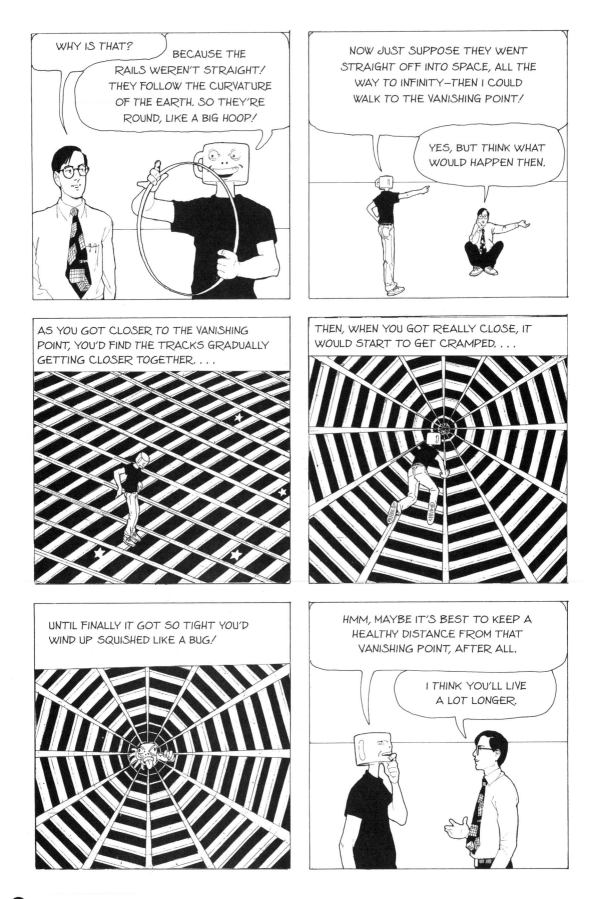

CHAPTER FIVE

CUBES IN SPACE!

In this chapter, we learn a basic fact that will help us unlock the science of perspective: We live in a boxy world. Most objects in the man-made environment, from the houses we live in to the dice we toss, are variations on the basic shape of the box, or cube. If this were not so, then perspective would look very different, and we might not have ever discovered it at all.

The cartoonist Burne Hogarth, who produced many fine books on drawing and anatomy, never wrote a book about perspective. Perhaps it was because he spent most of his career drawing Tarzan, who lives in the jungle, far away from the boxy buildings of civilization and their cuby perspective, and therefore had little need of it.

There is a chapter devoted to perspective shortcuts at the end of this book, but here is one more. If you don't have time to set up a full-blown perspective, loosely pencil in an imaginary set of monkey bars before drawing anything else—if the monkey bars are plausible, any object based on them will be, too.

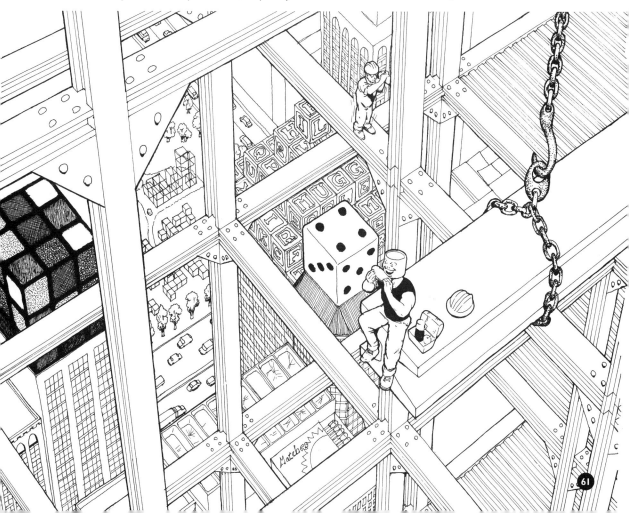

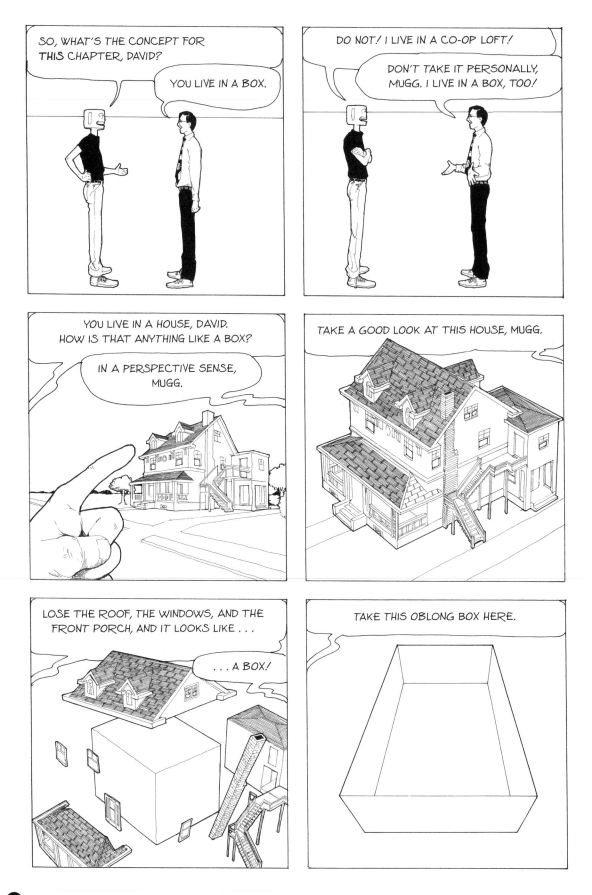

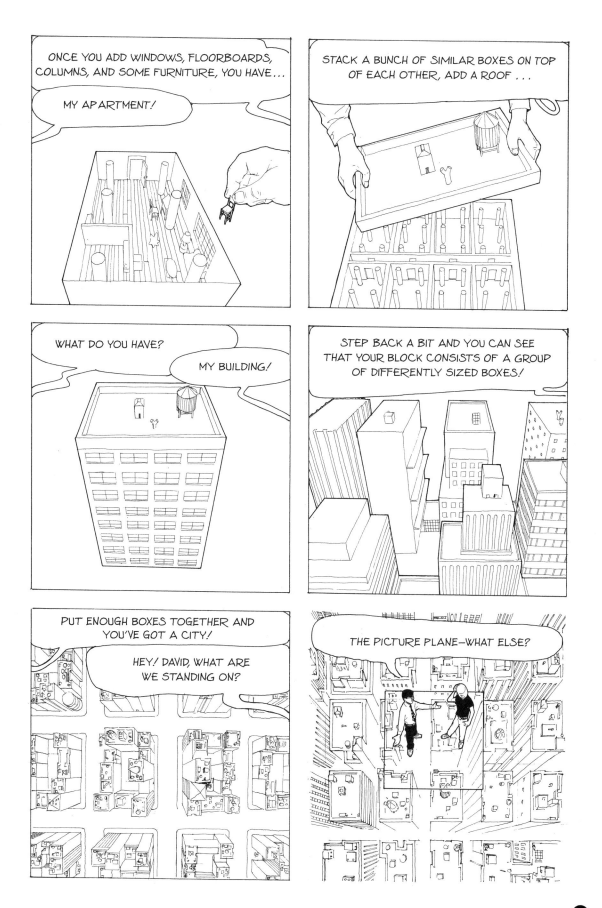

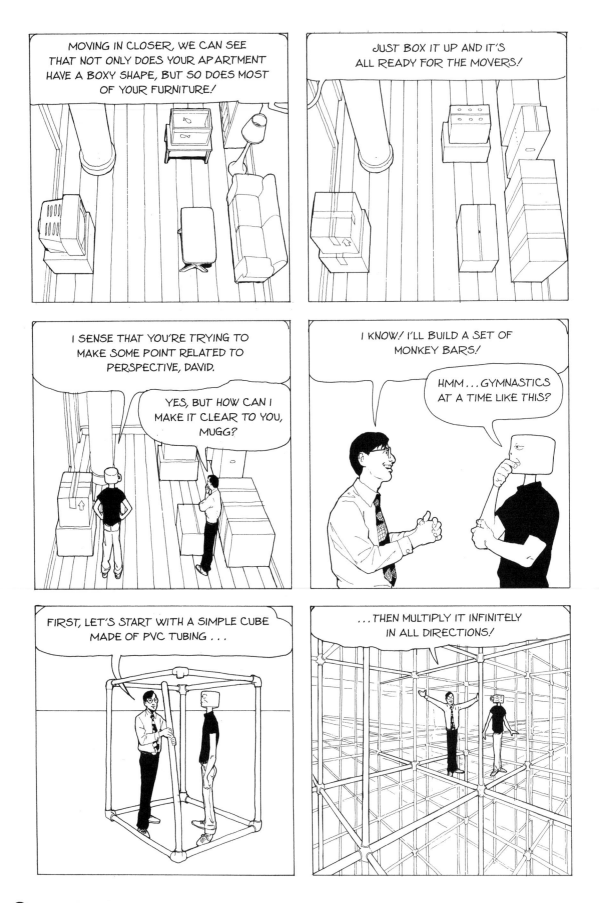

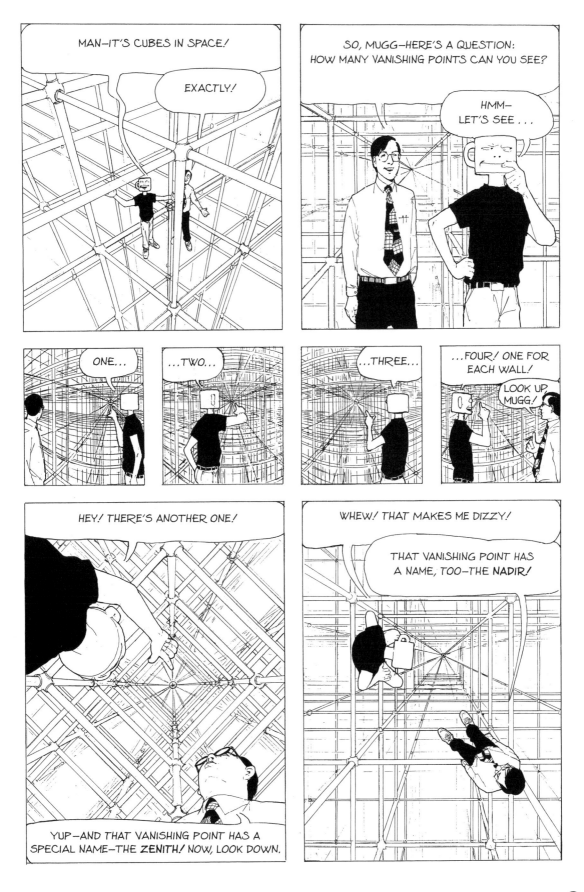

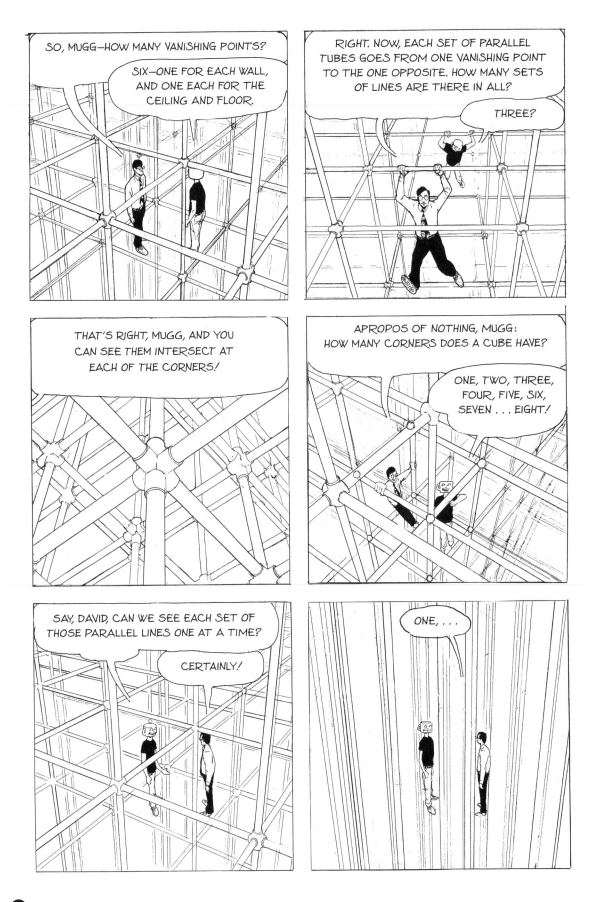

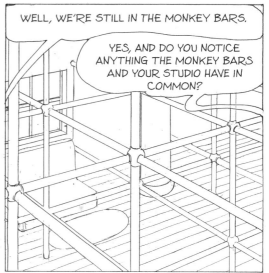

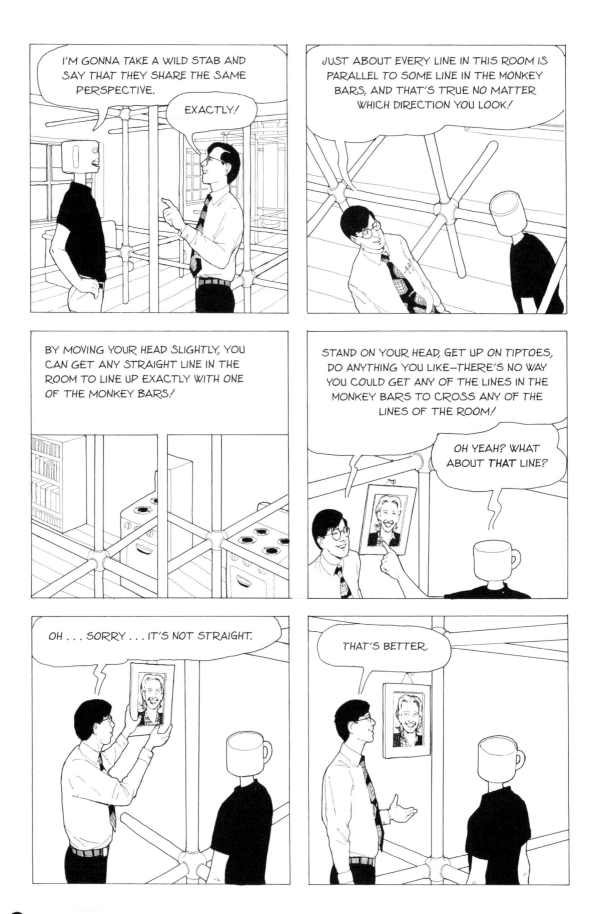

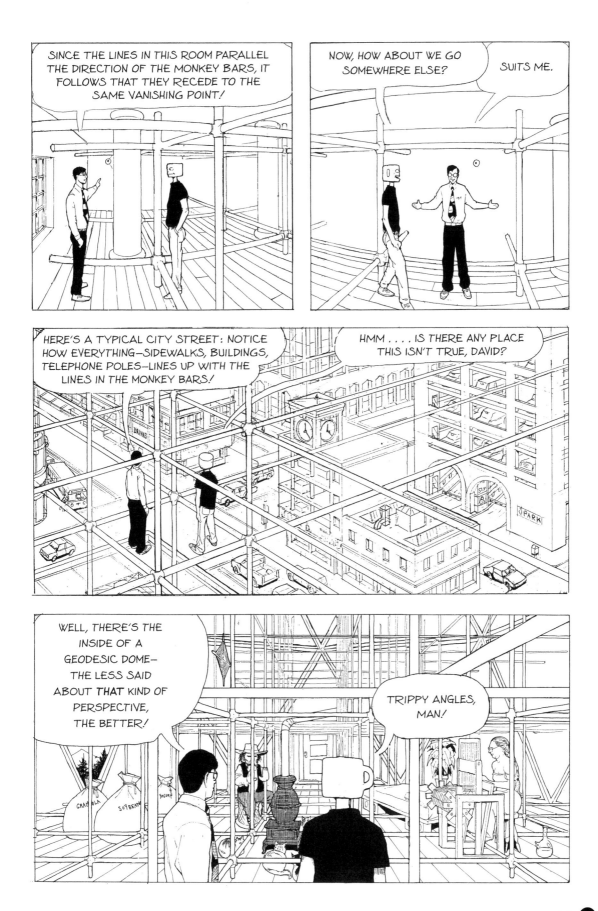

AND HERE'S ANOTHER. OUT IN THE NATURAL LANDSCAPE, VERY FEW LINES MATCH THE MONKEY BARS—A FEW VERTICAL TREE TRUNKS, THE HORIZON, AND THAT'S ABOUT IT!

BUT GO VIRTUALLY ANYWHERE BUILT BY HUMANS AND YOU'LL SEE THOSE MONKEY BAR LINES AGAIN!

WHY IS THAT, DAVID?

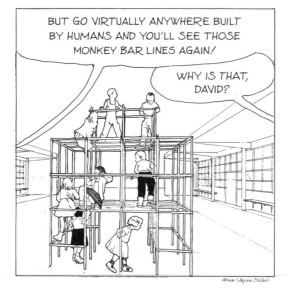

After Wayne Miller

I DON'T KNOW—MAYBE IT HAS SOMETHING TO DO WITH THE CONSTRUCTION MATERIALS. . . .

WHATEVER THE REASON, IT MEANS THAT IF YOU CAN DRAW A BOX OR A CUBE OR A BRICK, YOU'RE WELL ON YOUR WAY TO BEING ABLE TO DRAW MOST MAN-MADE OBJECTS IN PERSPECTIVE.

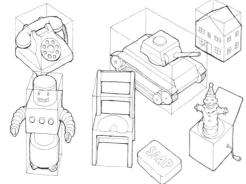

SO SHOW ME HOW TO DRAW A BOX, DAVID. HOW HARD CAN IT BE?

YOU'LL FIND OUT IN THE NEXT THRILLING CHAPTER!

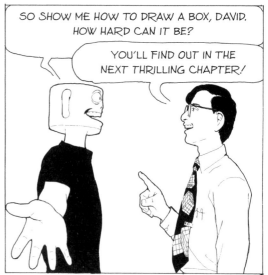

ONE-POINT PERSPECTIVE

One-point perspective is the simplest type of perspective to draw, and many people stick to it for that reason. While it can be used loosely, just to define the direction of receding lines, in this chapter I show you a method of using it with great precision, dividing space up into square divisions using the diagonal vanishing point. Also in this chapter, I explain the concept of the cone of vision, and the advantages of staying within a narrow—as opposed to a wider—cone.

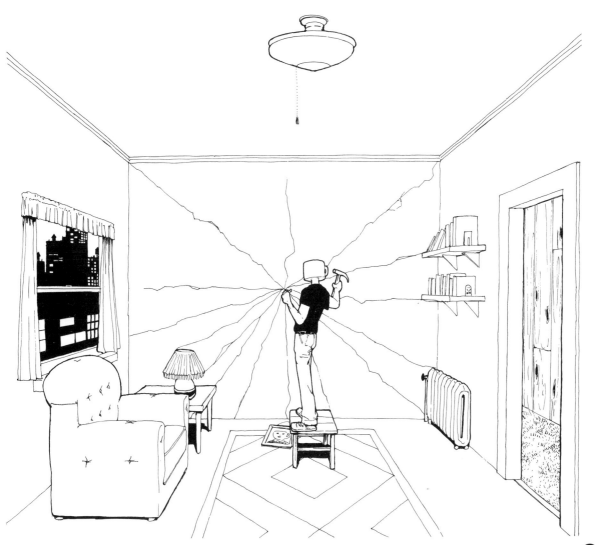

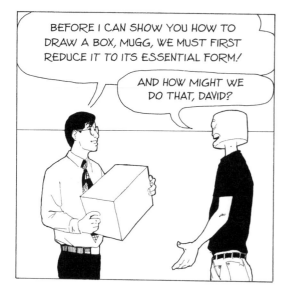

BEFORE I CAN SHOW YOU HOW TO DRAW A BOX, MUGG, WE MUST FIRST REDUCE IT TO ITS ESSENTIAL FORM!

AND HOW MIGHT WE DO THAT, DAVID?

LIKE THIS!

BEHOLD! A CUBE WITH PERFECTLY EQUAL SIDES!

SO, NOW ARE WE READY?

RIGHT AFTER THIS, MUGG!

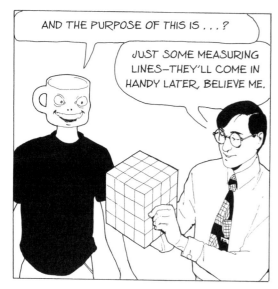

AND THE PURPOSE OF THIS IS . . . ?

JUST SOME MEASURING LINES—THEY'LL COME IN HANDY LATER, BELIEVE ME.

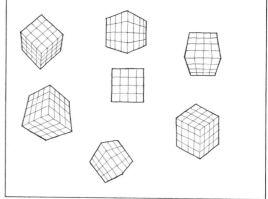

HERE ARE A FEW OF THE MANY POSSIBLE VIEWS OF THE CUBE—WE'RE GOING TO START WITH THE EASIEST. WHICH DO YOU SUPPOSE THAT WOULD BE?

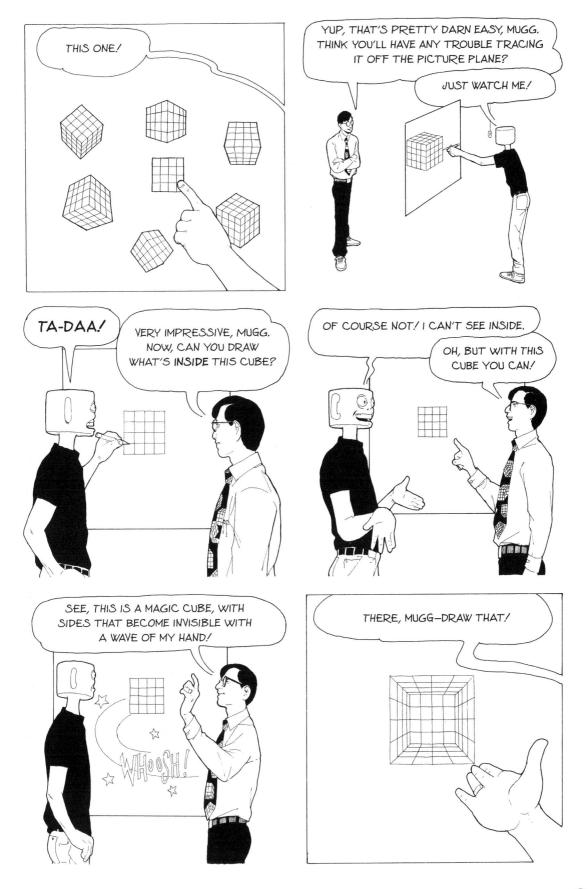

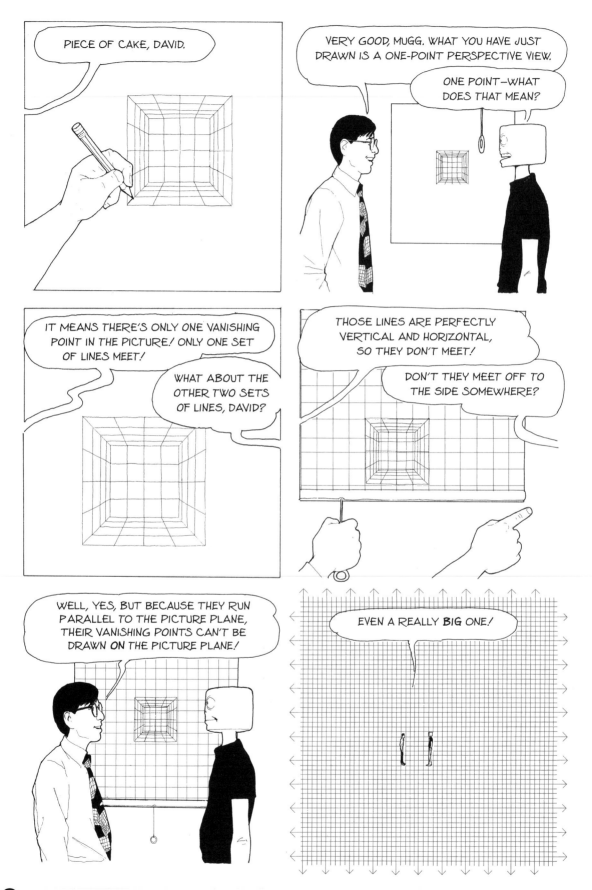

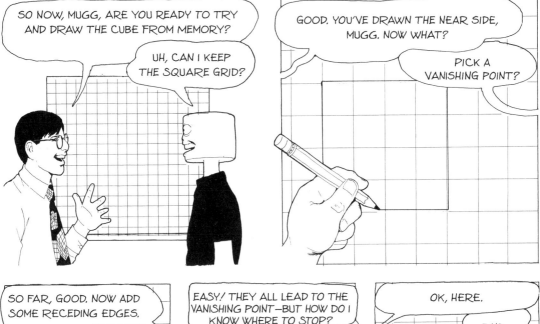

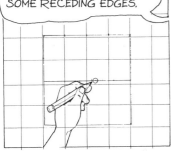

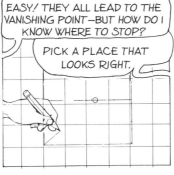

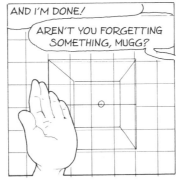

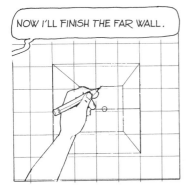

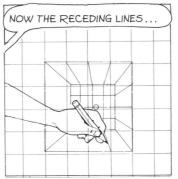

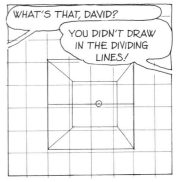

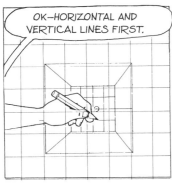

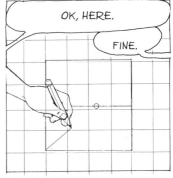

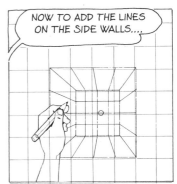

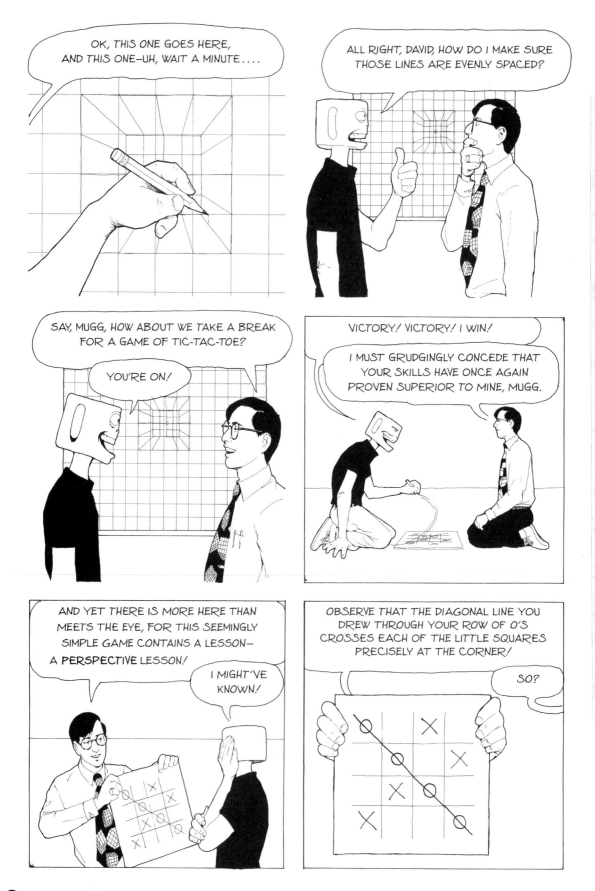

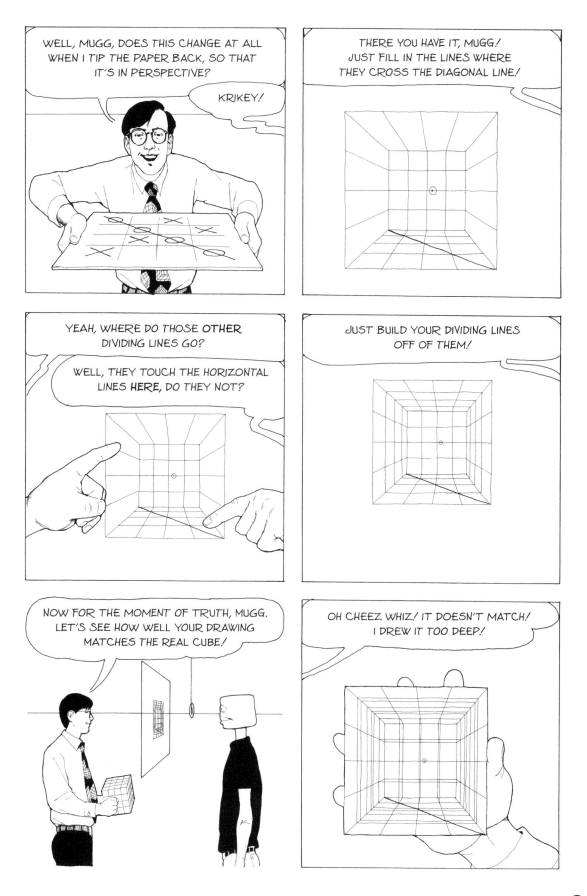

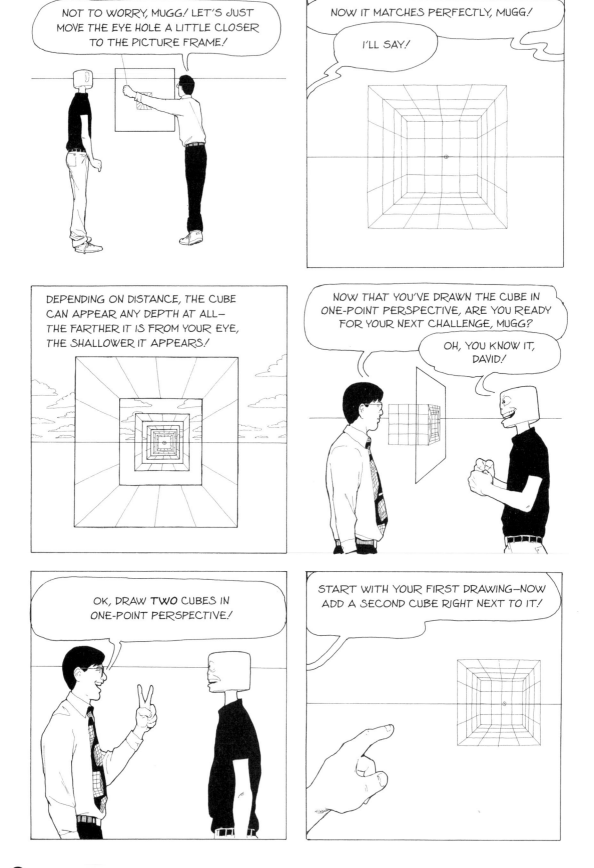

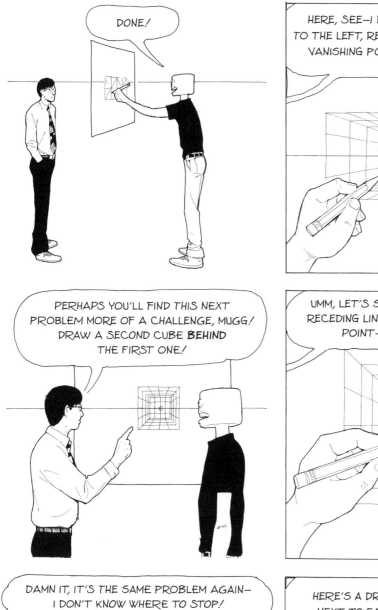

DONE!

HERE, SEE—I DREW ANOTHER SQUARE TO THE LEFT, RECEDING LINES BACK TO THE VANISHING POINTS, AND A BACK WALL.

SWELL!

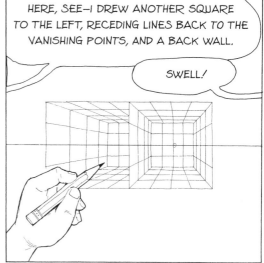

PERHAPS YOU'LL FIND THIS NEXT PROBLEM MORE OF A CHALLENGE, MUGG! DRAW A SECOND CUBE **BEHIND** THE FIRST ONE!

UMM, LET'S SEE—FIRST I CONTINUE THE RECEDING LINES BACK TO THE VANISHING POINT—THEN I . . . THEN I . . .

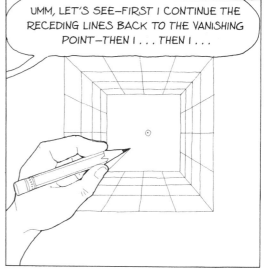

DAMN IT, IT'S THE SAME PROBLEM AGAIN— I DON'T KNOW WHERE TO STOP!

MAYBE I CAN HELP.

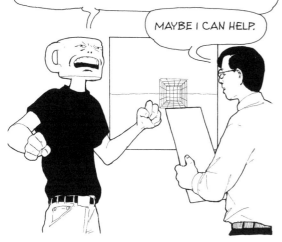

HERE'S A DRAWING OF TWO SQUARES NEXT TO EACH OTHER. WATCH WHAT HAPPENS WHEN I DRAW DIAGONAL LINES ACROSS FROM OPPOSITE CORNERS.

THEY MAKE AN "X," AND WHERE THEY MEET IS EXACTLY IN THE MIDDLE!

SO WHAT?

SO, THAT DOESN'T CHANGE WHEN YOU PUT IT IN PERSPECTIVE. THE LINES STILL CROSS EXACTLY WHERE THE MIDDLE IS—IN PERSPECTIVE.

SO IF YOU HAVE ONE SQUARE IN PERSPECTIVE AND YOU WANT TO ADD ANOTHER, FIND A LINE THAT DIVIDES IT IN HALF, THEN DRAW A LINE FROM THE BOTTOM CORNER PASSING THROUGH THE LINE AT MIDPOINT, UP TO THE TOP EDGE—AND THERE YOU HAVE IT! THAT'S WHERE YOUR RECTANGLE ENDS!

ONCE YOU'VE GOT ONE SIDE COMPLETE, FINISHING THE BOX IS A SIMPLE MATTER!

THE "X METHOD" CAN BE USED ANYTIME YOU NEED TO FIND THE CENTER OF ANY RECTANGULAR FORM IN PERSPECTIVE...

...NOT TO MENTION HOW USEFUL IT IS IN LOCATING OBJECTS IN AN EQUALLY SPACED SERIES!

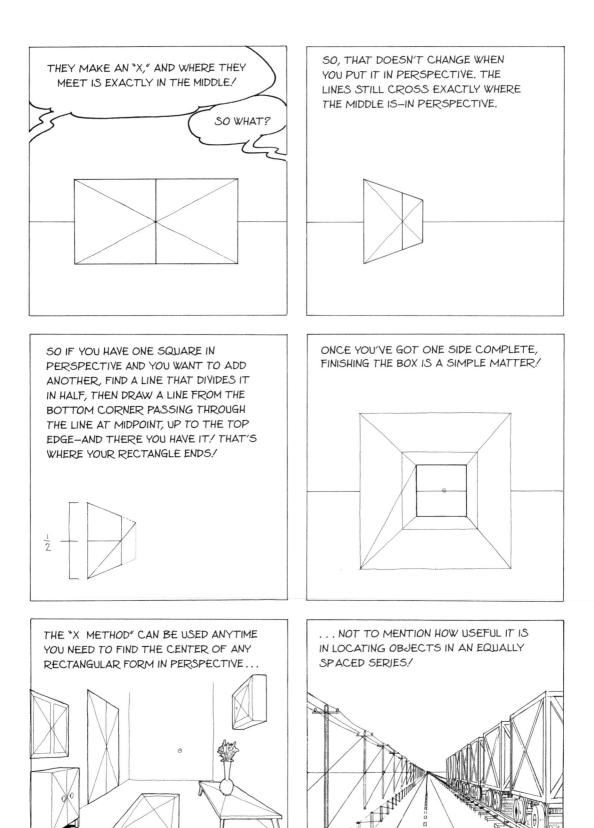

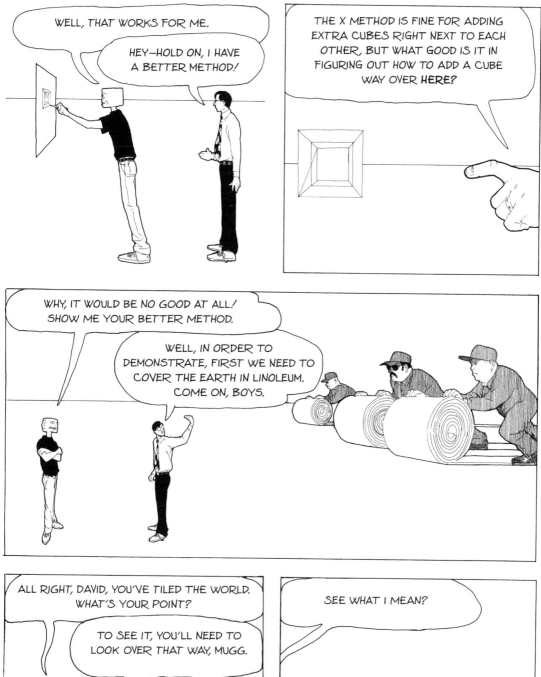

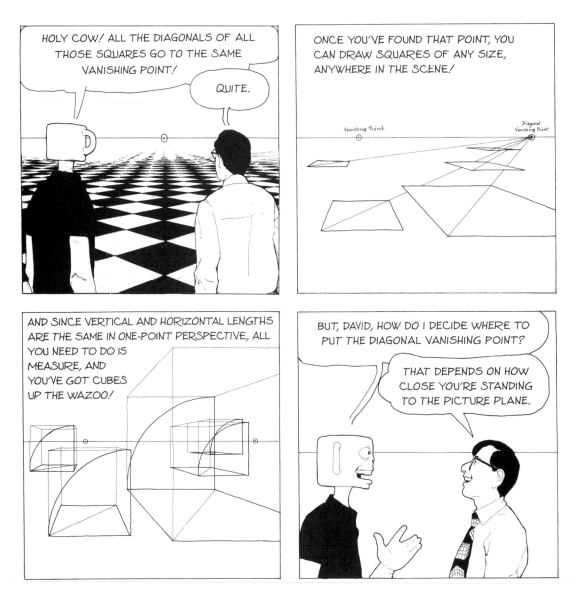

HOLY COW! ALL THE DIAGONALS OF ALL THOSE SQUARES GO TO THE SAME VANISHING POINT!

QUITE.

ONCE YOU'VE FOUND THAT POINT, YOU CAN DRAW SQUARES OF ANY SIZE, ANYWHERE IN THE SCENE!

AND SINCE VERTICAL AND HORIZONTAL LENGTHS ARE THE SAME IN ONE-POINT PERSPECTIVE, ALL YOU NEED TO DO IS MEASURE, AND YOU'VE GOT CUBES UP THE WAZOO!

BUT, DAVID, HOW DO I DECIDE WHERE TO PUT THE DIAGONAL VANISHING POINT?

THAT DEPENDS ON HOW CLOSE YOU'RE STANDING TO THE PICTURE PLANE.

IF YOU NEED TO BE PRECISE, FIRST ESTABLISH A STATION POINT (THE POINT YOU'RE STANDING ON) AND THE BOTTOM EDGE OF THE PICTURE PLANE.

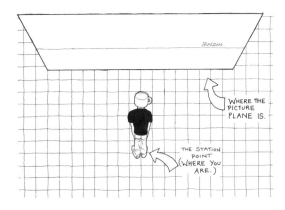

THEN DRAW DIAGONAL LINES FROM THE STATION POINT TO THE PICTURE PLANE AND MARK WHERE THEY INTERSECT IT.

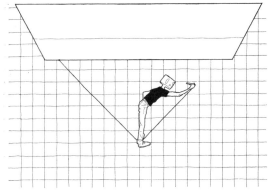

THOSE DIAGONAL VANISHING POINTS WILL BE LOCATED ON THE HORIZON, DIRECTLY ABOVE WHERE THE DIAGONAL LINES MEET THE PICTURE PLANE.

THE TWO DIAGONAL VANISHING POINTS WILL BE LOCATED AN EQUAL DISTANCE AWAY FROM THE CENTRAL VANISHING POINT!

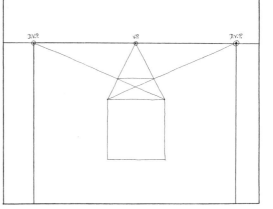

IF YOU STAND CLOSE TO THE PICTURE PLANE, THE DIAGONAL VANISHING POINTS WILL BE CLOSE TOGETHER. STAND FARTHER BACK AND THEY'LL BE FARTHER APART.

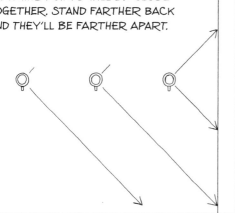

WHAT IF I DON'T NEED TO BE THAT PRECISE, DAVID?

OH, JUST PUT 'EM ANYWHERE ON THE HORIZON, MUGG.

JUST REMEMBER THAT THE CLOSER IN YOU PUT THEM, THE NARROWER THE AREA YOU HAVE TO DRAW IN. ONCE YOU GET CLOSER TO THE DIAGONAL VANISHING POINTS, CUBES START TO LOOK REALLY DISTORTED.

AND ONCE YOU GO PAST THE DIAGONAL VANISHING POINTS, CUBES ARE HARDLY RECOGNIZABLE AT ALL, NOT TO MENTION CUBIC FORMS.

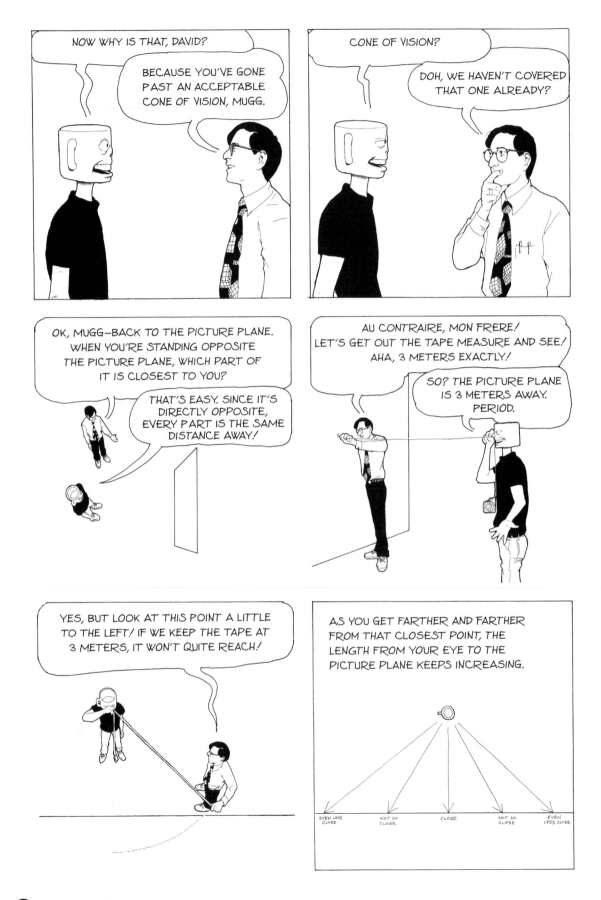

NOW WHY IS THAT, DAVID?

BECAUSE YOU'VE GONE PAST AN ACCEPTABLE CONE OF VISION, MUGG.

CONE OF VISION?

DOH, WE HAVEN'T COVERED THAT ONE ALREADY?

OK, MUGG—BACK TO THE PICTURE PLANE. WHEN YOU'RE STANDING OPPOSITE THE PICTURE PLANE, WHICH PART OF IT IS CLOSEST TO YOU?

THAT'S EASY. SINCE IT'S DIRECTLY OPPOSITE, EVERY PART IS THE SAME DISTANCE AWAY!

AU CONTRAIRE, MON FRERE! LET'S GET OUT THE TAPE MEASURE AND SEE! AHA, 3 METERS EXACTLY!

SO? THE PICTURE PLANE IS 3 METERS AWAY. PERIOD.

YES, BUT LOOK AT THIS POINT A LITTLE TO THE LEFT! IF WE KEEP THE TAPE AT 3 METERS, IT WON'T QUITE REACH!

AS YOU GET FARTHER AND FARTHER FROM THAT CLOSEST POINT, THE LENGTH FROM YOUR EYE TO THE PICTURE PLANE KEEPS INCREASING.

EVEN LESS CLOSE

NOT SO CLOSE

CLOSE

NOT SO CLOSE

EVEN LESS CLOSE

IF YOU MARK OUT AREAS OF EQUAL DISTANCE, YOU FIND THAT THEY MAKE CIRCULAR RINGS AROUND THE CLOSEST POINT.

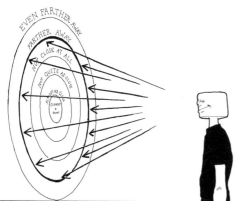

WE CALL THAT POINT **THE CENTER OF VISION.** IN ONE-POINT PERSPECTIVE IT COINCIDES WITH THE VANISHING POINT!

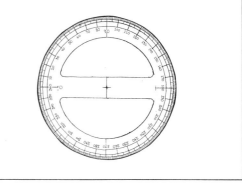

THOSE CIRCLES CAN BE THOUGHT OF AS THE BASES OF A SERIES OF CONCENTRIC CONES POINTING AT YOUR EYE—LONG, SKINNY CONES ON THE INSIDE, FATTER ONES FARTHER OUT.

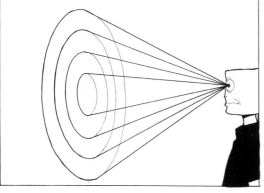

NOW, YOU MAY REMEMBER FROM HIGH SCHOOL GEOMETRY THAT THE CIRCLE IS DIVIDED INTO 360° (DEGREES) OR SECTIONS. THIS COMES IN HANDY WHEN YOU WANT TO LABEL THOSE CONES!

SET UP A PROTRACTOR, WHICH IS LIKE A RULER FOR MEASURING THE DEGREES OF A CIRCLE, WITH THE CENTER AT YOUR EYE AND 0° POINTING AT THE CENTER OF VISION.

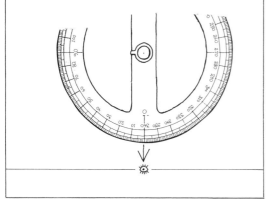

BY DRAWING LINES THROUGH THE OTHER DEGREE MARKINGS, YOU CAN MARK ON THE HORIZON PLANE THE EDGES OF ALL THOSE CONES. (DOUBLE THE MEASUREMENTS, SINCE THE DISTANCE ACROSS THE BASE OF A CONE IS TWICE THE DISTANCE FROM THE CENTER OF THE EDGE.)

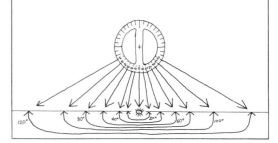

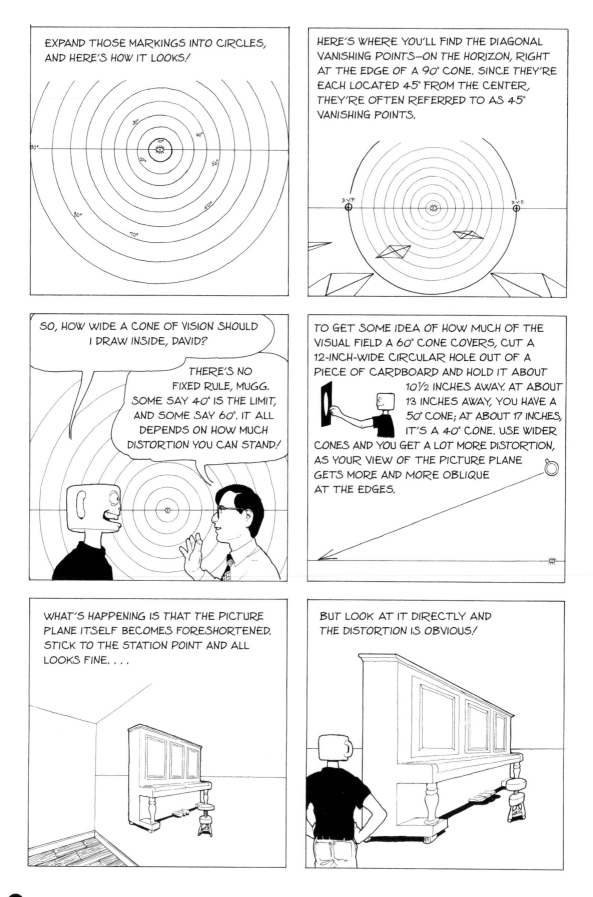

EXPAND THOSE MARKINGS INTO CIRCLES, AND HERE'S HOW IT LOOKS!

HERE'S WHERE YOU'LL FIND THE DIAGONAL VANISHING POINTS—ON THE HORIZON, RIGHT AT THE EDGE OF A 90° CONE. SINCE THEY'RE EACH LOCATED 45° FROM THE CENTER, THEY'RE OFTEN REFERRED TO AS 45° VANISHING POINTS.

SO, HOW WIDE A CONE OF VISION SHOULD I DRAW INSIDE, DAVID?

THERE'S NO FIXED RULE, MUGG. SOME SAY 40° IS THE LIMIT, AND SOME SAY 60°. IT ALL DEPENDS ON HOW MUCH DISTORTION YOU CAN STAND!

TO GET SOME IDEA OF HOW MUCH OF THE VISUAL FIELD A 60° CONE COVERS, CUT A 12-INCH-WIDE CIRCULAR HOLE OUT OF A PIECE OF CARDBOARD AND HOLD IT ABOUT 10½ INCHES AWAY. AT ABOUT 13 INCHES AWAY, YOU HAVE A 50° CONE; AT ABOUT 17 INCHES, IT'S A 40° CONE. USE WIDER CONES AND YOU GET A LOT MORE DISTORTION, AS YOUR VIEW OF THE PICTURE PLANE GETS MORE AND MORE OBLIQUE AT THE EDGES.

WHAT'S HAPPENING IS THAT THE PICTURE PLANE ITSELF BECOMES FORESHORTENED. STICK TO THE STATION POINT AND ALL LOOKS FINE. . . .

BUT LOOK AT IT DIRECTLY AND THE DISTORTION IS OBVIOUS!

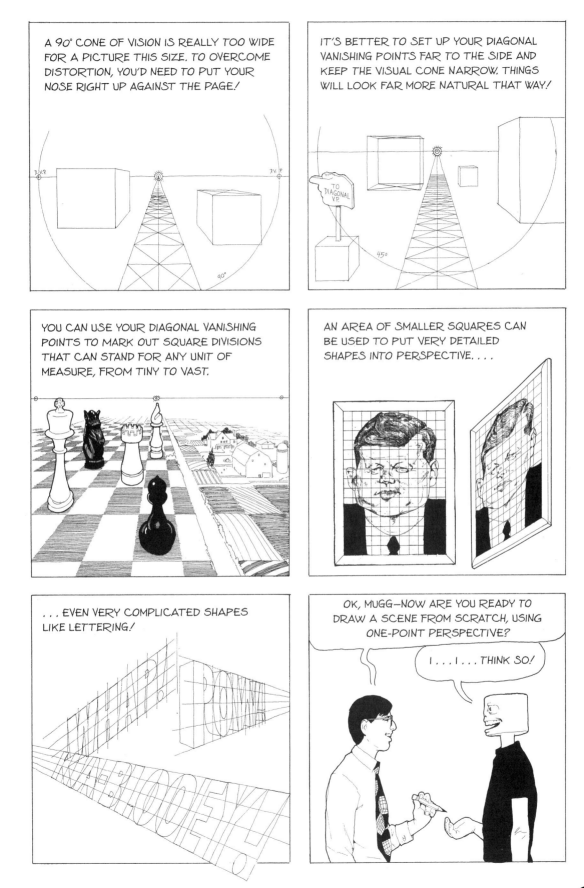

A 90° CONE OF VISION IS REALLY TOO WIDE FOR A PICTURE THIS SIZE. TO OVERCOME DISTORTION, YOU'D NEED TO PUT YOUR NOSE RIGHT UP AGAINST THE PAGE!

IT'S BETTER TO SET UP YOUR DIAGONAL VANISHING POINTS FAR TO THE SIDE AND KEEP THE VISUAL CONE NARROW. THINGS WILL LOOK FAR MORE NATURAL THAT WAY!

YOU CAN USE YOUR DIAGONAL VANISHING POINTS TO MARK OUT SQUARE DIVISIONS THAT CAN STAND FOR ANY UNIT OF MEASURE, FROM TINY TO VAST.

AN AREA OF SMALLER SQUARES CAN BE USED TO PUT VERY DETAILED SHAPES INTO PERSPECTIVE. . . .

. . . EVEN VERY COMPLICATED SHAPES LIKE LETTERING!

OK, MUGG—NOW ARE YOU READY TO DRAW A SCENE FROM SCRATCH, USING ONE-POINT PERSPECTIVE?

I . . . I . . . THINK SO!

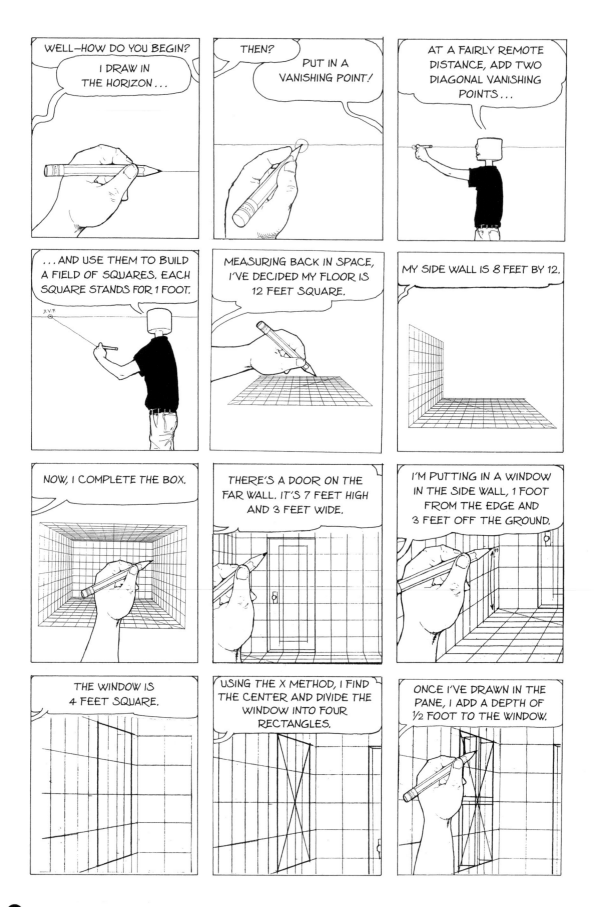

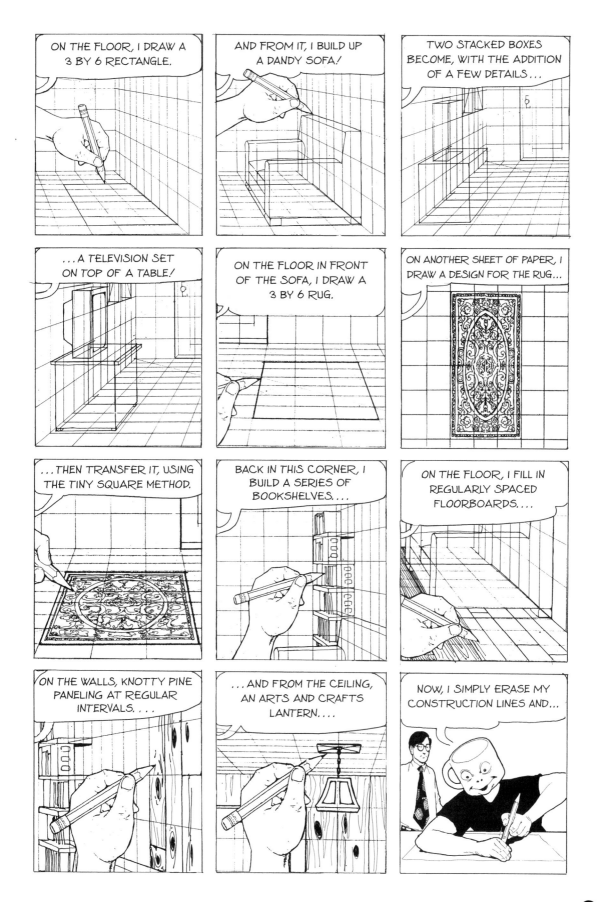

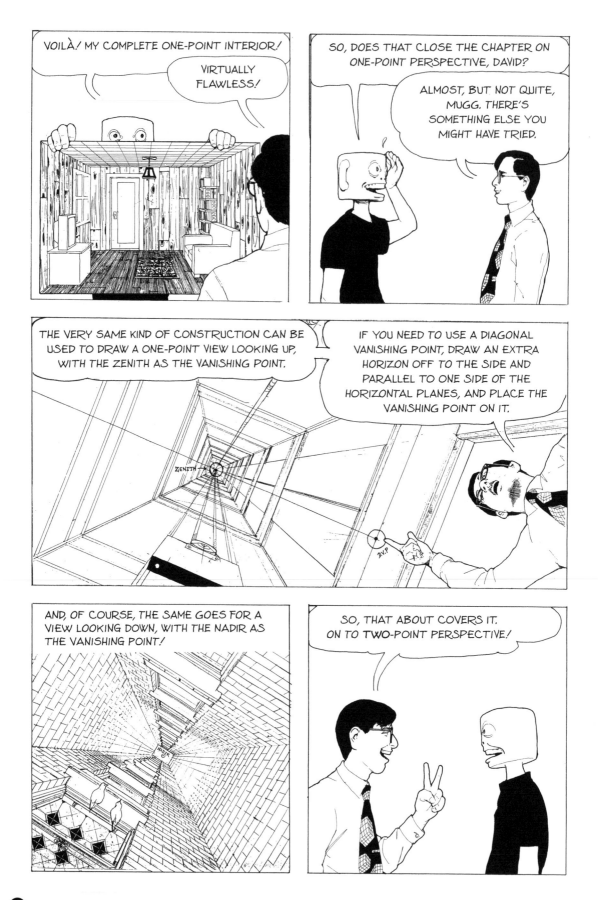

VOILÀ! MY COMPLETE ONE-POINT INTERIOR!

VIRTUALLY FLAWLESS!

SO, DOES THAT CLOSE THE CHAPTER ON ONE-POINT PERSPECTIVE, DAVID?

ALMOST, BUT NOT QUITE, MUGG. THERE'S SOMETHING ELSE YOU MIGHT HAVE TRIED.

THE VERY SAME KIND OF CONSTRUCTION CAN BE USED TO DRAW A ONE-POINT VIEW LOOKING UP, WITH THE ZENITH AS THE VANISHING POINT.

IF YOU NEED TO USE A DIAGONAL VANISHING POINT, DRAW AN EXTRA HORIZON OFF TO THE SIDE AND PARALLEL TO ONE SIDE OF THE HORIZONTAL PLANES, AND PLACE THE VANISHING POINT ON IT.

AND, OF COURSE, THE SAME GOES FOR A VIEW LOOKING DOWN, WITH THE NADIR AS THE VANISHING POINT!

SO, THAT ABOUT COVERS IT. ON TO **TWO-POINT** PERSPECTIVE!

CHAPTER SEVEN

TWO-POINT PERSPECTIVE

There is a certain school of thought that thinks of perspective as "artificial," a rigid, mechanical, and ultimately false system imposed on reality by dead white European males. Of course, I disagree, but what I *think* people have in mind when they talk this way is one-point perspective, which frankly even I find a little boringly frontal. Two-point perspective, which you have when you rotate a boxy object so that you are facing it diagonally, is far more dynamic in the look it gives your pictures, and adventurous artists have long been attracted to it despite the difficulties introduced by an additional vanishing point.

While two-point perspective is more complicated to construct than one-point, it is also more forgiving. Since *two* sets of lines are foreshortened, each recedes into space more gradually than that single, sharply receding set of lines in one-point. Therefore, it is easier to estimate depth by eye, without precise measurement, and still wind up with a convincing result, as Mugg does at the end of this chapter.

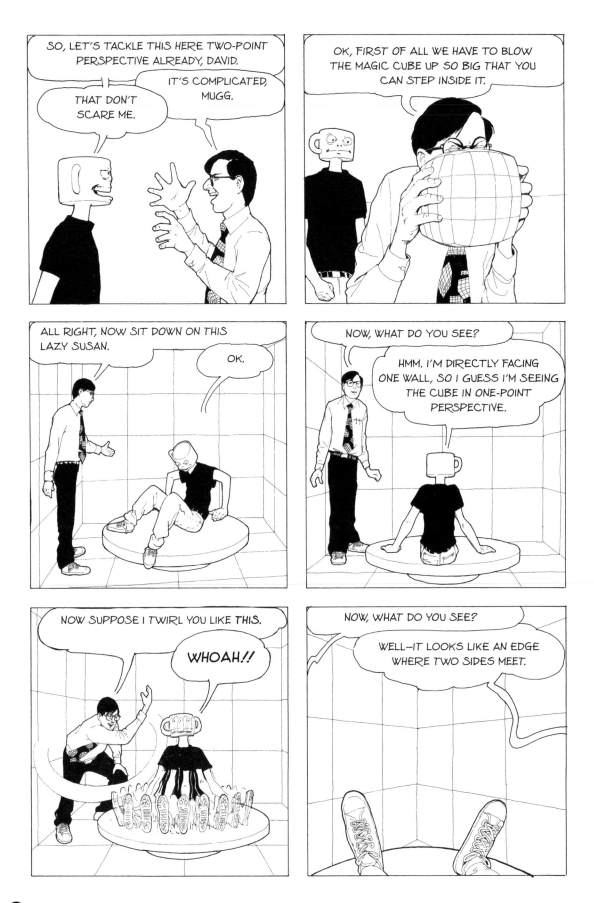

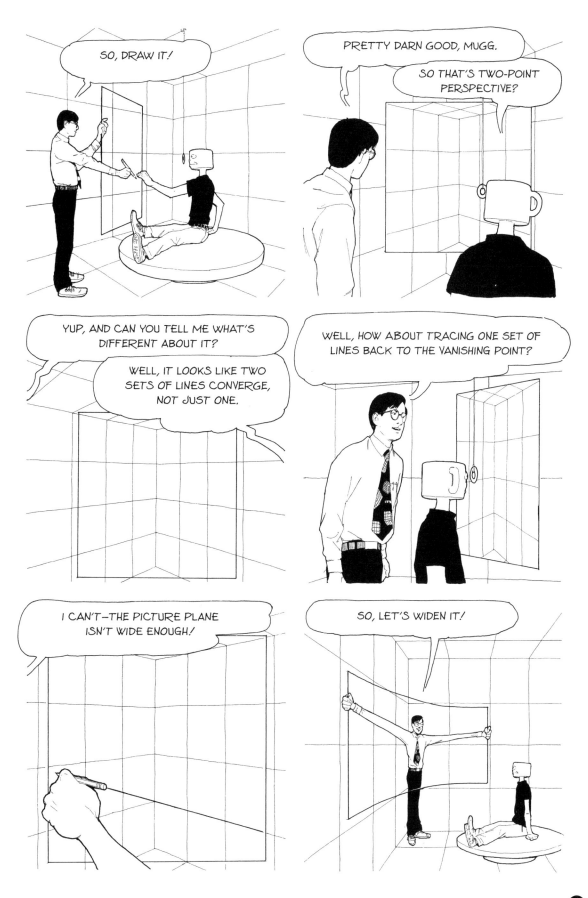

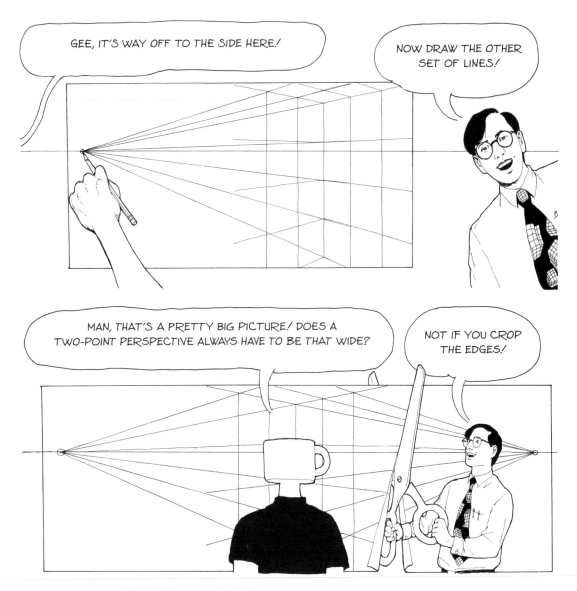

GEE, IT'S WAY OFF TO THE SIDE HERE!

NOW DRAW THE OTHER SET OF LINES!

MAN, THAT'S A PRETTY BIG PICTURE! DOES A TWO-POINT PERSPECTIVE ALWAYS HAVE TO BE THAT WIDE?

NOT IF YOU CROP THE EDGES!

THERE, ISN'T THAT NICER?

YEAH, BUT ISN'T THIS CHEATING? YOU CAN'T SEE THE VANISHING POINTS!

WELL, IN TWO-POINT PERSPECTIVE, BOTH VANISHING POINTS ARE USUALLY SO FAR FROM YOUR CENTER OF VISION THAT YOU NEED TOO WIDE A CONE OF VISION TO FIT THEM IN. USE THEM IN CONSTRUCTION— THEN JUST THROW THEM AWAY!

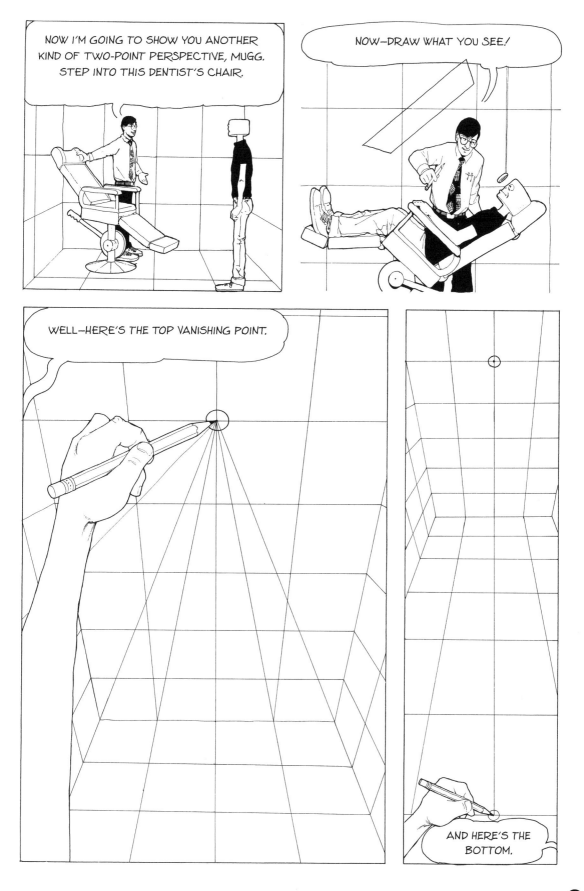

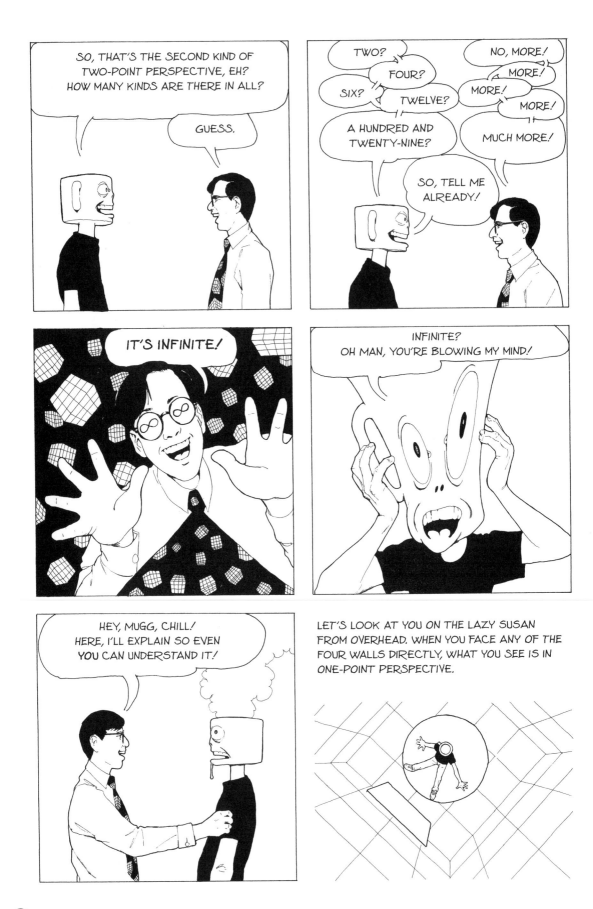

BUT LOOK IN ANY DIRECTION IN BETWEEN, AND WHAT YOU SEE IS IN TWO-POINT PERSPECTIVE. HOW MANY OTHER DIRECTIONS CAN YOU LOOK IN? IT'S INFINITE!

SAME DEAL IF YOU PUT THE CUBE ON THE LAZY SUSAN. EACH TIME YOU MOVE THE WHEEL, EVEN SLIGHTLY, YOU SHIFT THE VANISHING POINTS, AND IT'S A NEW KIND OF TWO-POINT PERSPECTIVE!

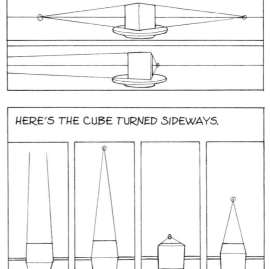

IN THE DENTIST'S CHAIR, STRAIGHT UP AND DIRECTLY ACROSS ARE ONE-POINT. ANYTHING IN BETWEEN IS TWO-POINT.

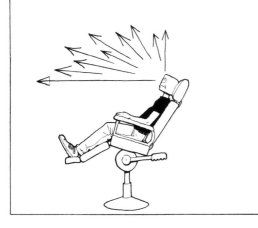

HERE'S THE CUBE TURNED SIDEWAYS.

OK, SO NOW INSTEAD OF DEALING WITH ONE VANISHING POINT, I GOT TWO? IS IT REALLY WORTH IT, DAVID?

SURE IT IS, MUGG.

JUST IMAGINE WHAT LIFE WOULD BE LIKE IF YOU COULD ONLY SEE IN ONE-POINT.

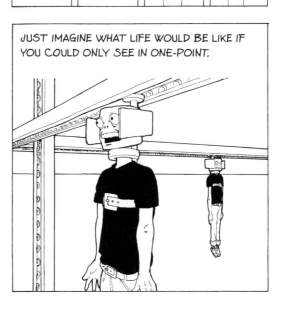

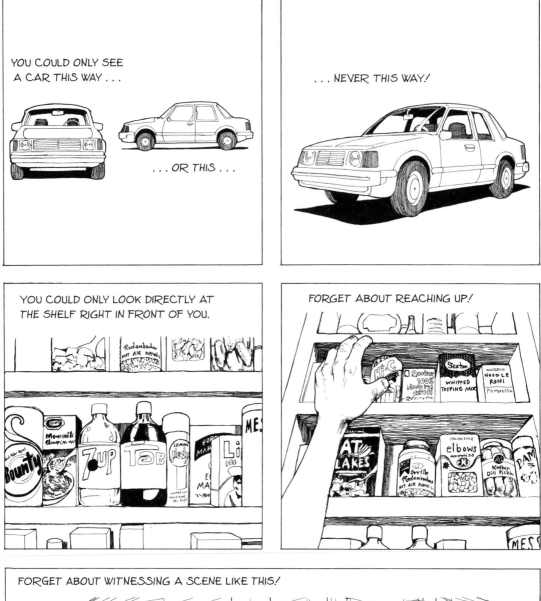

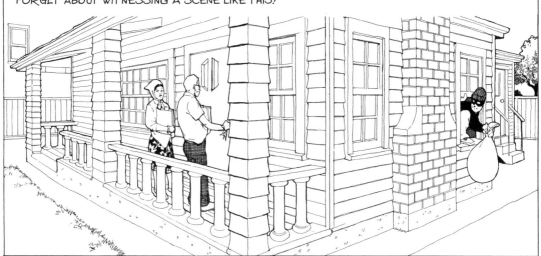

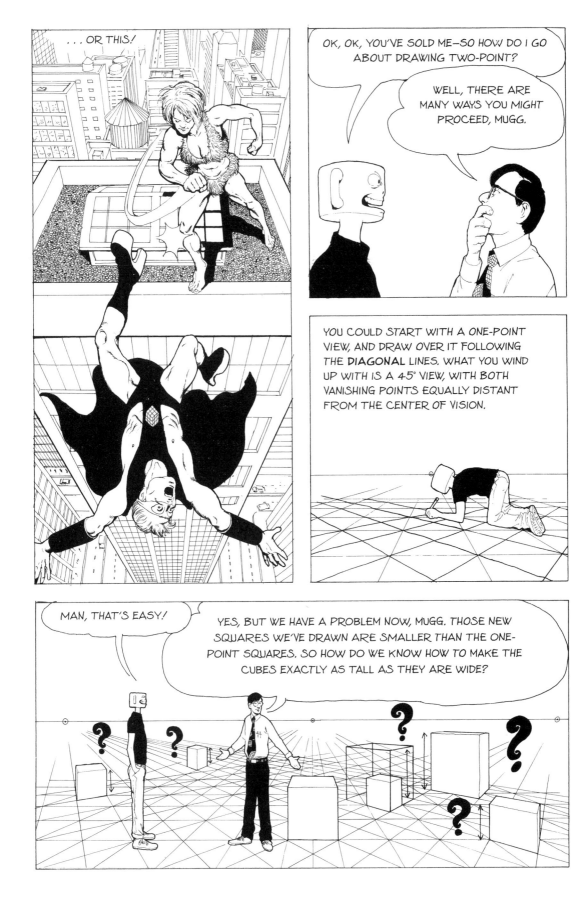

...OR THIS!

OK, OK, YOU'VE SOLD ME—SO HOW DO I GO ABOUT DRAWING TWO-POINT?

WELL, THERE ARE MANY WAYS YOU MIGHT PROCEED, MUGG.

YOU COULD START WITH A ONE-POINT VIEW, AND DRAW OVER IT FOLLOWING THE **DIAGONAL** LINES. WHAT YOU WIND UP WITH IS A 45° VIEW, WITH BOTH VANISHING POINTS EQUALLY DISTANT FROM THE CENTER OF VISION.

MAN, THAT'S EASY!

YES, BUT WE HAVE A PROBLEM NOW, MUGG. THOSE NEW SQUARES WE'VE DRAWN ARE SMALLER THAN THE ONE-POINT SQUARES. SO HOW DO WE KNOW HOW TO MAKE THE CUBES EXACTLY AS TALL AS THEY ARE WIDE?

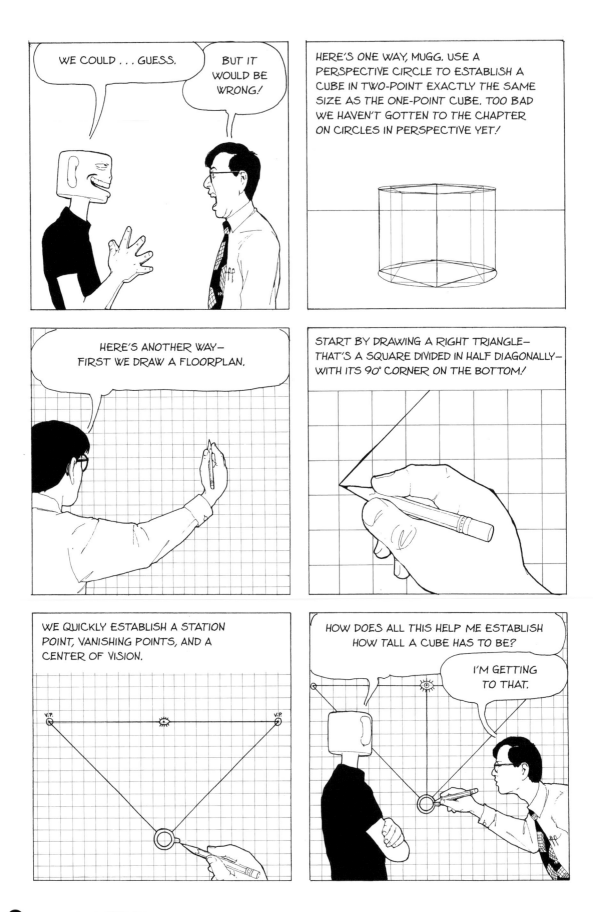

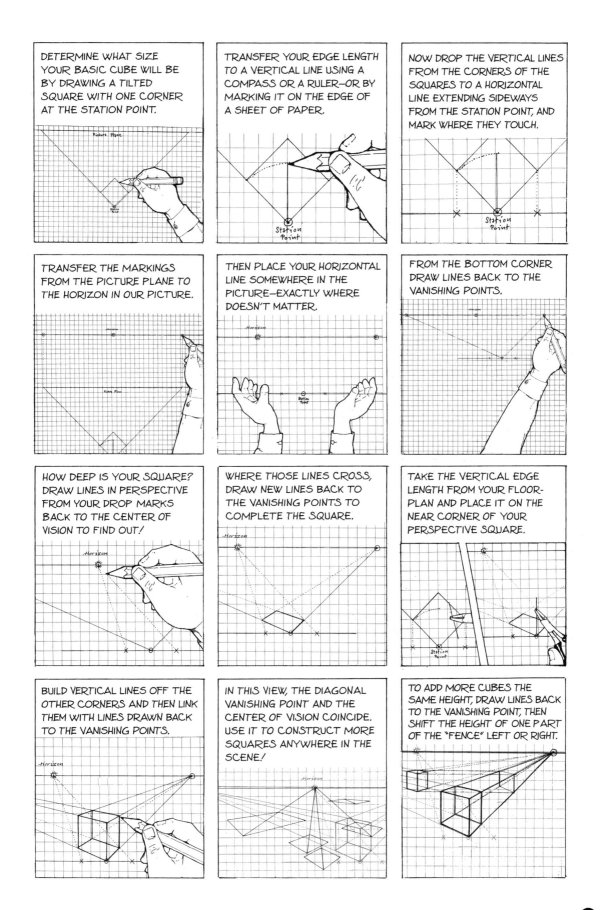

DETERMINE WHAT SIZE YOUR BASIC CUBE WILL BE BY DRAWING A TILTED SQUARE WITH ONE CORNER AT THE STATION POINT.

TRANSFER YOUR EDGE LENGTH TO A VERTICAL LINE USING A COMPASS OR A RULER—OR BY MARKING IT ON THE EDGE OF A SHEET OF PAPER.

NOW DROP THE VERTICAL LINES FROM THE CORNERS OF THE SQUARES TO A HORIZONTAL LINE EXTENDING SIDEWAYS FROM THE STATION POINT, AND MARK WHERE THEY TOUCH.

TRANSFER THE MARKINGS FROM THE PICTURE PLANE TO THE HORIZON IN OUR PICTURE.

THEN PLACE YOUR HORIZONTAL LINE SOMEWHERE IN THE PICTURE—EXACTLY WHERE DOESN'T MATTER.

FROM THE BOTTOM CORNER DRAW LINES BACK TO THE VANISHING POINTS.

HOW DEEP IS YOUR SQUARE? DRAW LINES IN PERSPECTIVE FROM YOUR DROP MARKS BACK TO THE CENTER OF VISION TO FIND OUT!

WHERE THOSE LINES CROSS, DRAW NEW LINES BACK TO THE VANISHING POINTS TO COMPLETE THE SQUARE.

TAKE THE VERTICAL EDGE LENGTH FROM YOUR FLOOR-PLAN AND PLACE IT ON THE NEAR CORNER OF YOUR PERSPECTIVE SQUARE.

BUILD VERTICAL LINES OFF THE OTHER CORNERS AND THEN LINK THEM WITH LINES DRAWN BACK TO THE VANISHING POINTS.

IN THIS VIEW, THE DIAGONAL VANISHING POINT AND THE CENTER OF VISION COINCIDE. USE IT TO CONSTRUCT MORE SQUARES ANYWHERE IN THE SCENE!

TO ADD MORE CUBES THE SAME HEIGHT, DRAW LINES BACK TO THE VANISHING POINT, THEN SHIFT THE HEIGHT OF ONE PART OF THE "FENCE" LEFT OR RIGHT.

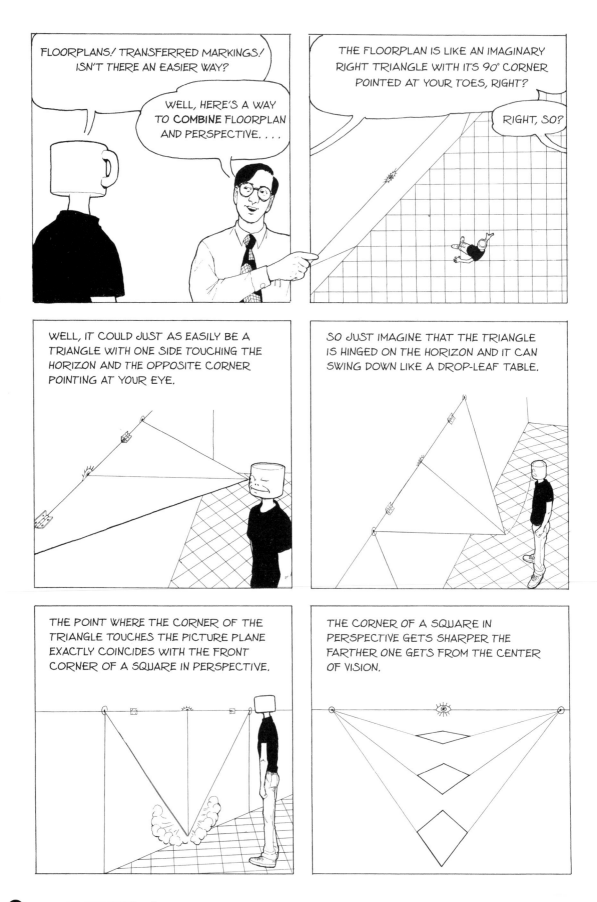

FLOORPLANS! TRANSFERRED MARKINGS! ISN'T THERE AN EASIER WAY?

WELL, HERE'S A WAY TO **COMBINE** FLOORPLAN AND PERSPECTIVE. . . .

THE FLOORPLAN IS LIKE AN IMAGINARY RIGHT TRIANGLE WITH ITS 90° CORNER POINTED AT YOUR TOES, RIGHT?

RIGHT, SO?

WELL, IT COULD JUST AS EASILY BE A TRIANGLE WITH ONE SIDE TOUCHING THE HORIZON AND THE OPPOSITE CORNER POINTING AT YOUR EYE.

SO JUST IMAGINE THAT THE TRIANGLE IS HINGED ON THE HORIZON AND IT CAN SWING DOWN LIKE A DROP-LEAF TABLE.

THE POINT WHERE THE CORNER OF THE TRIANGLE TOUCHES THE PICTURE PLANE EXACTLY COINCIDES WITH THE FRONT CORNER OF A SQUARE IN PERSPECTIVE.

THE CORNER OF A SQUARE IN PERSPECTIVE GETS SHARPER THE FARTHER ONE GETS FROM THE CENTER OF VISION.

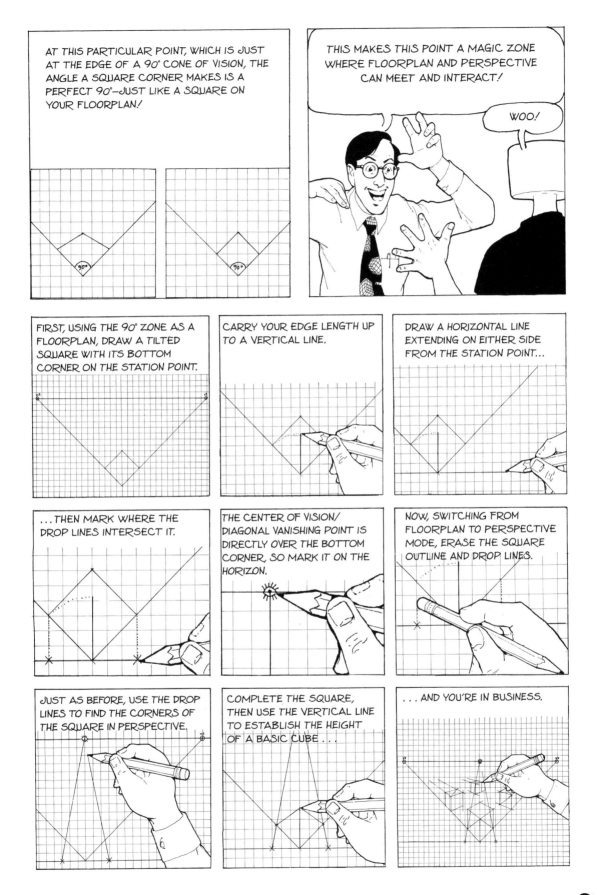

AT THIS PARTICULAR POINT, WHICH IS JUST AT THE EDGE OF A 90° CONE OF VISION, THE ANGLE A SQUARE CORNER MAKES IS A PERFECT 90°—JUST LIKE A SQUARE ON YOUR FLOORPLAN!

THIS MAKES THIS POINT A MAGIC ZONE WHERE FLOORPLAN AND PERSPECTIVE CAN MEET AND INTERACT!

WOO!

FIRST, USING THE 90° ZONE AS A FLOORPLAN, DRAW A TILTED SQUARE WITH ITS BOTTOM CORNER ON THE STATION POINT.

CARRY YOUR EDGE LENGTH UP TO A VERTICAL LINE.

DRAW A HORIZONTAL LINE EXTENDING ON EITHER SIDE FROM THE STATION POINT...

...THEN MARK WHERE THE DROP LINES INTERSECT IT.

THE CENTER OF VISION/ DIAGONAL VANISHING POINT IS DIRECTLY OVER THE BOTTOM CORNER, SO MARK IT ON THE HORIZON.

NOW, SWITCHING FROM FLOORPLAN TO PERSPECTIVE MODE, ERASE THE SQUARE OUTLINE AND DROP LINES.

JUST AS BEFORE, USE THE DROP LINES TO FIND THE CORNERS OF THE SQUARE IN PERSPECTIVE.

COMPLETE THE SQUARE, THEN USE THE VERTICAL LINE TO ESTABLISH THE HEIGHT OF A BASIC CUBE...

...AND YOU'RE IN BUSINESS.

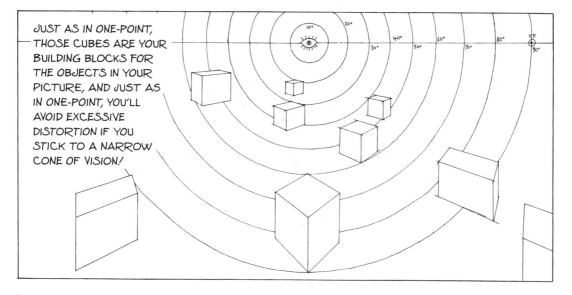

JUST AS IN ONE-POINT, THOSE CUBES ARE YOUR BUILDING BLOCKS FOR THE OBJECTS IN YOUR PICTURE, AND JUST AS IN ONE-POINT, YOU'LL AVOID EXCESSIVE DISTORTION IF YOU STICK TO A NARROW CONE OF VISION!

SO, WHAT ABOUT THOSE OTHER KINDS OF TWO-POINT PERSPECTIVE?

OH, THIS METHOD WORKS FOR THEM, TOO!

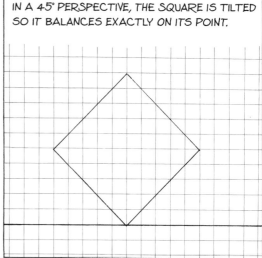

IN A 45° PERSPECTIVE, THE SQUARE IS TILTED SO IT BALANCES EXACTLY ON ITS POINT.

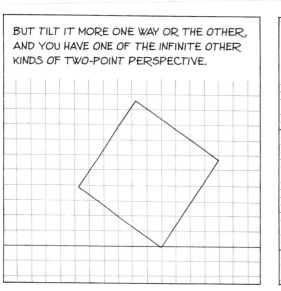

BUT TILT IT MORE ONE WAY OR THE OTHER, AND YOU HAVE ONE OF THE INFINITE OTHER KINDS OF TWO-POINT PERSPECTIVE.

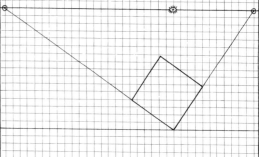

TO FIND WHERE THE VANISHING POINTS ARE, JUST CONTINUE THE LINES OF THE SQUARE BACK TO THE HORIZON.

THE CENTER OF VISION IS STILL RIGHT OVER THAT BOTTOM CORNER. THE CLOSER ONE VANISHING POINT IS TO IT, THE FARTHER AWAY THE OTHER ONE HAS TO BE.

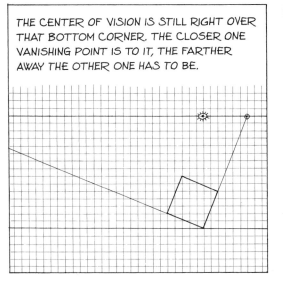

BE CAREFUL WHERE YOU PUT YOUR VANISHING POINTS, OR YOU MAY NEED MORE SPACE THAN YOU HAVE.

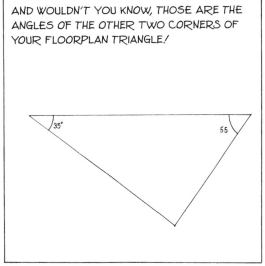

VANISHING POINTS ARE ALWAYS A QUARTER CIRCLE APART, OR 90°, AND IF THE CENTER OF VISION IS 0°, THE ANGULAR DISTANCES TO LEFT AND RIGHT VANISHING POINTS ADDED TOGETHER ALWAYS MAKE 90°.

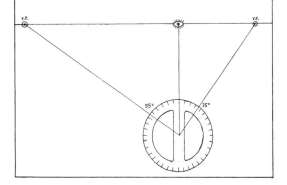

AND WOULDN'T YOU KNOW, THOSE ARE THE ANGLES OF THE OTHER TWO CORNERS OF YOUR FLOORPLAN TRIANGLE!

SINCE THE DIAGONAL VANISHING POINT **ONLY** COINCIDES WITH THE CENTER OF VISION AT 45°, YOU HAVE TO FIND IT USING A PROTRACTOR OR SHEET OF GRAPH PAPER WITH THE DIAGONAL MARKED. (ONE HINT: THE CENTER OF VISION IS ALWAYS IN BETWEEN THE DIAGONAL VANISHING POINT AND THE **NEARER** VANISHING POINT.)

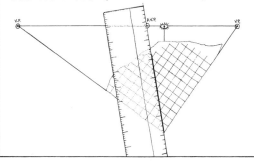

CHANGING THE ANGLE CHANGES HOW THINGS LOOK. HERE'S WHAT A 30°/60° PERSPECTIVE LOOKS LIKE.

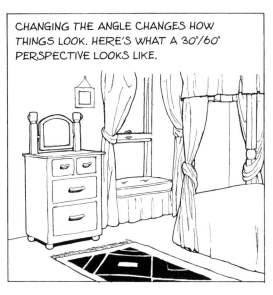

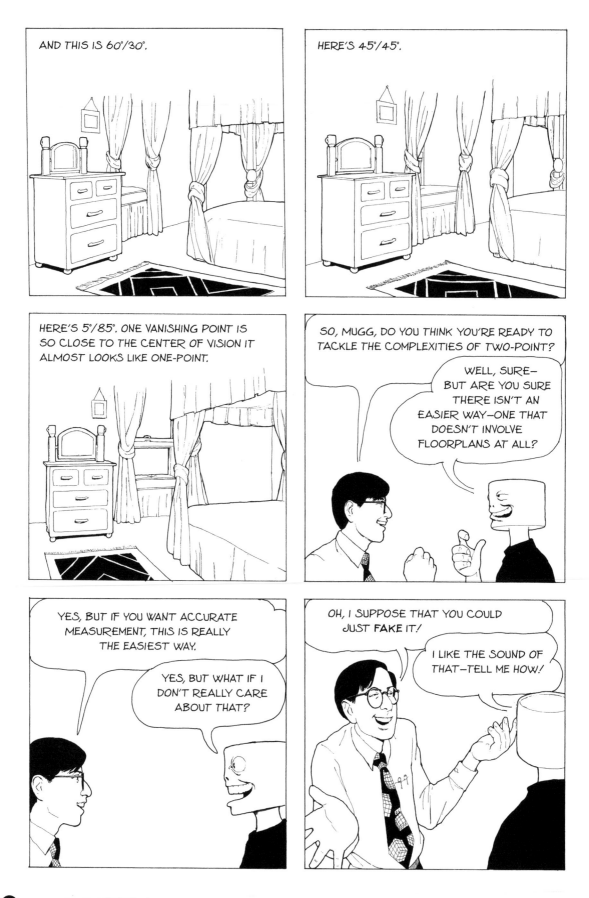

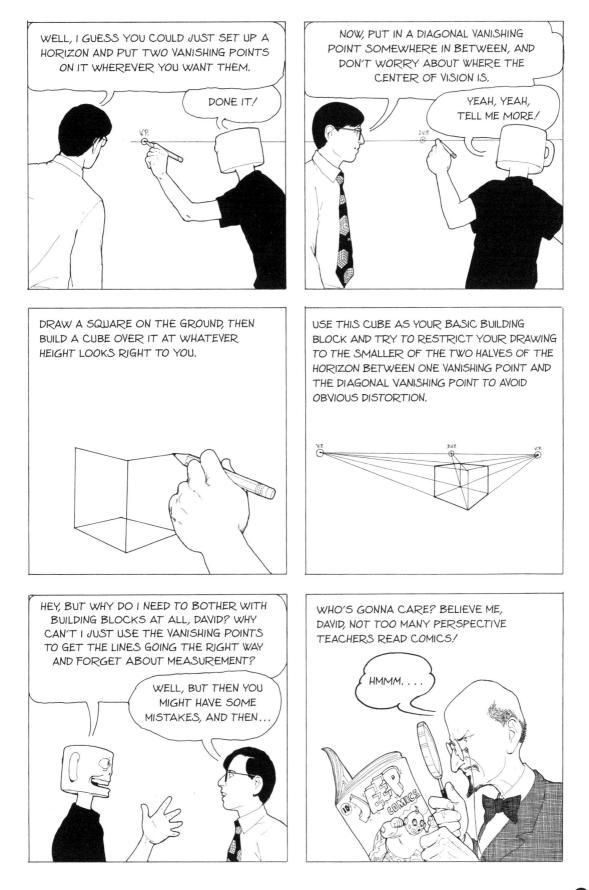

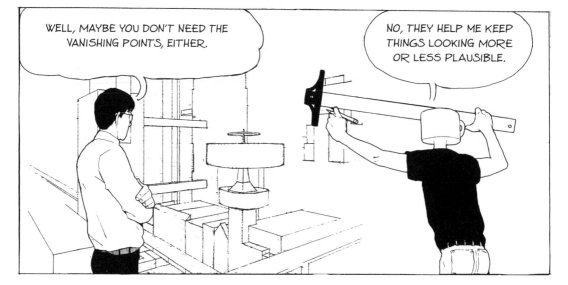

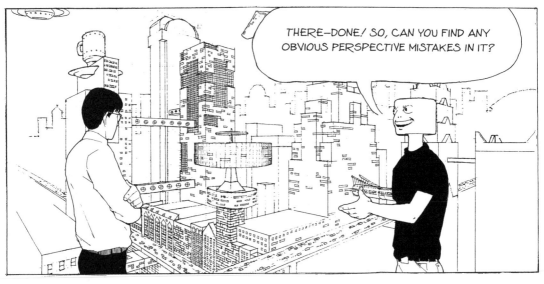

CHAPTER EIGHT

THREE-POINT PERSPECTIVE

I can't remember seeing a single three-point perspective from before the invention of photography, or indeed from before the 20th century. The age of the airplane and the skyscraper seems suited to the plunging vistas of three-point, and photographers, with their ability to capture unusual views quickly without neck strain, were there first. Artists have only belatedly followed suit, and comics artists have been more adventurous than most. Three-point perspective is perfect for the comics, with its emphasis on dynamic, explosive compositions.

　　Three-point presents a few more complexities than one- or two-point, but the principles are the same, and readers who have gotten this far should have no difficulty in understanding it. Where three-point introduces real difficulties, however, is in the amount of space needed to accommodate those distant vanishing points. I have read that in order to construct his print *Relativity,* M. C. Escher needed to draw a triangle 7 feet wide on his studio floor. In this chapter, we learn a few methods to conserve space in drawing three-point, and we'll learn a few more in the final chapter.

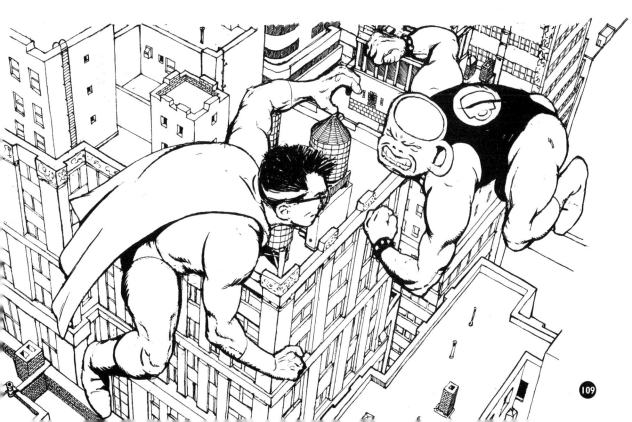

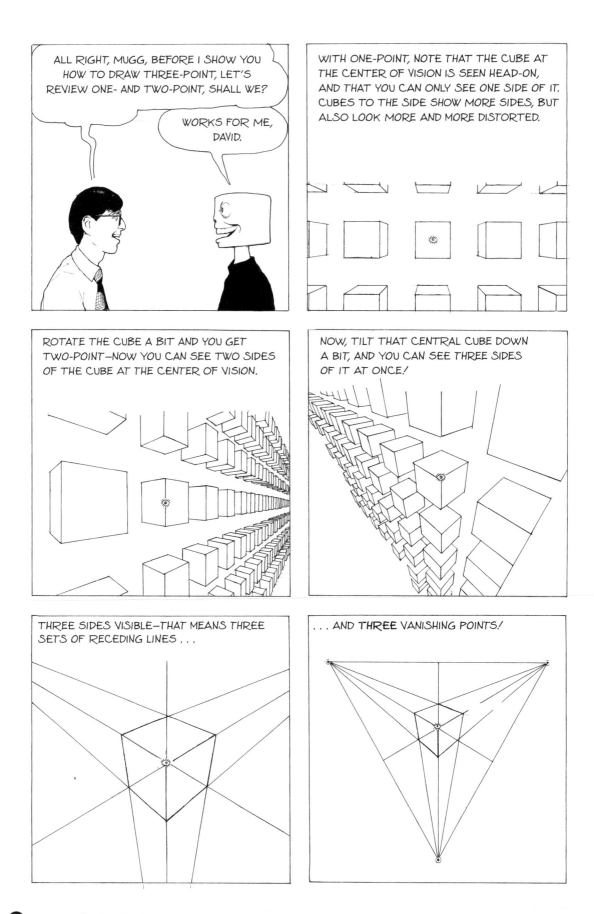

ALL RIGHT, MUGG, BEFORE I SHOW YOU HOW TO DRAW THREE-POINT, LET'S REVIEW ONE- AND TWO-POINT, SHALL WE?

WORKS FOR ME, DAVID.

WITH ONE-POINT, NOTE THAT THE CUBE AT THE CENTER OF VISION IS SEEN HEAD-ON, AND THAT YOU CAN ONLY SEE ONE SIDE OF IT. CUBES TO THE SIDE SHOW MORE SIDES, BUT ALSO LOOK MORE AND MORE DISTORTED.

ROTATE THE CUBE A BIT AND YOU GET TWO-POINT—NOW YOU CAN SEE TWO SIDES OF THE CUBE AT THE CENTER OF VISION.

NOW, TILT THAT CENTRAL CUBE DOWN A BIT, AND YOU CAN SEE THREE SIDES OF IT AT ONCE!

THREE SIDES VISIBLE—THAT MEANS THREE SETS OF RECEDING LINES . . .

. . . AND **THREE** VANISHING POINTS!

HMM . . . SO, WHEN WOULD YOU WANT TO USE THREE-POINT PERSPECTIVE, DAVID?

WHEN **WOULDN'T** YOU USE IT, MUGG?

IMAGINE FOR A MOMENT YOU'RE WALKING AROUND INSIDE A GIANT CUBE. IT FOLLOWS YOU EVERYWHERE, BUT STAYS ALIGNED WITH THE DIRECTION OF STREETS AND BUILDINGS NO MATTER WHICH WAY YOU TURN.

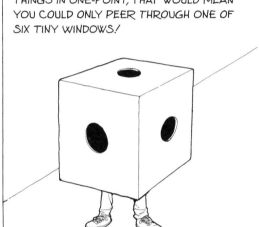

IF YOU WERE RESTRICTED TO ONLY SEEING THINGS IN ONE-POINT, THAT WOULD MEAN YOU COULD ONLY PEER THROUGH ONE OF SIX TINY WINDOWS!

YOUR VIEW ISN'T MUCH BETTER IN TWO-POINT— THREE SETS OF TINY SLITS!

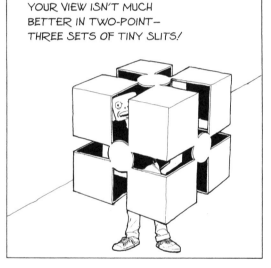

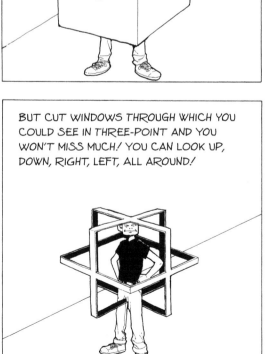

BUT CUT WINDOWS THROUGH WHICH YOU COULD SEE IN THREE-POINT AND YOU WON'T MISS MUCH! YOU CAN LOOK UP, DOWN, RIGHT, LEFT, ALL AROUND!

HERE'S ANOTHER WAY OF DESCRIBING IT, MUGG—HAVE A CHAIR!

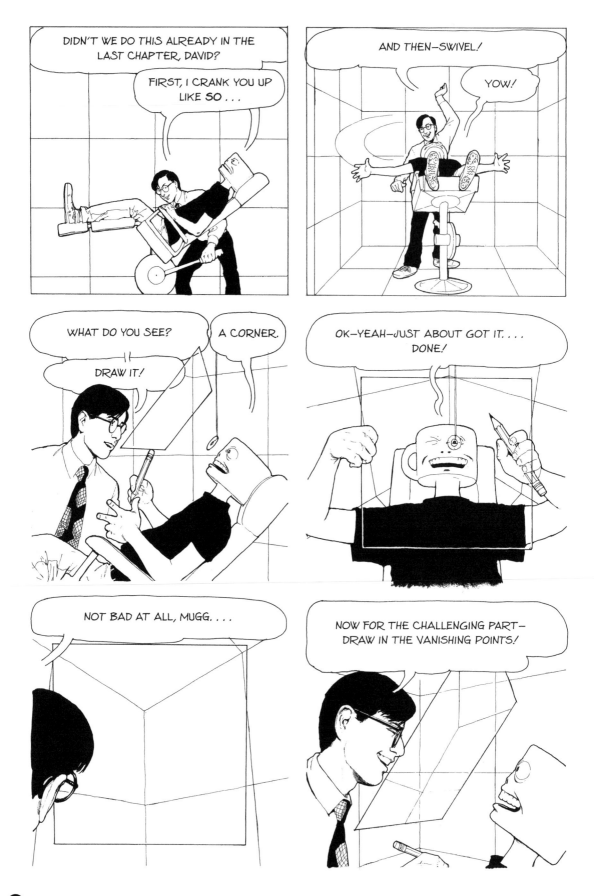

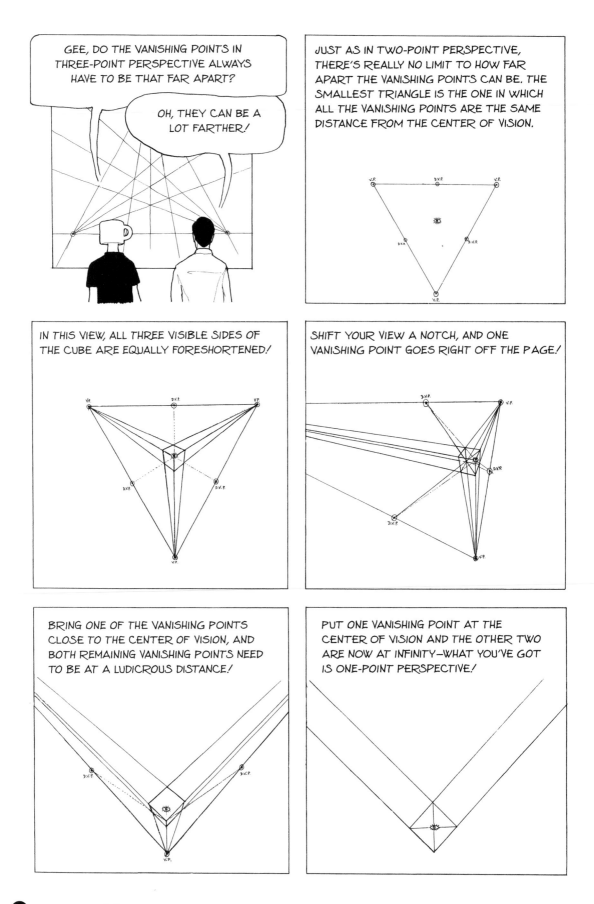

GEE, DO THE VANISHING POINTS IN THREE-POINT PERSPECTIVE ALWAYS HAVE TO BE THAT FAR APART?

OH, THEY CAN BE A LOT FARTHER!

JUST AS IN TWO-POINT PERSPECTIVE, THERE'S REALLY NO LIMIT TO HOW FAR APART THE VANISHING POINTS CAN BE. THE SMALLEST TRIANGLE IS THE ONE IN WHICH ALL THE VANISHING POINTS ARE THE SAME DISTANCE FROM THE CENTER OF VISION.

IN THIS VIEW, ALL THREE VISIBLE SIDES OF THE CUBE ARE EQUALLY FORESHORTENED!

SHIFT YOUR VIEW A NOTCH, AND ONE VANISHING POINT GOES RIGHT OFF THE PAGE!

BRING ONE OF THE VANISHING POINTS CLOSE TO THE CENTER OF VISION, AND BOTH REMAINING VANISHING POINTS NEED TO BE AT A LUDICROUS DISTANCE!

PUT ONE VANISHING POINT AT THE CENTER OF VISION AND THE OTHER TWO ARE NOW AT INFINITY—WHAT YOU'VE GOT IS ONE-POINT PERSPECTIVE!

SO, HOW MANY DIFFERENT KINDS OF THREE-POINT DO YOU THINK THERE ARE, MUGG?

LET ME GUESS. . . . IS IT . . . INFINITE?

RIGHT YOU ARE, MUGG. IN FACT, IF THERE ARE AN INFINITE NUMBER OF DIRECTIONS YOU CAN LOOK TO SEE IN TWO-POINT PERSPECTIVE JUST BY KEEPING YOUR EYE ON THE HORIZON . . .

. . . THEN THE NUMBER OF POSSIBLE DIRECTIONS YOU COULD LOOK TO SEE IN THREE-POINT IS INFINITY CUBED!

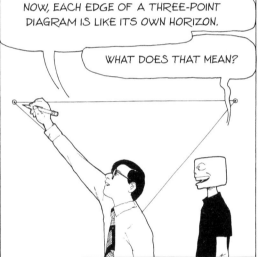

NOW, EACH EDGE OF A THREE-POINT DIAGRAM IS LIKE ITS OWN HORIZON,

WHAT DOES THAT MEAN?

IT MEANS THAT ANY LINE CAN BE USED AS A HORIZON AND EACH GRID CAN BE USED THREE DIFFERENT WAYS.

THIS WAY UP?

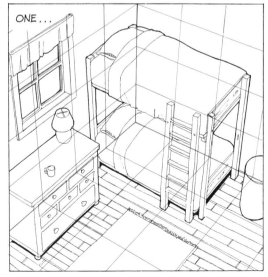

ONE . . .

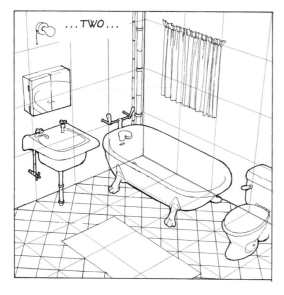

...TWO...

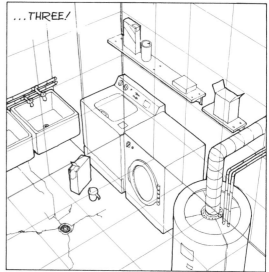

...THREE!

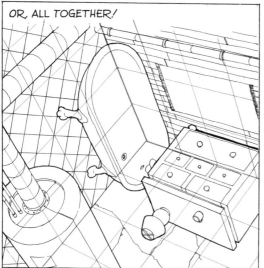

OR, ALL TOGETHER!

AND WHEN YOU CONSIDER THAT THE SAME GRID CAN BE USED TO DRAW VIEWS LOOKING UP, IT'S REALLY SIX!

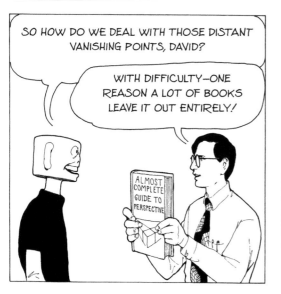

SO HOW DO WE DEAL WITH THOSE DISTANT VANISHING POINTS, DAVID?

WITH DIFFICULTY—ONE REASON A LOT OF BOOKS LEAVE IT OUT ENTIRELY!

ALMOST COMPLETE GUIDE TO PERSPECTIVE

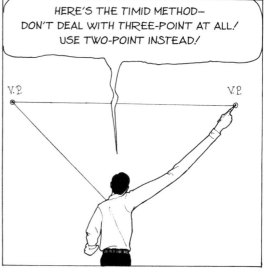

HERE'S THE TIMID METHOD— DON'T DEAL WITH THREE-POINT AT ALL! USE TWO-POINT INSTEAD!

V.P.

V.P.

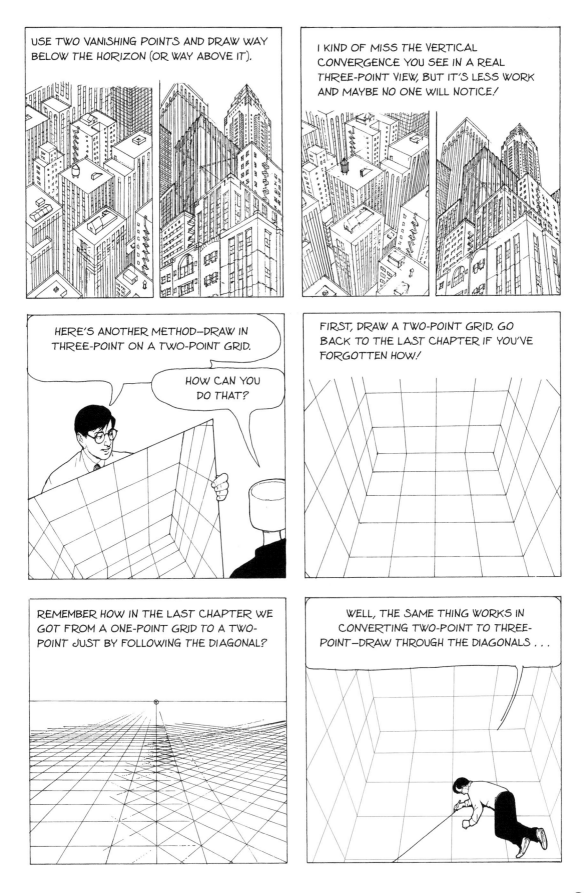

USE TWO VANISHING POINTS AND DRAW WAY BELOW THE HORIZON (OR WAY ABOVE IT).

I KIND OF MISS THE VERTICAL CONVERGENCE YOU SEE IN A REAL THREE-POINT VIEW, BUT IT'S LESS WORK AND MAYBE NO ONE WILL NOTICE!

HERE'S ANOTHER METHOD—DRAW IN THREE-POINT ON A TWO-POINT GRID.

HOW CAN YOU DO THAT?

FIRST, DRAW A TWO-POINT GRID. GO BACK TO THE LAST CHAPTER IF YOU'VE FORGOTTEN HOW!

REMEMBER HOW IN THE LAST CHAPTER WE GOT FROM A ONE-POINT GRID TO A TWO-POINT JUST BY FOLLOWING THE DIAGONAL?

WELL, THE SAME THING WORKS IN CONVERTING TWO-POINT TO THREE-POINT—DRAW THROUGH THE DIAGONALS . . .

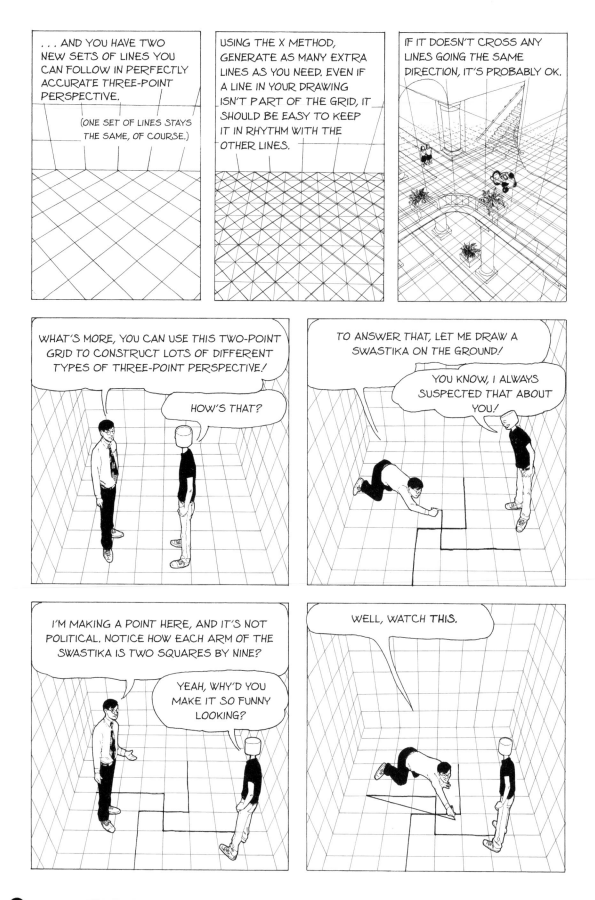

CHECK IT OUT, MUGG! LINES DRAWN FROM OPPOSITE ARMS CROSS RIGHT IN THE MIDDLE AND AT RIGHT ANGLES!

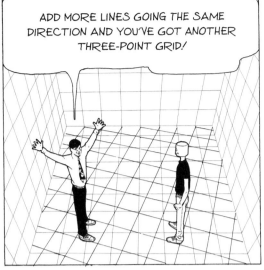

ADD MORE LINES GOING THE SAME DIRECTION AND YOU'VE GOT ANOTHER THREE-POINT GRID!

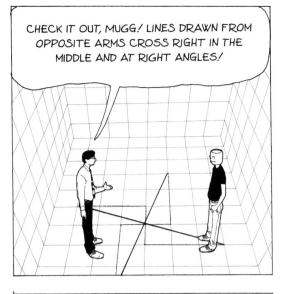

THE NUMBER OF POSSIBLE THREE-POINT PERSPECTIVES YOU CAN DRAW THIS WAY IS COUNTLESS! JUST REMEMBER: X UP AND Y OVER MAKES A RIGHT ANGLE WITH Y UP AND X OVER!

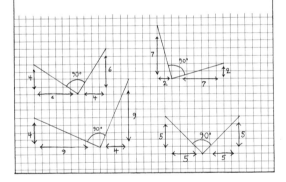

BUT FOR ME, THE METHOD THAT WORKS BEST IS TO START SMALL AND THEN BLOW THINGS UP.

SO SHOW ME HOW TO DO THAT.

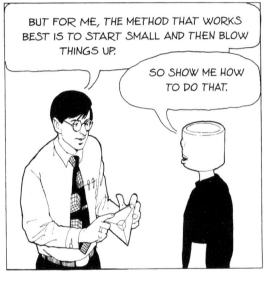

WELL, FIRST I LOOSELY SKETCH IN SOME KIND OF BOXY SHAPE, NOT NECESSARILY A CUBE.

THEN I DRAW LINES FROM IT BACK TO A COMMON HORIZON AND FIX A COUPLE OF VANISHING POINTS.

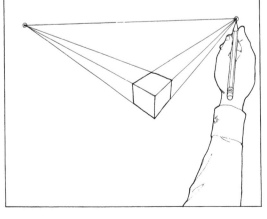

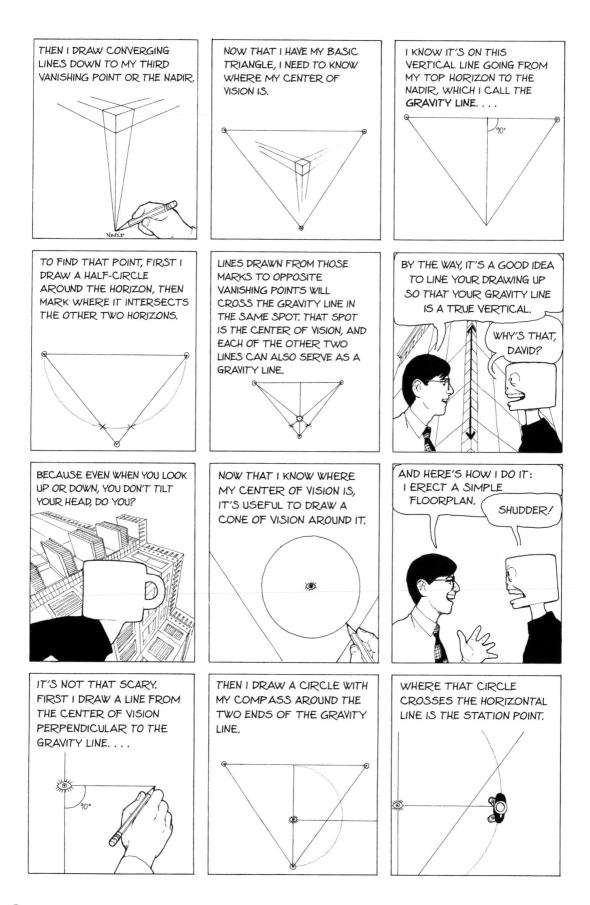

THEN I DRAW CONVERGING LINES DOWN TO MY THIRD VANISHING POINT OR THE NADIR.

NOW THAT I HAVE MY BASIC TRIANGLE, I NEED TO KNOW WHERE MY CENTER OF VISION IS.

I KNOW IT'S ON THIS VERTICAL LINE GOING FROM MY TOP HORIZON TO THE NADIR, WHICH I CALL THE GRAVITY LINE. . . .

TO FIND THAT POINT, FIRST I DRAW A HALF-CIRCLE AROUND THE HORIZON, THEN MARK WHERE IT INTERSECTS THE OTHER TWO HORIZONS.

LINES DRAWN FROM THOSE MARKS TO OPPOSITE VANISHING POINTS WILL CROSS THE GRAVITY LINE IN THE SAME SPOT. THAT SPOT IS THE CENTER OF VISION, AND EACH OF THE OTHER TWO LINES CAN ALSO SERVE AS A GRAVITY LINE.

BY THE WAY, IT'S A GOOD IDEA TO LINE YOUR DRAWING UP SO THAT YOUR GRAVITY LINE IS A TRUE VERTICAL.

WHY'S THAT, DAVID?

BECAUSE EVEN WHEN YOU LOOK UP OR DOWN, YOU DON'T TILT YOUR HEAD, DO YOU?

NOW THAT I KNOW WHERE MY CENTER OF VISION IS, IT'S USEFUL TO DRAW A CONE OF VISION AROUND IT.

AND HERE'S HOW I DO IT: I ERECT A SIMPLE FLOORPLAN.

SHUDDER!

IT'S NOT THAT SCARY. FIRST I DRAW A LINE FROM THE CENTER OF VISION PERPENDICULAR TO THE GRAVITY LINE. . . .

THEN I DRAW A CIRCLE WITH MY COMPASS AROUND THE TWO ENDS OF THE GRAVITY LINE.

WHERE THAT CIRCLE CROSSES THE HORIZONTAL LINE IS THE STATION POINT.

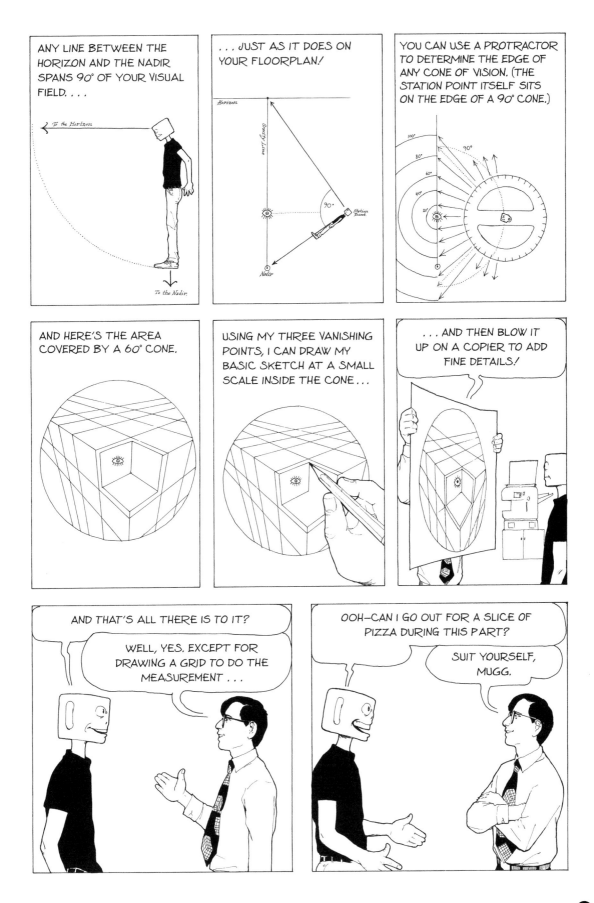

ANY LINE BETWEEN THE HORIZON AND THE NADIR SPANS 90° OF YOUR VISUAL FIELD. . . .

. . . JUST AS IT DOES ON YOUR FLOORPLAN!

YOU CAN USE A PROTRACTOR TO DETERMINE THE EDGE OF ANY CONE OF VISION. (THE STATION POINT ITSELF SITS ON THE EDGE OF A 90° CONE.)

AND HERE'S THE AREA COVERED BY A 60° CONE.

USING MY THREE VANISHING POINTS, I CAN DRAW MY BASIC SKETCH AT A SMALL SCALE INSIDE THE CONE . . .

. . . AND THEN BLOW IT UP ON A COPIER TO ADD FINE DETAILS!

AND THAT'S ALL THERE IS TO IT?

WELL, YES, EXCEPT FOR DRAWING A GRID TO DO THE MEASUREMENT . . .

OOH—CAN I GO OUT FOR A SLICE OF PIZZA DURING THIS PART?

SUIT YOURSELF, MUGG.

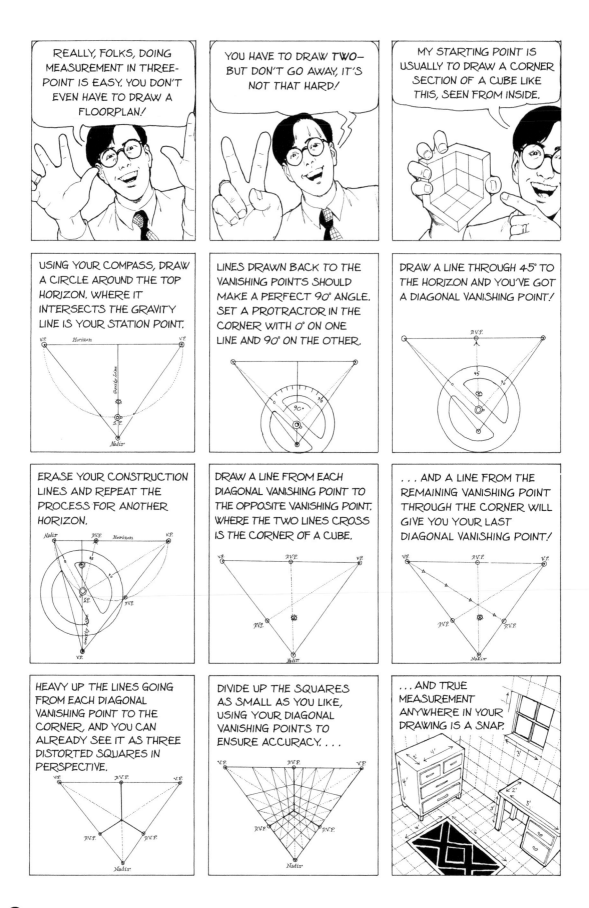

REALLY, FOLKS, DOING MEASUREMENT IN THREE-POINT IS EASY. YOU DON'T EVEN HAVE TO DRAW A FLOORPLAN!

YOU HAVE TO DRAW TWO— BUT DON'T GO AWAY, IT'S NOT THAT HARD!

MY STARTING POINT IS USUALLY TO DRAW A CORNER SECTION OF A CUBE LIKE THIS, SEEN FROM INSIDE.

USING YOUR COMPASS, DRAW A CIRCLE AROUND THE TOP HORIZON. WHERE IT INTERSECTS THE GRAVITY LINE IS YOUR STATION POINT.

LINES DRAWN BACK TO THE VANISHING POINTS SHOULD MAKE A PERFECT 90° ANGLE. SET A PROTRACTOR IN THE CORNER WITH 0° ON ONE LINE AND 90° ON THE OTHER.

DRAW A LINE THROUGH 45° TO THE HORIZON AND YOU'VE GOT A DIAGONAL VANISHING POINT!

ERASE YOUR CONSTRUCTION LINES AND REPEAT THE PROCESS FOR ANOTHER HORIZON.

DRAW A LINE FROM EACH DIAGONAL VANISHING POINT TO THE OPPOSITE VANISHING POINT. WHERE THE TWO LINES CROSS IS THE CORNER OF A CUBE.

... AND A LINE FROM THE REMAINING VANISHING POINT THROUGH THE CORNER WILL GIVE YOU YOUR LAST DIAGONAL VANISHING POINT!

HEAVY UP THE LINES GOING FROM EACH DIAGONAL VANISHING POINT TO THE CORNER, AND YOU CAN ALREADY SEE IT AS THREE DISTORTED SQUARES IN PERSPECTIVE.

DIVIDE UP THE SQUARES AS SMALL AS YOU LIKE, USING YOUR DIAGONAL VANISHING POINTS TO ENSURE ACCURACY. . . .

... AND TRUE MEASUREMENT ANYWHERE IN YOUR DRAWING IS A SNAP.

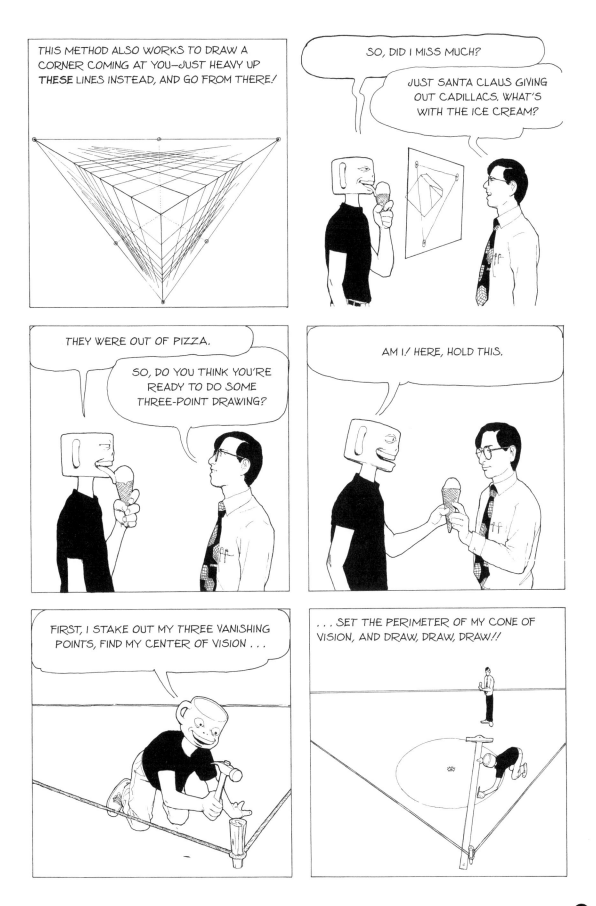

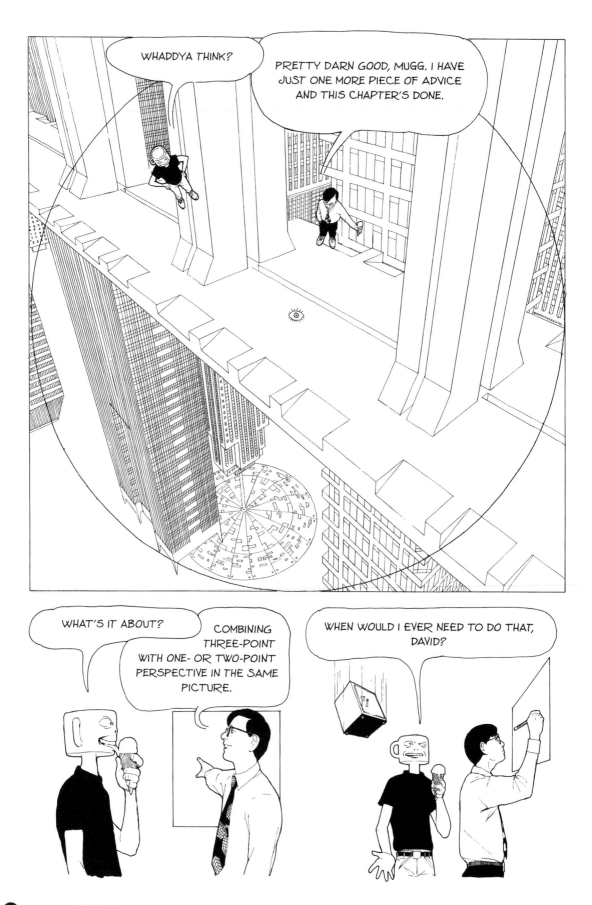

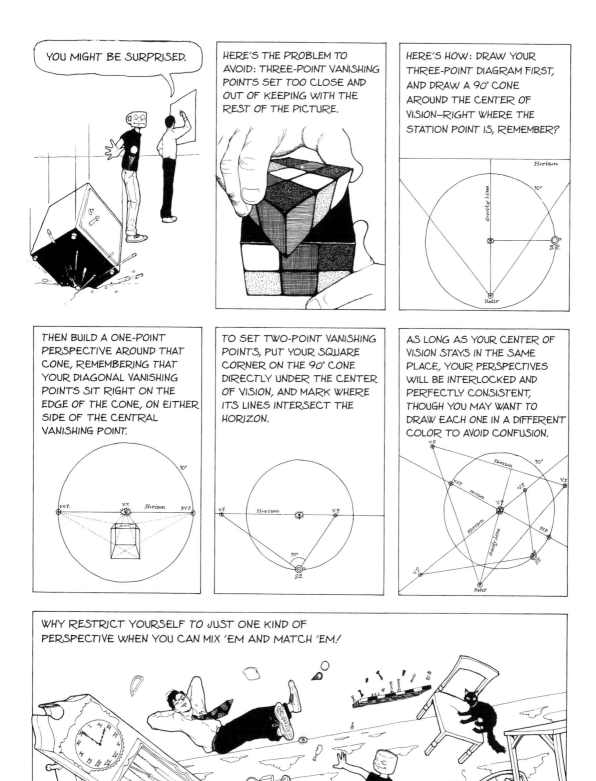

YOU MIGHT BE SURPRISED.

HERE'S THE PROBLEM TO AVOID: THREE-POINT VANISHING POINTS SET TOO CLOSE AND OUT OF KEEPING WITH THE REST OF THE PICTURE.

HERE'S HOW: DRAW YOUR THREE-POINT DIAGRAM FIRST, AND DRAW A 90° CONE AROUND THE CENTER OF VISION—RIGHT WHERE THE STATION POINT IS, REMEMBER?

THEN BUILD A ONE-POINT PERSPECTIVE AROUND THAT CONE, REMEMBERING THAT YOUR DIAGONAL VANISHING POINTS SIT RIGHT ON THE EDGE OF THE CONE, ON EITHER SIDE OF THE CENTRAL VANISHING POINT.

TO SET TWO-POINT VANISHING POINTS, PUT YOUR SQUARE CORNER ON THE 90° CONE DIRECTLY UNDER THE CENTER OF VISION, AND MARK WHERE ITS LINES INTERSECT THE HORIZON.

AS LONG AS YOUR CENTER OF VISION STAYS IN THE SAME PLACE, YOUR PERSPECTIVES WILL BE INTERLOCKED AND PERFECTLY CONSISTENT, THOUGH YOU MAY WANT TO DRAW EACH ONE IN A DIFFERENT COLOR TO AVOID CONFUSION.

WHY RESTRICT YOURSELF TO JUST ONE KIND OF PERSPECTIVE WHEN YOU CAN MIX 'EM AND MATCH 'EM!

CHAPTER NINE

CIRCLES IN PERSPECTIVE

Here we depart from the cube, and from straight lines altogether, and we are in a much more slippery and elusive world. Curved lines don't behave like straight lines, and circles foreshorten in a way that is maddeningly unlike squares. Inscribing the circle within a square helps us some, and fixing twelve points on it using a variation on the "X" method (which I picked up from *Perspective: A New System for Designers* by Jay Doblin) gives us even more accuracy. This results in a circle foreshortened into an ellipse, which seems true to our experience.

However, as we construct more and more perspective circles by this method, we notice something disturbing. Circles off to the side of the picture are developing an odd and unnatural tilt, quite unlike anything we can observe in the real world. What's going on here? This chapter attempts to explain.

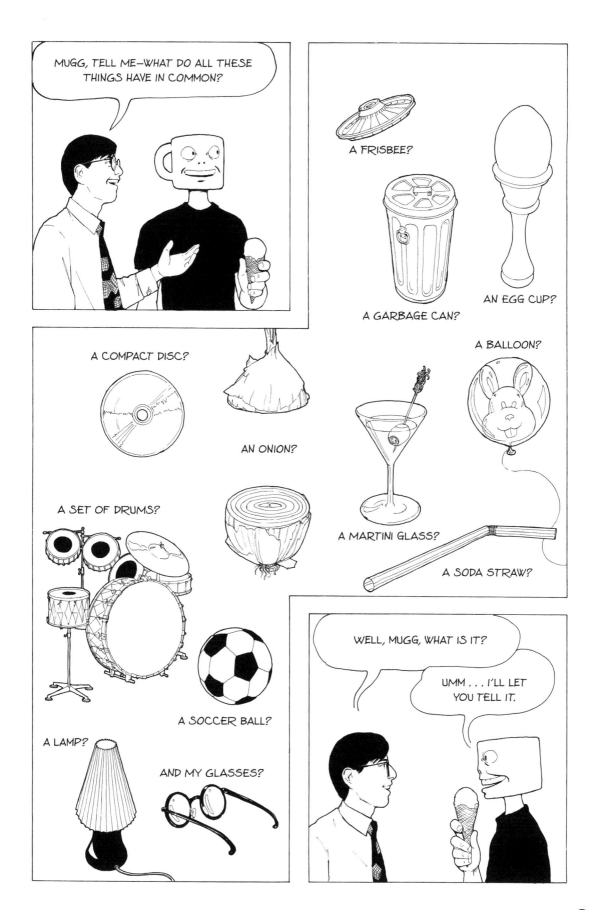

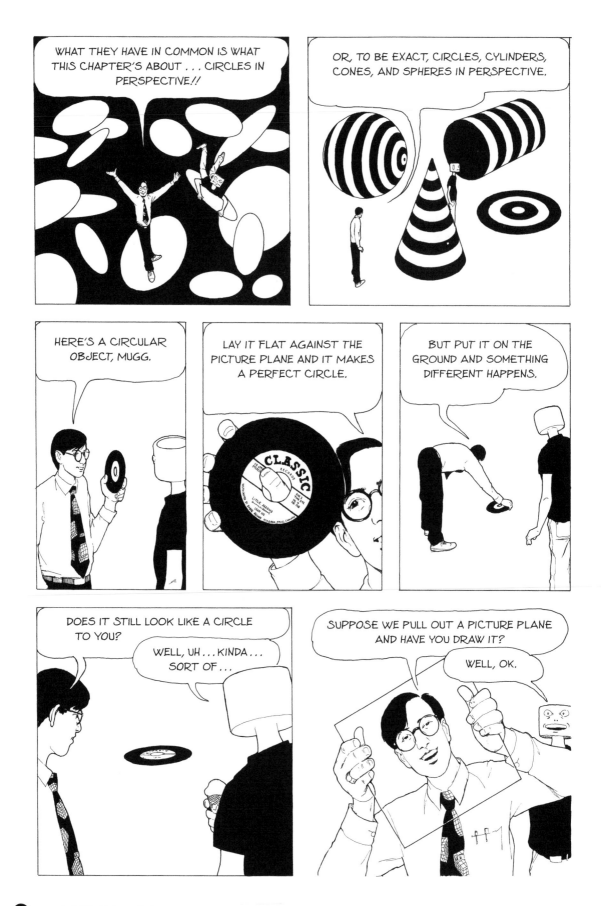

WHAT THEY HAVE IN COMMON IS WHAT THIS CHAPTER'S ABOUT . . . CIRCLES IN PERSPECTIVE!!

OR, TO BE EXACT, CIRCLES, CYLINDERS, CONES, AND SPHERES IN PERSPECTIVE.

HERE'S A CIRCULAR OBJECT, MUGG.

LAY IT FLAT AGAINST THE PICTURE PLANE AND IT MAKES A PERFECT CIRCLE.

CLASSIC

BUT PUT IT ON THE GROUND AND SOMETHING DIFFERENT HAPPENS.

DOES IT STILL LOOK LIKE A CIRCLE TO YOU?

WELL, UH . . . KINDA . . . SORT OF . . .

SUPPOSE WE PULL OUT A PICTURE PLANE AND HAVE YOU DRAW IT?

WELL, OK.

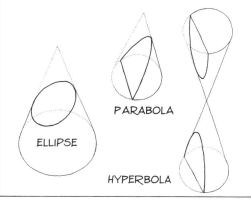

THERE ARE AN INFINITE NUMBER OF POSSIBLE ELLIPSES, EACH CREATED BY SLICING THE CONE AT A DIFFERENT ANGLE.

SHALLOW CUTS MAKE FAT ELLIPSES AND STEEPER CUTS MAKE SKINNIER ONES. SEEN THIS WAY, THE CIRCLE IS JUST A VERY **FAT** ELLIPSE, MADE BY SLICING THE CONE AT THE SHALLOWEST POSSIBLE ANGLE— STRAIGHT ACROSS!

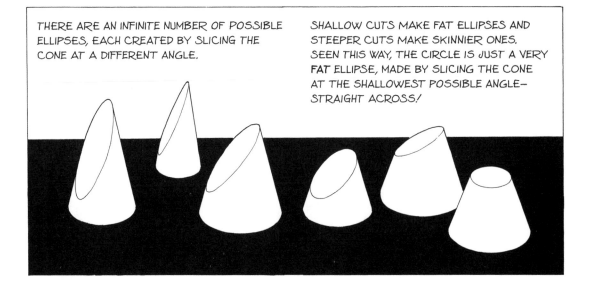

A CIRCLE LYING ON THE GROUND FORMS A **TILTED** CONE, WITH YOUR EYE AT THE APEX. WHERE THE PICTURE PLANE INTERRUPTS IT, THE EDGES OF THE CONE FORM THE IMAGE OF THE CIRCLE IN PERSPECTIVE.

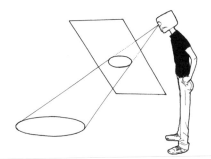

AT THE CENTER OF VISION, THE PICTURE PLANE CUTS THE TILTED CONE STRAIGHT ACROSS AND FORMS AN ELLIPSE IDENTICAL TO ONE PRODUCED BY CUTTING AN ORDINARY CONE AT THE SAME ANGLE AS YOUR TILTED CONE IS TILTED. GET IT?

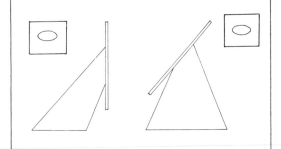

AWAY FROM THE CENTER OF VISION, THE ELLIPSES FORMED DEPEND ON A COMPLICATED INTERACTION OF THE TILT OF EACH CONE AND THE ANGLE THE PICTURE PLANE SLICES IT AT.

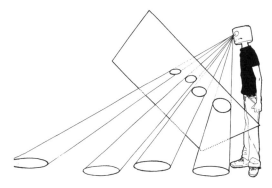

FOR CIRCLES PARALLEL TO THE GROUND, SKINNIER ELLIPSES ARE SEEN CLOSE TO THE HORIZON AND FATTER ONES FARTHER AWAY.

CIRCLES AT THE HORIZON ARE SEEN EDGE ON AND ARE DRAWN AS STRAIGHT LINES!

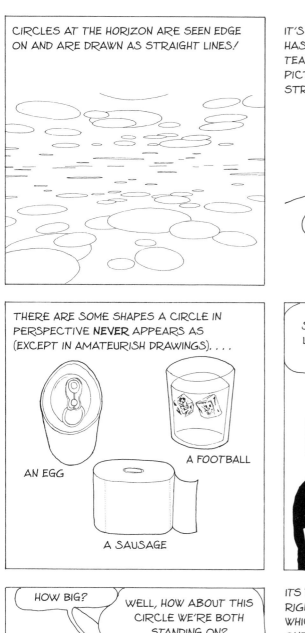

IT'S NOT DIFFICULT TO SEE WHY—THE CONE HAS GOTTEN SO SKINNY IT'S FLATTENED TO A TEARDROP SHAPE. WHATEVER ANGLE THE PICTURE PLANE CUTS IT AT, IT'S **STILL** A STRAIGHT LINE.

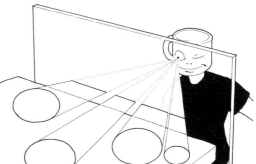

THERE ARE SOME SHAPES A CIRCLE IN PERSPECTIVE **NEVER** APPEARS AS (EXCEPT IN AMATEURISH DRAWINGS). . . .

AN EGG

A FOOTBALL

A SAUSAGE

SO, ELLIPSES, CIRCLES, AND STRAIGHT LINES—THAT ABOUT COVERS IT, RIGHT?

NOT QUITE, MUGG. THERE'S STILL THE CASE OF REALLY, REALLY BIG CIRCLES!

HOW BIG?

WELL, HOW ABOUT THIS CIRCLE WE'RE BOTH STANDING ON?

ITS FRONT EDGE SITS RIGHT OVER THE NADIR, WHICH IS AT INFINITY IN ONE-POINT PERSPECTIVE, WHICH MEANS YOU CAN NEVER, EVER FIT THE WHOLE THING ON YOUR PICTURE PLANE!

THIS KIND OF CIRCLE IS DRAWN ON THE PICTURE PLANE AS A **PARABOLA**, AN OPEN-ENDED CURVE YOU GET WHEN YOU SLICE A CONE AT AN ANGLE PARALLEL TO ONE SIDE.

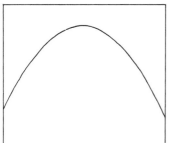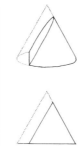

SINCE YOUR CHIN IS DIRECTLY OVER THE RIM OF THE HOT TUB, BOTH THE RIM AND THE WATERLINE ARE DRAWN AS PARABOLAS.

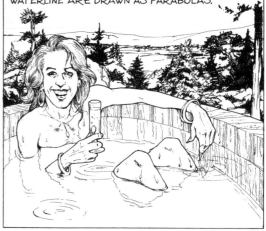

AND THEN THERE'S THE CIRCLE YOU'RE STANDING INSIDE OF.

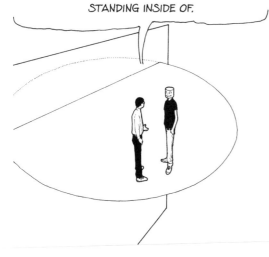

THAT KIND OF CIRCLE FORMS A **HYPERBOLA** ON THE PICTURE PLANE, A CURVE DERIVED BY SLICING THE CONE AT ANY ANGLE STEEPER THAN ITS SIDE.

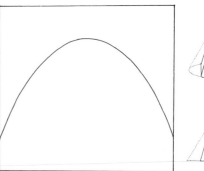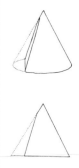

A CIRCLE LIKE THIS, WITH YOUR TUSH AT ITS CENTER SITTING RIGHT OVER THE NADIR, REQUIRES YOU TO DRAW A HYPERBOLA. . . .

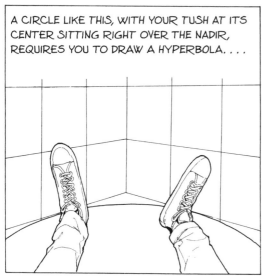

SO DO THE RINGS IN THIS VIEW.

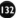

THIS SCENE CALLS FOR A HYPERBOLA, PARABOLA, AND ELLIPSES. REMEMBER: IF YOU'RE IN IT, IT'S A HYPERBOLA; IF YOU'RE ON IT, IT'S A PARABOLA; AND IF YOU'RE OUTSIDE IT, IT'S AN ELLIPSE.

DON'T FORGET THAT IF ANY OF THOSE CIRCLES ARE DIRECTLY AT YOUR EYE LEVEL, THEY'RE DRAWN AS STRAIGHT LINES!

SO, IF I NEED TO DRAW CIRCLES IN PERSPECTIVE, I'D BETTER KEEP PLENTY OF ICE CREAM CONES ON HAND, EH?

THAT'S NOT NECESSARY, MUGG.

PARABOLAS AND HYPERBOLAS ARE PRETTY COMPLICATED TO DRAW. THERE ARE FORMULAS YOU CAN USE, BUT PROBABLY THE SIMPLEST METHOD IS TO DRAW CIRCLES FIRST ON GRAPH PAPER AND THEN TRANSFER THEM!

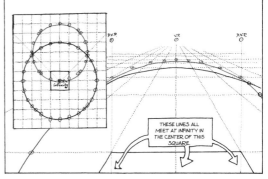

AS FOR ELLIPSES, YOU CAN BUY TEMPLATES AT THE ART SUPPLY STORE THAT YOU CAN TRACE RIGHT ONTO YOUR DRAWING.

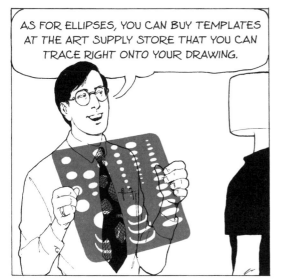

FIGURING OUT WHICH ANGLE OF ELLIPSE TO USE WHERE TAKES PRACTICE—A FAT ELLIPSE TOO CLOSE TO THE HORIZON LOOKS TIPPED FORWARD, WHILE A SKINNY ONE TOO FAR AWAY LOOKS TIPPED BACK.

IF YOU WANT TO BE ABSOLUTELY PRECISE, FIRST DRAW A SQUARE IN PERSPECTIVE, THEN DRAW YOUR ELLIPSE INSIDE IT. JUST AS A CIRCLE TOUCHES THE MIDPOINT OF EACH SIDE OF THE SQUARE IN THE PLANE, THE ELLIPSE TOUCHES THE PERSPECTIVE MIDPOINTS OF EACH SIDE OF THE FORESHORTENED SQUARE.

TEMPLATES USUALLY PROVIDE ONLY A LIMITED VARIETY OF ELLIPSES, SO YOU MAY NOT FIND ONE THAT EXACTLY FITS YOUR SQUARE.

WHEN THAT HAPPENS, YOU CAN DRAW AN ELLIPSE FREEHAND. OFTEN A SIMPLE CLOSED CURVE LINKING THE MIDPOINTS IS CLOSE ENOUGH.

FOR A BIT MORE GUIDANCE, DRAW IN THE DIAGONALS AND THEN MARK POINTS THAT SEEM ROUGHLY TWO-THIRDS OF THE DISTANCE FROM THE CENTER TO THE CORNERS.

EVEN THOUGH IT'S NOT STRICTLY ACCURATE, THIS IS CLOSE ENOUGH TO WORK IN A LOT OF SITUATIONS.

FOR MORE ACCURACY, DIVIDE THE SQUARE INTO QUARTERS.

USING THE "X" METHOD, DIVIDE IT AGAIN INTO SIXTEENTHS.

NOW, DRAW IN OBLIQUE LINES FROM EACH CORNER TO POINTS FOUR SQUARES DOWN AND ONE OVER.

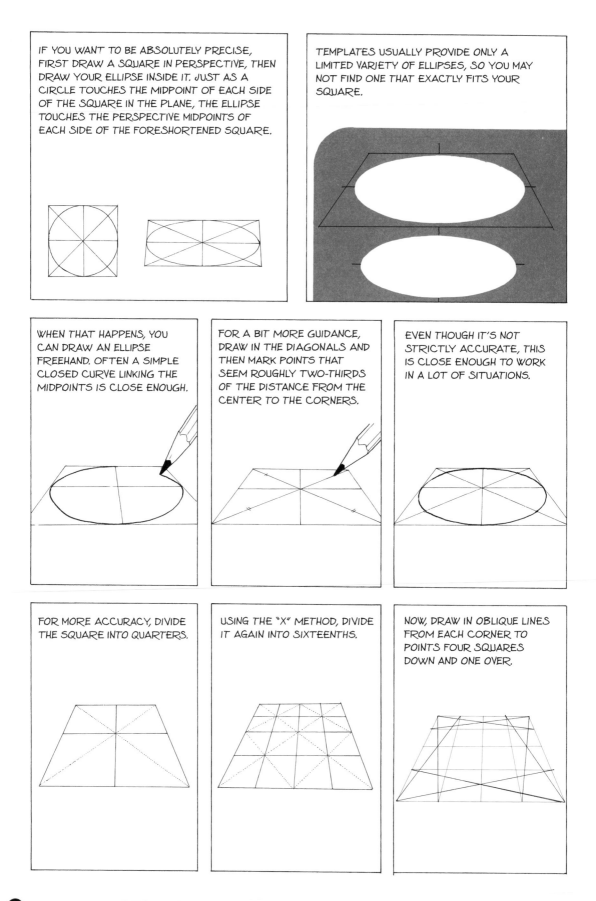

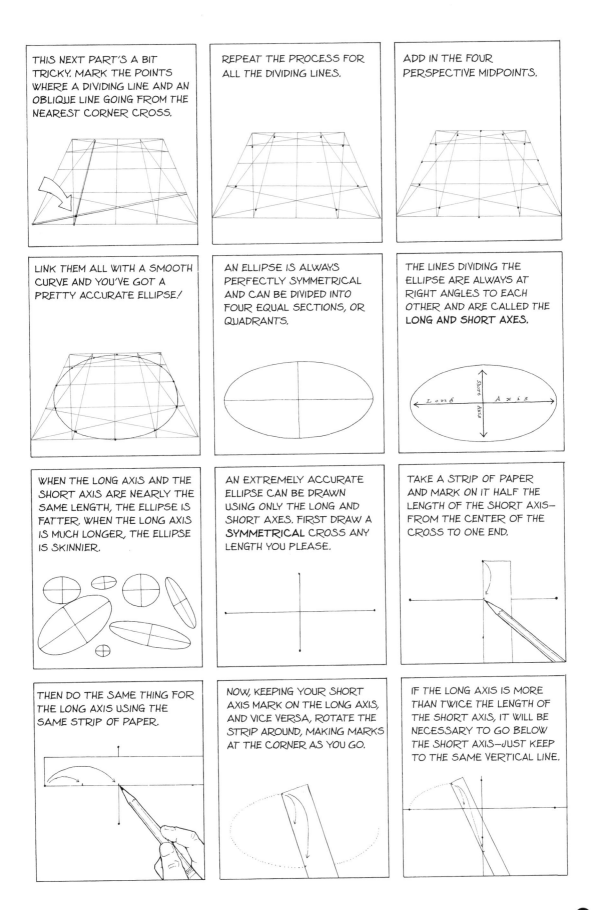

THIS NEXT PART'S A BIT TRICKY. MARK THE POINTS WHERE A DIVIDING LINE AND AN OBLIQUE LINE GOING FROM THE NEAREST CORNER CROSS.

REPEAT THE PROCESS FOR ALL THE DIVIDING LINES.

ADD IN THE FOUR PERSPECTIVE MIDPOINTS.

LINK THEM ALL WITH A SMOOTH CURVE AND YOU'VE GOT A PRETTY ACCURATE ELLIPSE!

AN ELLIPSE IS ALWAYS PERFECTLY SYMMETRICAL AND CAN BE DIVIDED INTO FOUR EQUAL SECTIONS, OR QUADRANTS.

THE LINES DIVIDING THE ELLIPSE ARE ALWAYS AT RIGHT ANGLES TO EACH OTHER AND ARE CALLED THE **LONG AND SHORT AXES.**

Long Axis

Short Axis

WHEN THE LONG AXIS AND THE SHORT AXIS ARE NEARLY THE SAME LENGTH, THE ELLIPSE IS FATTER. WHEN THE LONG AXIS IS MUCH LONGER, THE ELLIPSE IS SKINNIER.

AN EXTREMELY ACCURATE ELLIPSE CAN BE DRAWN USING ONLY THE LONG AND SHORT AXES. FIRST DRAW A **SYMMETRICAL** CROSS ANY LENGTH YOU PLEASE.

TAKE A STRIP OF PAPER AND MARK ON IT HALF THE LENGTH OF THE SHORT AXIS— FROM THE CENTER OF THE CROSS TO ONE END.

THEN DO THE SAME THING FOR THE LONG AXIS USING THE SAME STRIP OF PAPER.

NOW, KEEPING YOUR SHORT AXIS MARK ON THE LONG AXIS, AND VICE VERSA, ROTATE THE STRIP AROUND, MAKING MARKS AT THE CORNER AS YOU GO.

IF THE LONG AXIS IS MORE THAN TWICE THE LENGTH OF THE SHORT AXIS, IT WILL BE NECESSARY TO GO BELOW THE SHORT AXIS—JUST KEEP TO THE SAME VERTICAL LINE.

YOU SHOULD WIND UP WITH A DOTTED LINE THAT PERFECTLY DEFINES YOUR ELLIPSE. (TO SAVE WORK, DRAW ONE QUADRANT, FOLD YOUR PAPER OVER, AND TRACE THE OTHER THREE.)

YOU MIGHT THINK THAT THE CENTER OF THE ELLIPSE IS AT THE PERSPECTIVE CENTER OF THE CIRCLE, BUT THIS IS **NEVER** THE CASE.

CENTER OF CIRCLE

CENTER OF ELLIPSE

INSTEAD, THE CENTER OF THE CIRCLE IS AT THE PERSPECTIVE CENTER OF THE SQUARE IT'S INSCRIBED IN.

CONCENTRIC CIRCLES ARE ALL THE SAME TYPE OF ELLIPSE—OUTER ONES ARE JUST LARGER VERSIONS OF INNER ONES.

THEY ALL SHARE A COMMON PERSPECTIVE CENTER, BUT AS THEY GET LARGER THE CENTERS OF THE ELLIPSES GET MORE AND MORE DISPLACED FROM THE PERSPECTIVE CENTER.

J.V.P.

AS I SAID BEFORE, SKINNY CIRCLES ARE SEEN NEAR THE HORIZON, FAT ONES FARTHER AWAY, UNTIL AT THE EDGE OF A 90° CONE, DIRECTLY UNDER THE CENTER OF VISION, DISTORTION AND FORESHORTENING EXACTLY BALANCE, AND THE CIRCLE IS DRAWN AS . . . A CIRCLE!

90°

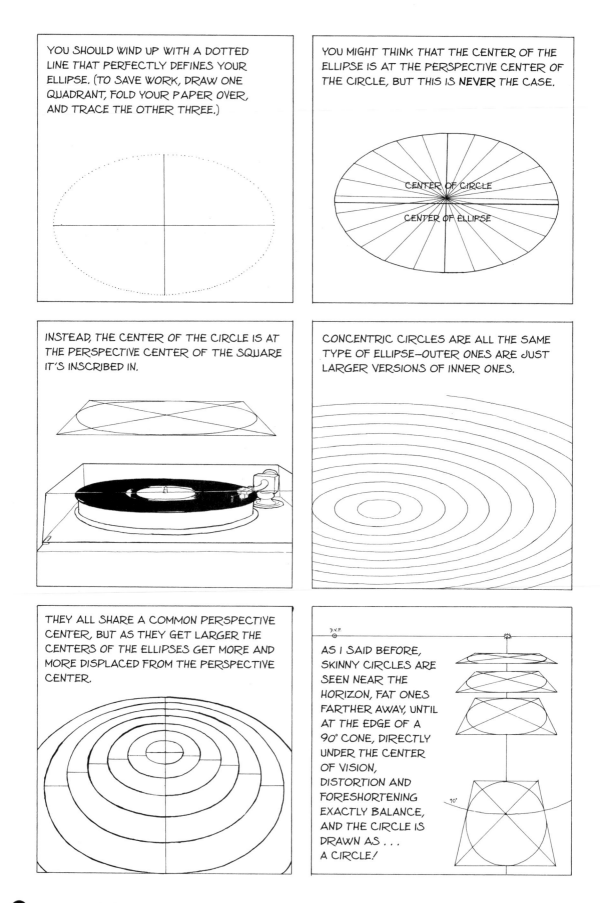

FARTHER OUT, DISTORTION TAKES OVER AND ELLIPSES GET SKINNY AGAIN, WITH THEIR **LONG** AXES POINTED AT THE CENTER OF VISION.

KNOWING THIS WILL COME IN HANDY IF YOU NEED TO DRAW PART OF A **REALLY** BIG CIRCLE, WITH ITS CENTER FAR OUTSIDE YOUR CONE OF VISION.

OF COURSE, ONCE ANY PART OF IT TOUCHES INFINITY, IT BECOMES A PARABOLA OR HYPERBOLA.

NOW WE COME TO A VERY IMPORTANT RULE. IT'S IN ALL THE BOOKS, AND IT'S WRONG, WRONG, WRONG!

HERE'S WHAT THEY SAY: PERSPECTIVE CIRCLES PARALLEL TO THE GROUND ALWAYS HAVE THEIR LONG AXES PARALLEL TO THE HORIZON.

HERE'S THE TRUTH: EXCEPT FOR DIRECTLY UNDER THE CENTER OF VISION, PERSPECTIVE CIRCLES TILT LIKE CRAZY!

ELLIPSES DIRECTLY UNDER THE CENTER OF VISION **DO** HAVE THEIR LONG AXES PARALLEL TO THE HORIZON, AND ONES NEARBY ARE ONLY SLIGHTLY TILTED.

FARTHER OUT, THE EFFECT IS FAR MORE OBVIOUS!

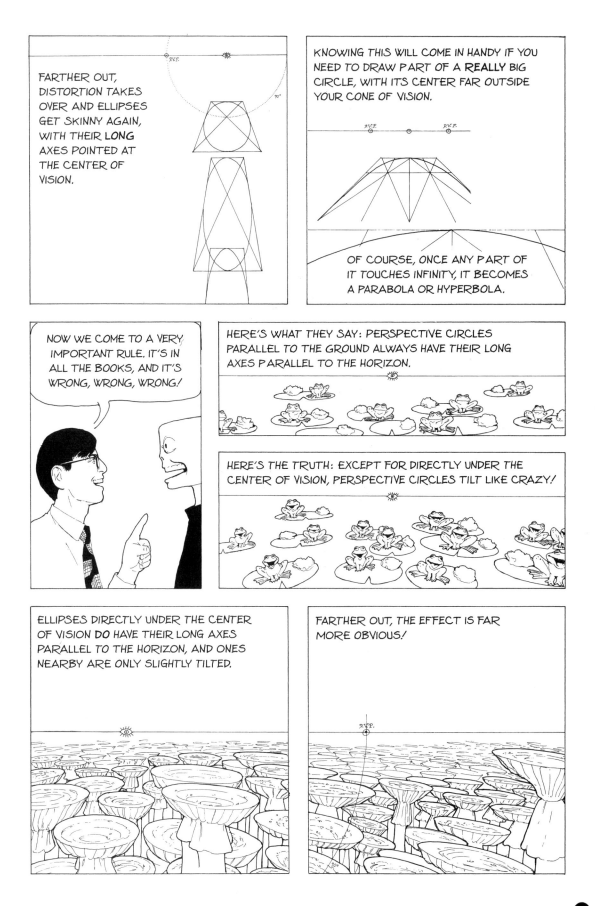

SO, DAVID, HOW DO I FIGURE OUT HOW MUCH TO TILT AN ELLIPSE?

WELL, IT MIGHT SEND THIS CHAPTER INTO OVERTIME TO EXPLAIN, BUT HERE GOES. . . .

MOST BOOKS TELL YOU TO IGNORE THE TILT—JUST LINE ALL YOUR ELLIPSES UP WITH THE HORIZON. THEY SAY IT LOOKS BETTER THAT WAY. MAYBE THEY'RE RIGHT, AND IT IS EASIER TO CONSTRUCT, ESPECIALLY USING THE TEMPLATES, BUT HEY, THIS ISN'T MOST BOOKS!

SO, PICTURE YOURSELF AT THE CENTER OF A RING OF LITTLE CIRCLES.

EACH CIRCLE IS THE SAME DISTANCE FROM YOUR EYE AND THEY ALL LOOK IDENTICAL. WHAT'S MORE, ALL THEIR LONG AXES LINK UP TO FORM A CONTINUOUS LINE, PARALLEL TO THE HORIZON.

THEY LOOK KIND OF LIKE BEADS ON A STRING.

HOWEVER, IN TRACING THAT LINE ONTO THE PICTURE PLANE SO THAT IT LOOKS CORRECT TO YOUR EYE, THAT CHAIN OF ELLIPSES HAS TO BE BENT TILL IT FORMS . . .

. . . A HYPERBOLA!

OBVIOUSLY, THE STRAIGHT LINES OF THE LONG AXES CAN ONLY APPROXIMATE THE CURVE OF THE HYPERBOLA, BUT THEY BASICALLY FOLLOW ITS DIRECTION.

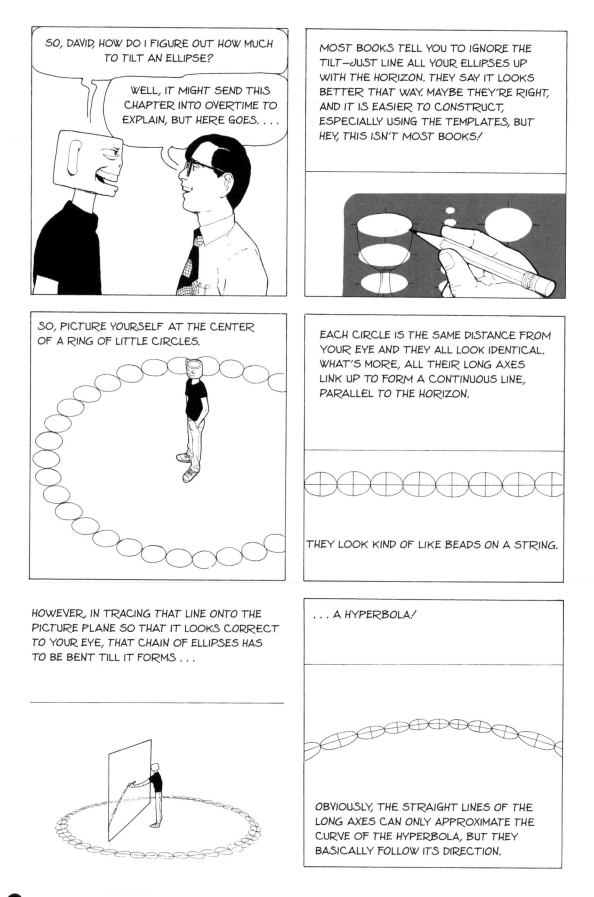

ADD MORE RINGS OF ELLIPSES, AND THEY FORM MORE HYPERBOLAS ON THE PICTURE PLANE!

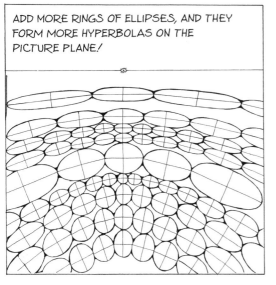

OF COURSE, IN MOST DRAWINGS CIRCLES WON'T LINE UP IN RINGS LIKE THAT, BUT ADD ENOUGH HYPERBOLAS TO YOUR DRAWING AND YOU CAN FIND THE DIRECTION FOR ANY LONG AXIS YOU NEED!

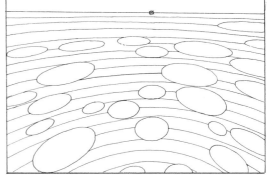

HERE'S AN ADDITIONAL GUIDELINE: IMAGINE RADIATING LINES CENTERED ON THE SPOT RIGHT UNDER YOUR FEET, DEFINING YOUR ANGLES OF VISION.

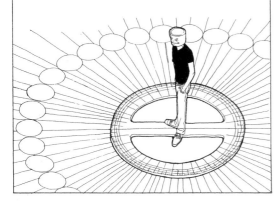

ON THE PICTURE PLANE, THESE WILL APPEAR AS VERTICAL LINES, BECAUSE THE POINT AT WHICH THEY MEET IS UNDER YOUR FEET, DIRECTLY OVER THE NADIR (I.E., AT INFINITY ON THE PICTURE PLANE).

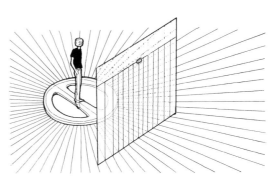

ALL ELLIPSES WITH THEIR PERSPECTIVE CENTERS ON A GIVEN LINE WILL APPEAR FROM THE STATION POINT TO HAVE THEIR LONG AXES PARALLEL TO EACH OTHER AND TO THE HORIZON—REALLY, THEIR LONG AXES WILL MEET AT A POINT ON THE HORIZON 90° AWAY FROM THE LINE.

WHAT CAN I SAY? OPPOSITES ATTRACT.

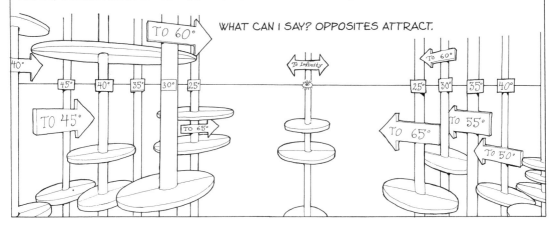

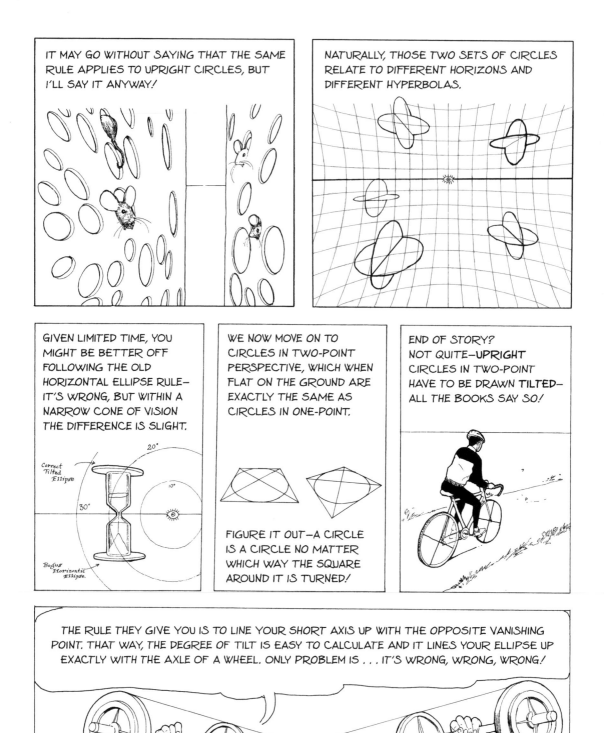

IT MAY GO WITHOUT SAYING THAT THE SAME RULE APPLIES TO UPRIGHT CIRCLES, BUT I'LL SAY IT ANYWAY!

NATURALLY, THOSE TWO SETS OF CIRCLES RELATE TO DIFFERENT HORIZONS AND DIFFERENT HYPERBOLAS.

GIVEN LIMITED TIME, YOU MIGHT BE BETTER OFF FOLLOWING THE OLD HORIZONTAL ELLIPSE RULE—IT'S WRONG, BUT WITHIN A NARROW CONE OF VISION THE DIFFERENCE IS SLIGHT.

Correct Tilted Ellipse
20°
10°
30°
Bogus Horizontal Ellipse.

WE NOW MOVE ON TO CIRCLES IN TWO-POINT PERSPECTIVE, WHICH WHEN FLAT ON THE GROUND ARE EXACTLY THE SAME AS CIRCLES IN ONE-POINT.

FIGURE IT OUT—A CIRCLE IS A CIRCLE NO MATTER WHICH WAY THE SQUARE AROUND IT IS TURNED!

END OF STORY? NOT QUITE—UPRIGHT CIRCLES IN TWO-POINT HAVE TO BE DRAWN TILTED—ALL THE BOOKS SAY SO!

THE RULE THEY GIVE YOU IS TO LINE YOUR SHORT AXIS UP WITH THE OPPOSITE VANISHING POINT. THAT WAY, THE DEGREE OF TILT IS EASY TO CALCULATE AND IT LINES YOUR ELLIPSE UP EXACTLY WITH THE AXLE OF A WHEEL. ONLY PROBLEM IS . . . IT'S WRONG, WRONG, WRONG!

V.P.

V.P.

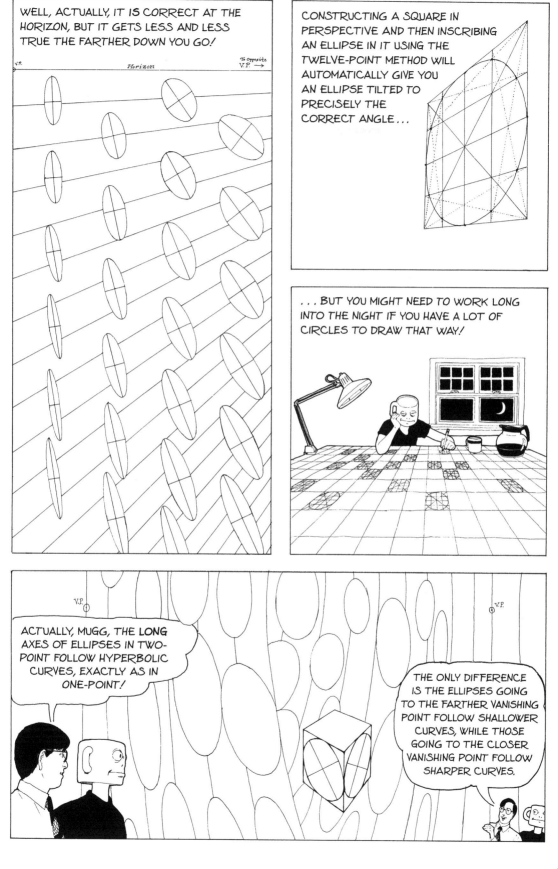

WELL, ACTUALLY, IT IS CORRECT AT THE HORIZON, BUT IT GETS LESS AND LESS TRUE THE FARTHER DOWN YOU GO!

CONSTRUCTING A SQUARE IN PERSPECTIVE AND THEN INSCRIBING AN ELLIPSE IN IT USING THE TWELVE-POINT METHOD WILL AUTOMATICALLY GIVE YOU AN ELLIPSE TILTED TO PRECISELY THE CORRECT ANGLE...

...BUT YOU MIGHT NEED TO WORK LONG INTO THE NIGHT IF YOU HAVE A LOT OF CIRCLES TO DRAW THAT WAY!

ACTUALLY, MUGG, THE **LONG** AXES OF ELLIPSES IN TWO-POINT FOLLOW HYPERBOLIC CURVES, EXACTLY AS IN ONE-POINT!

THE ONLY DIFFERENCE IS THE ELLIPSES GOING TO THE FARTHER VANISHING POINT FOLLOW SHALLOWER CURVES, WHILE THOSE GOING TO THE CLOSER VANISHING POINT FOLLOW SHARPER CURVES.

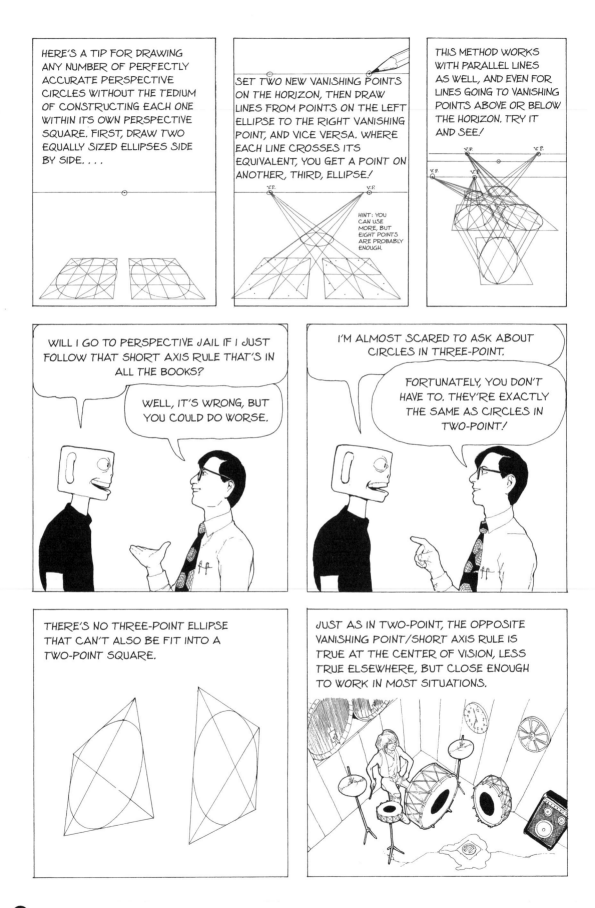

HERE'S A TIP FOR DRAWING ANY NUMBER OF PERFECTLY ACCURATE PERSPECTIVE CIRCLES WITHOUT THE TEDIUM OF CONSTRUCTING EACH ONE WITHIN ITS OWN PERSPECTIVE SQUARE. FIRST, DRAW TWO EQUALLY SIZED ELLIPSES SIDE BY SIDE. . . .

SET TWO NEW VANISHING POINTS ON THE HORIZON, THEN DRAW LINES FROM POINTS ON THE LEFT ELLIPSE TO THE RIGHT VANISHING POINT, AND VICE VERSA. WHERE EACH LINE CROSSES ITS EQUIVALENT, YOU GET A POINT ON ANOTHER, THIRD, ELLIPSE!

HINT: YOU CAN USE MORE, BUT EIGHT POINTS ARE PROBABLY ENOUGH.

THIS METHOD WORKS WITH PARALLEL LINES AS WELL, AND EVEN FOR LINES GOING TO VANISHING POINTS ABOVE OR BELOW THE HORIZON. TRY IT AND SEE!

WILL I GO TO PERSPECTIVE JAIL IF I JUST FOLLOW THAT SHORT AXIS RULE THAT'S IN ALL THE BOOKS?

WELL, IT'S WRONG, BUT YOU COULD DO WORSE.

I'M ALMOST SCARED TO ASK ABOUT CIRCLES IN THREE-POINT.

FORTUNATELY, YOU DON'T HAVE TO. THEY'RE EXACTLY THE SAME AS CIRCLES IN TWO-POINT!

THERE'S NO THREE-POINT ELLIPSE THAT CAN'T ALSO BE FIT INTO A TWO-POINT SQUARE.

JUST AS IN TWO-POINT, THE OPPOSITE VANISHING POINT/SHORT AXIS RULE IS TRUE AT THE CENTER OF VISION, LESS TRUE ELSEWHERE, BUT CLOSE ENOUGH TO WORK IN MOST SITUATIONS.

THAT PRETTY MUCH COVERS THE CIRCLE, MUGG. TIME TO MOVE ON TO . . .

FLAP
FLOP
FLAPPITY
FLOP
FLOP
FLIP
FLIPPITY
FLOP
FLAP

. . . THE CYLINDER!

WHICH IS REALLY NOTHING MORE THAN A STACK, OR ROW, OF CIRCLES. IF YOU KNOW THE SHAPE OF THE ELLIPSE AT EITHER END, WHAT'S IN BETWEEN IS EASY!

BOW WOW CHOW

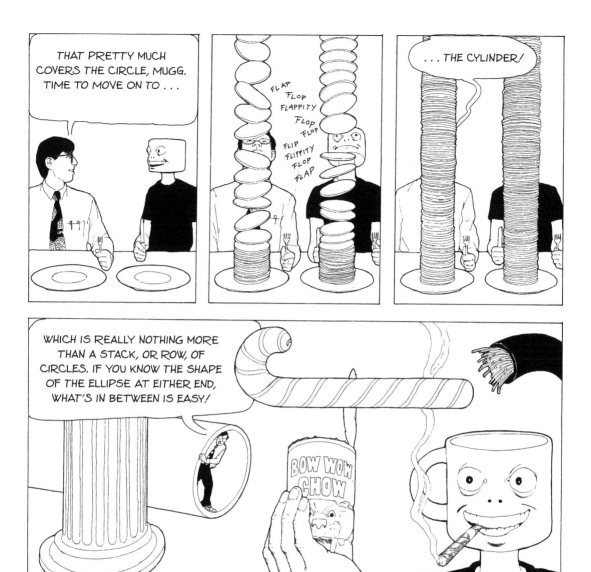

THE CONE IS SIMILAR—A STACK OF CIRCLES AROUND A COMMON CENTRAL LINE . . . ONLY THE CIRCLES TAPER TO A POINT.

A CONE CAN BE DRAWN AS A TRIANGLE WITH AN ELLIPSE AT ONE END, ITS SHORT AXIS POINTING AT THE APEX, AND THE TRIANGLE FATTER OR SKINNIER, DEPENDING ON YOUR ANGLE OF VIEW.

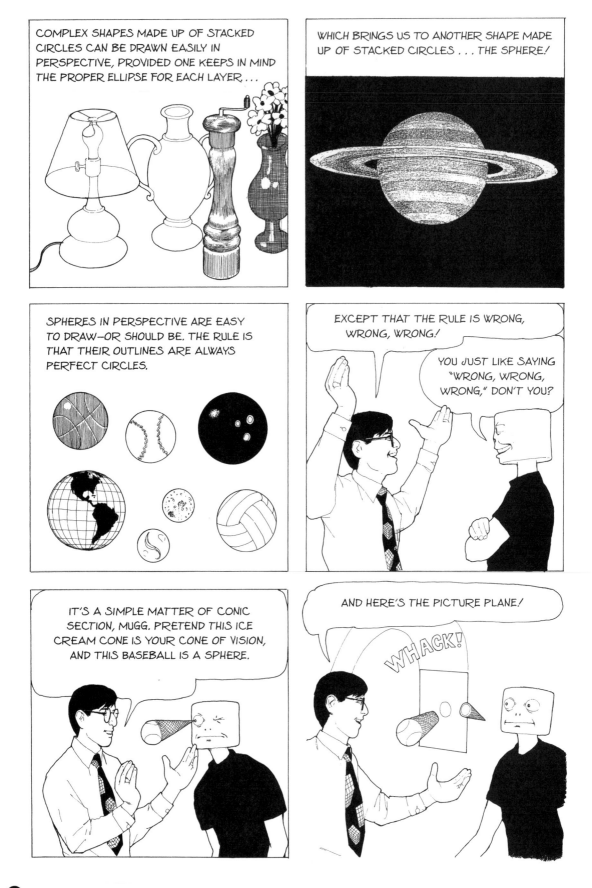

COMPLEX SHAPES MADE UP OF STACKED CIRCLES CAN BE DRAWN EASILY IN PERSPECTIVE, PROVIDED ONE KEEPS IN MIND THE PROPER ELLIPSE FOR EACH LAYER . . .

WHICH BRINGS US TO ANOTHER SHAPE MADE UP OF STACKED CIRCLES . . . THE SPHERE!

SPHERES IN PERSPECTIVE ARE EASY TO DRAW—OR SHOULD BE. THE RULE IS THAT THEIR OUTLINES ARE ALWAYS PERFECT CIRCLES.

EXCEPT THAT THE RULE IS WRONG, WRONG, WRONG!

YOU JUST LIKE SAYING "WRONG, WRONG, WRONG," DON'T YOU?

IT'S A SIMPLE MATTER OF CONIC SECTION, MUGG. PRETEND THIS ICE CREAM CONE IS YOUR CONE OF VISION, AND THIS BASEBALL IS A SPHERE.

AND HERE'S THE PICTURE PLANE!

WHACK!

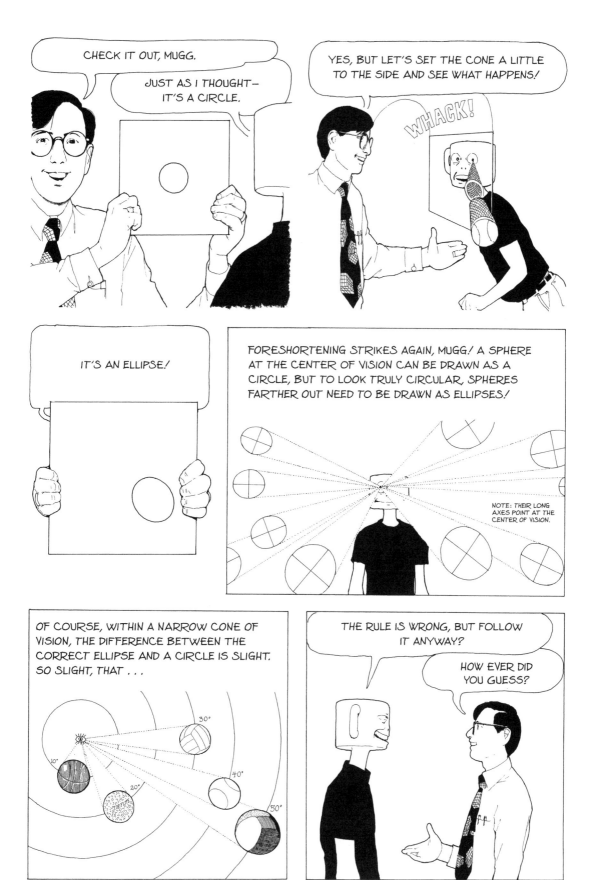

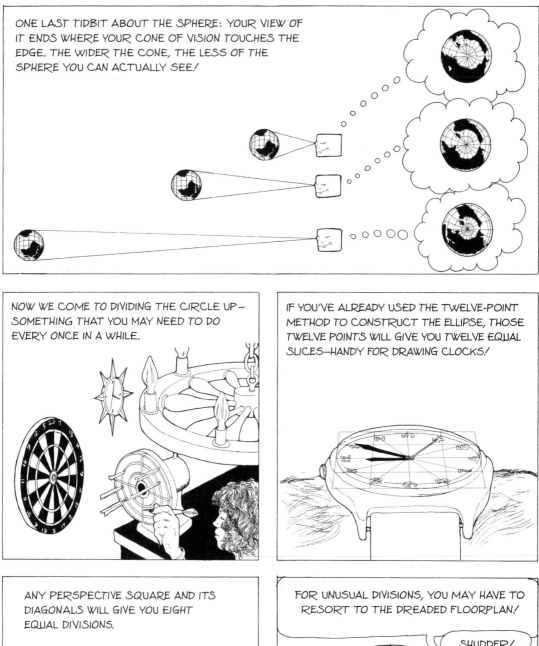

ONE LAST TIDBIT ABOUT THE SPHERE: YOUR VIEW OF IT ENDS WHERE YOUR CONE OF VISION TOUCHES THE EDGE. THE WIDER THE CONE, THE LESS OF THE SPHERE YOU CAN ACTUALLY SEE!

NOW WE COME TO DIVIDING THE CIRCLE UP—SOMETHING THAT YOU MAY NEED TO DO EVERY ONCE IN A WHILE.

IF YOU'VE ALREADY USED THE TWELVE-POINT METHOD TO CONSTRUCT THE ELLIPSE, THOSE TWELVE POINTS WILL GIVE YOU TWELVE EQUAL SLICES—HANDY FOR DRAWING CLOCKS!

ANY PERSPECTIVE SQUARE AND ITS DIAGONALS WILL GIVE YOU EIGHT EQUAL DIVISIONS.

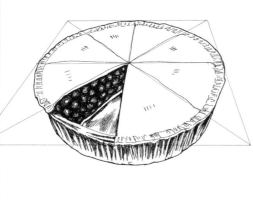

FOR UNUSUAL DIVISIONS, YOU MAY HAVE TO RESORT TO THE DREADED FLOORPLAN!

SHUDDER!

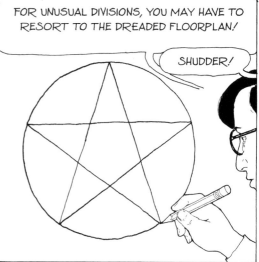

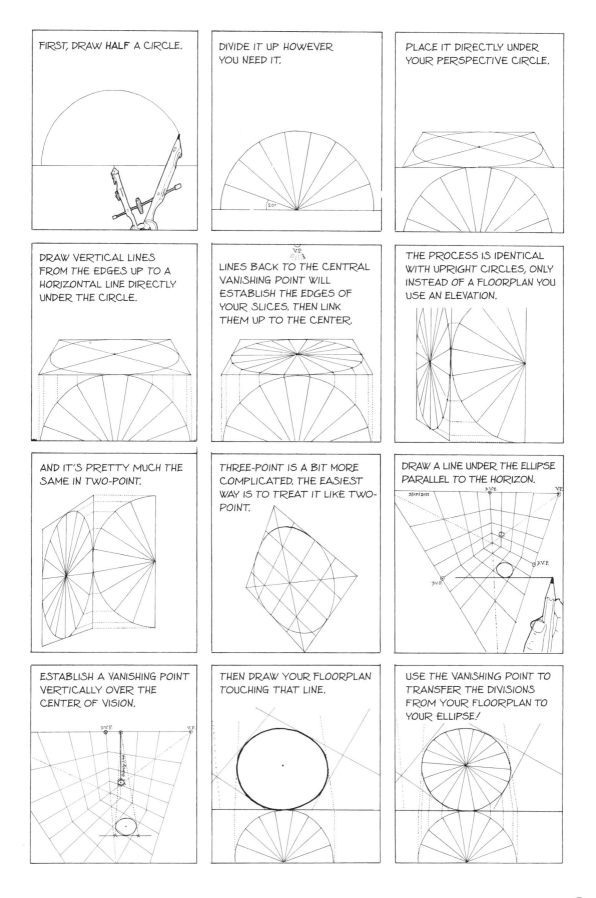

FIRST, DRAW **HALF** A CIRCLE.

DIVIDE IT UP HOWEVER YOU NEED IT.

PLACE IT DIRECTLY UNDER YOUR PERSPECTIVE CIRCLE.

DRAW VERTICAL LINES FROM THE EDGES UP TO A HORIZONTAL LINE DIRECTLY UNDER THE CIRCLE.

LINES BACK TO THE CENTRAL VANISHING POINT WILL ESTABLISH THE EDGES OF YOUR SLICES. THEN LINK THEM UP TO THE CENTER.

THE PROCESS IS IDENTICAL WITH UPRIGHT CIRCLES, ONLY INSTEAD OF A FLOORPLAN YOU USE AN ELEVATION.

AND IT'S PRETTY MUCH THE SAME IN TWO-POINT.

THREE-POINT IS A BIT MORE COMPLICATED. THE EASIEST WAY IS TO TREAT IT LIKE TWO-POINT.

DRAW A LINE UNDER THE ELLIPSE PARALLEL TO THE HORIZON.

ESTABLISH A VANISHING POINT VERTICALLY OVER THE CENTER OF VISION.

THEN DRAW YOUR FLOORPLAN TOUCHING THAT LINE.

USE THE VANISHING POINT TO TRANSFER THE DIVISIONS FROM YOUR FLOORPLAN TO YOUR ELLIPSE!

ONCE YOU HAVE DIVISIONS DRAWN ON THE ELLIPSE, YOU CAN EXTEND THEM TO PUT STRIPES ON THE CYLINDER OR CONE...

... AND AT LEAST MAKE A START ON MORE COMPLEX CURVED SHAPES!

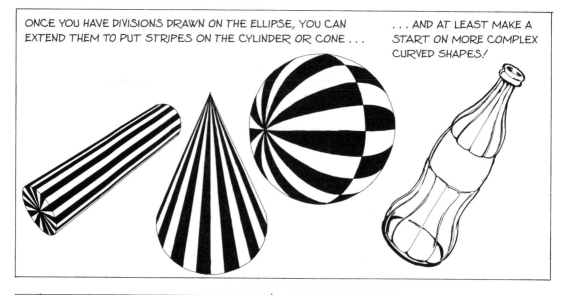

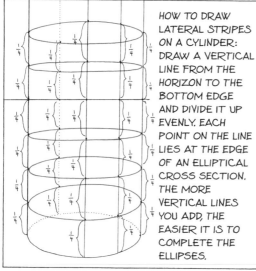

HOW TO DRAW LATERAL STRIPES ON A CYLINDER: DRAW A VERTICAL LINE FROM THE HORIZON TO THE BOTTOM EDGE AND DIVIDE IT UP EVENLY. EACH POINT ON THE LINE LIES AT THE EDGE OF AN ELLIPTICAL CROSS SECTION. THE MORE VERTICAL LINES YOU ADD, THE EASIER IT IS TO COMPLETE THE ELLIPSES.

AND AS I TOLD YOU IN A PREVIOUS CHAPTER, A PERSPECTIVE CIRCLE CAN HELP YOU ROTATE AN OBJECT, OR OPEN A DOOR!

ONCE YOU'VE MASTERED THE CUBE, THE SPHERE, THE CONE, AND THE CYLINDER, YOU CAN DRAW VIRTUALLY ANY OBJECT MADE BY MAN!

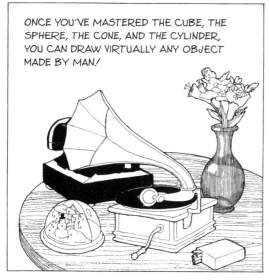

AND YOU'VE GOT A HEAD START ON SOME OBJECTS **NOT MADE BY MAN!**

CHAPTER TEN

THE HUMAN FIGURE

Perspective is of limited help in drawing as complex and irregular a shape as the human form, and yet the help it provides is invaluable. Most artists who hope to make a living at their art need to be good at drawing people, and most are happy to study the figure without incentive. Yet very few illustrators can make a career out of the figure alone (girlie artists like Vargas and their beefcake equivalents like Tom of Finland are the great exceptions), and the requirements of clients and of telling a story mean that your character must sit in chairs, climb stairs, drive cars, and talk on the telephone, all situations that require perspective. Getting perspective right in the human figure requires a solid command of foreshortening, if your characters are to fit plausibly within the settings you draw for them. The angle you take on the scene must match the foreshortening you draw into your figures, if they are not to seem to float free of gravity. Awareness of perspective will inevitably make the job of drawing the figure harder, not easier, at first. But the results, in the form of immeasurably more convincing drawings, will be well worth it.

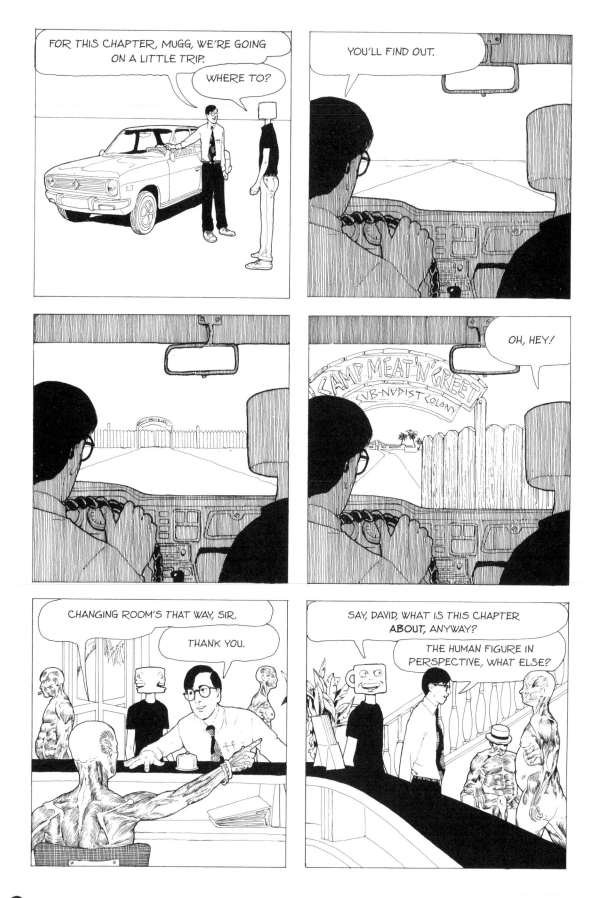

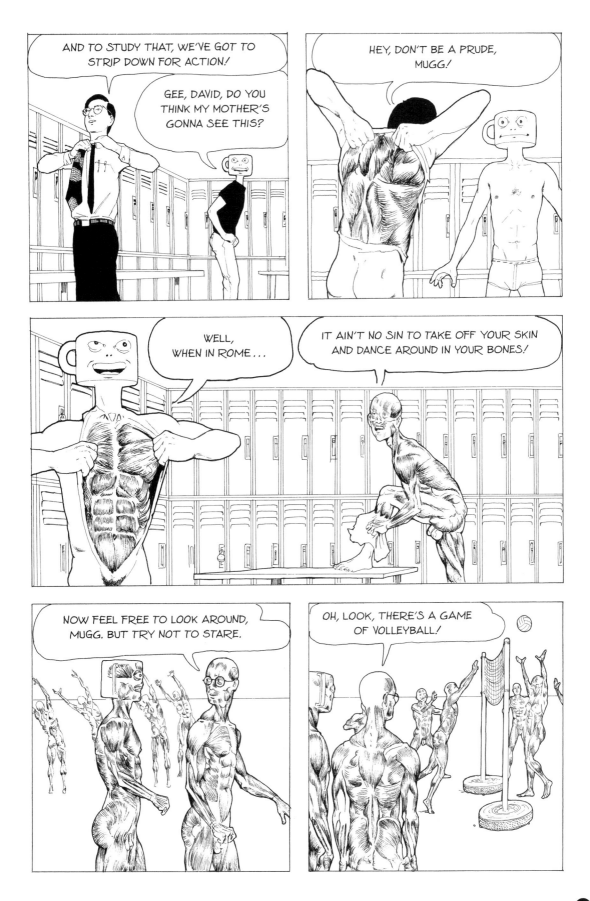

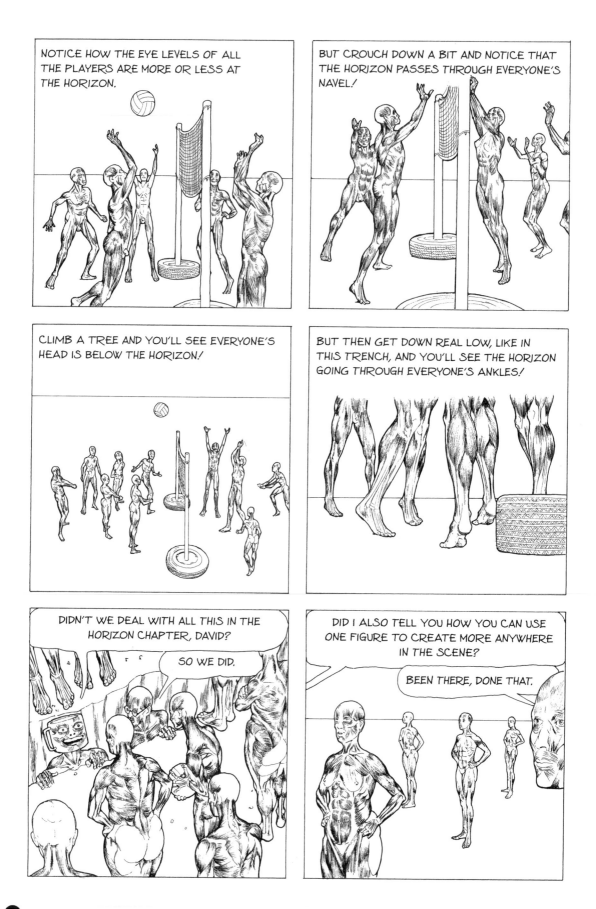

NOTICE HOW THE EYE LEVELS OF ALL THE PLAYERS ARE MORE OR LESS AT THE HORIZON.

BUT CROUCH DOWN A BIT AND NOTICE THAT THE HORIZON PASSES THROUGH EVERYONE'S NAVEL!

CLIMB A TREE AND YOU'LL SEE EVERYONE'S HEAD IS BELOW THE HORIZON!

BUT THEN GET DOWN REAL LOW, LIKE IN THIS TRENCH, AND YOU'LL SEE THE HORIZON GOING THROUGH EVERYONE'S ANKLES!

DIDN'T WE DEAL WITH ALL THIS IN THE HORIZON CHAPTER, DAVID?

SO WE DID.

DID I ALSO TELL YOU HOW YOU CAN USE ONE FIGURE TO CREATE MORE ANYWHERE IN THE SCENE?

BEEN THERE, DONE THAT.

GOOD, THEN WE CAN START TO DEAL WITH THE REAL TOUGH NUT IN DRAWING THE FIGURE IN PERSPECTIVE—FORESHORTENING!

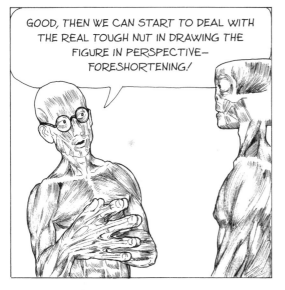

MUGG, THIS IS YOUR BODY, SEEN HEAD ON.

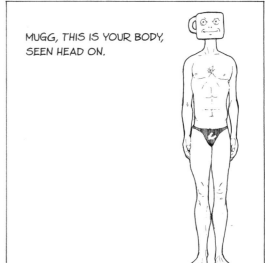

AND THIS IS YOUR BODY, FORESHORTENED. HOW CAN PERSPECTIVE HELP US GET FROM THAT TO THIS?

WILL IT HELP IF WE PUT THE BODY IN A BOX?

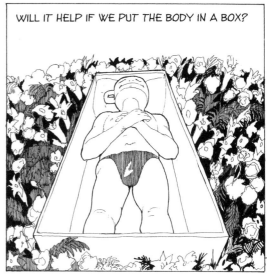

WELL, IN A KIND OF LOOSE AND GENERAL WAY, A BOX CAN SHOW YOU THE LIMITS OF THE SPACE A BODY CAN OCCUPY.

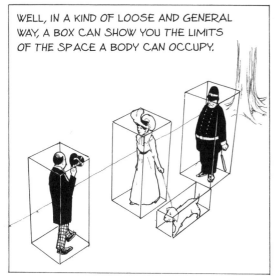

IT'S LIKE THE RELATIONSHIP BETWEEN A BLOCK OF MARBLE AND A STATUE. IT CAN PROVIDE A STRUCTURE AROUND THE BODY, BUT IT CAN'T DESCRIBE THE COMPLEXITY WITHIN!

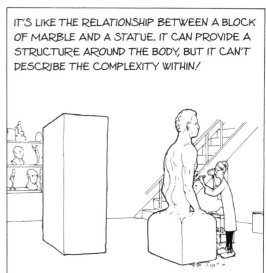

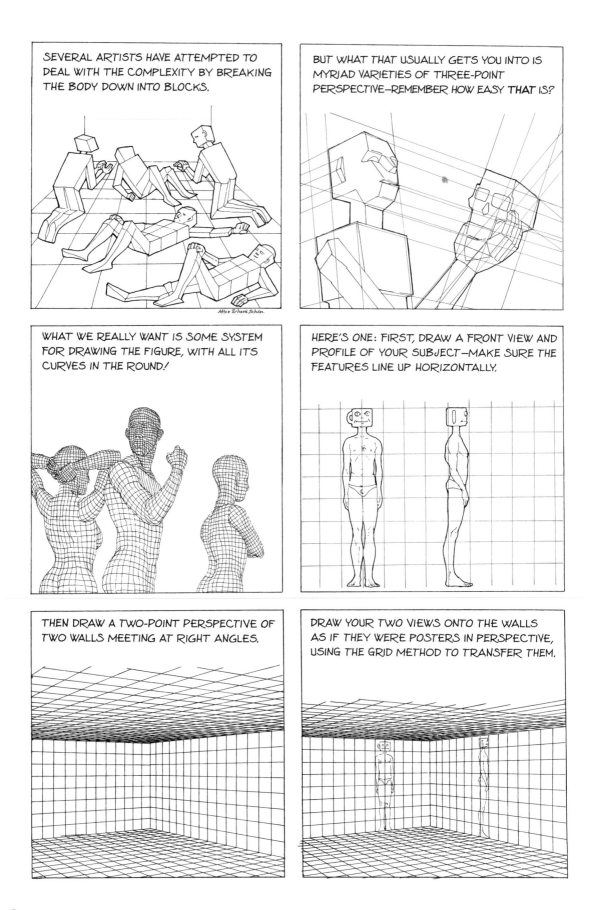

SEVERAL ARTISTS HAVE ATTEMPTED TO DEAL WITH THE COMPLEXITY BY BREAKING THE BODY DOWN INTO BLOCKS.

After Erhard Schön.

BUT WHAT THAT USUALLY GETS YOU INTO IS MYRIAD VARIETIES OF THREE-POINT PERSPECTIVE—REMEMBER HOW EASY **THAT** IS?

WHAT WE REALLY WANT IS SOME SYSTEM FOR DRAWING THE FIGURE, WITH ALL ITS CURVES IN THE ROUND!

HERE'S ONE: FIRST, DRAW A FRONT VIEW AND PROFILE OF YOUR SUBJECT—MAKE SURE THE FEATURES LINE UP HORIZONTALLY.

THEN DRAW A TWO-POINT PERSPECTIVE OF TWO WALLS MEETING AT RIGHT ANGLES.

DRAW YOUR TWO VIEWS ONTO THE WALLS AS IF THEY WERE POSTERS IN PERSPECTIVE, USING THE GRID METHOD TO TRANSFER THEM.

NOW, RUN LINES FORWARD FROM EACH VANISHING POINT UP THROUGH THE FEATURES. WHERE MATCHING FEATURES LINK UP IS WHERE THE FEATURE IS LOCATED IN THE ROUND.

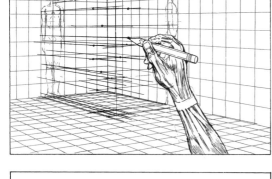

TRY IT—IT REALLY WORKS!

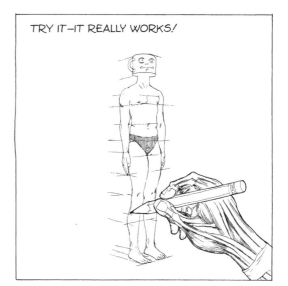

OF COURSE, IT MAY TAKE YOU ALL DAY TO TRANSFER THOSE DARNED FRONT AND PROFILE VIEWS INTO PERSPECTIVE AND **THEN** LINK THEM UP!

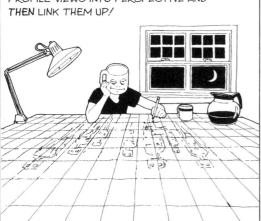

PEOPLE (AND ANIMALS AS WELL) ARE MUCH MORE COMPLEX AND CONVOLUTED FORMS THAN THE BLOCKY OBJECTS BASED ON THE CUBE. WHAT THEY RESEMBLE MORE ARE . . .

. . . CIRCLES IN PERSPECTIVE!

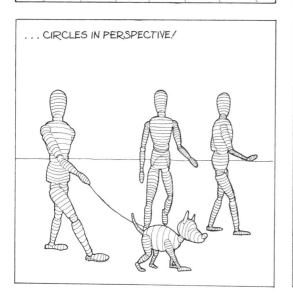

OBVIOUSLY, THIS IS ONLY TRUE IN A LOOSE SENSE, BUT THE HUMAN FORM IS BASICALLY MADE UP OF STACKED CIRCLES!

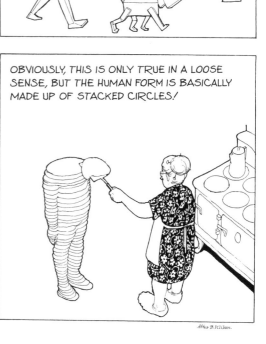

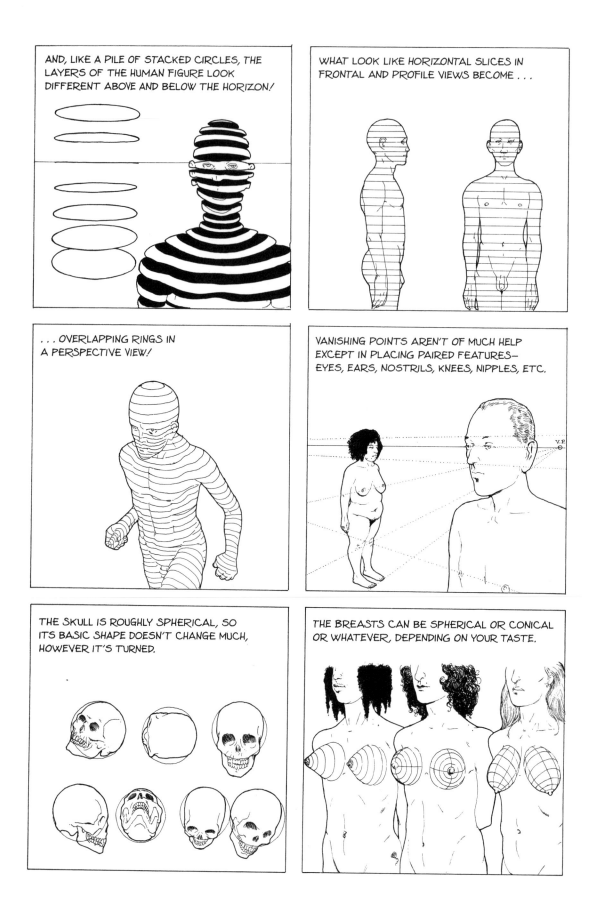

AND, LIKE A PILE OF STACKED CIRCLES, THE LAYERS OF THE HUMAN FIGURE LOOK DIFFERENT ABOVE AND BELOW THE HORIZON!

WHAT LOOK LIKE HORIZONTAL SLICES IN FRONTAL AND PROFILE VIEWS BECOME . . .

. . . OVERLAPPING RINGS IN A PERSPECTIVE VIEW!

VANISHING POINTS AREN'T OF MUCH HELP EXCEPT IN PLACING PAIRED FEATURES— EYES, EARS, NOSTRILS, KNEES, NIPPLES, ETC.

THE SKULL IS ROUGHLY SPHERICAL, SO ITS BASIC SHAPE DOESN'T CHANGE MUCH, HOWEVER IT'S TURNED.

THE BREASTS CAN BE SPHERICAL OR CONICAL OR WHATEVER, DEPENDING ON YOUR TASTE.

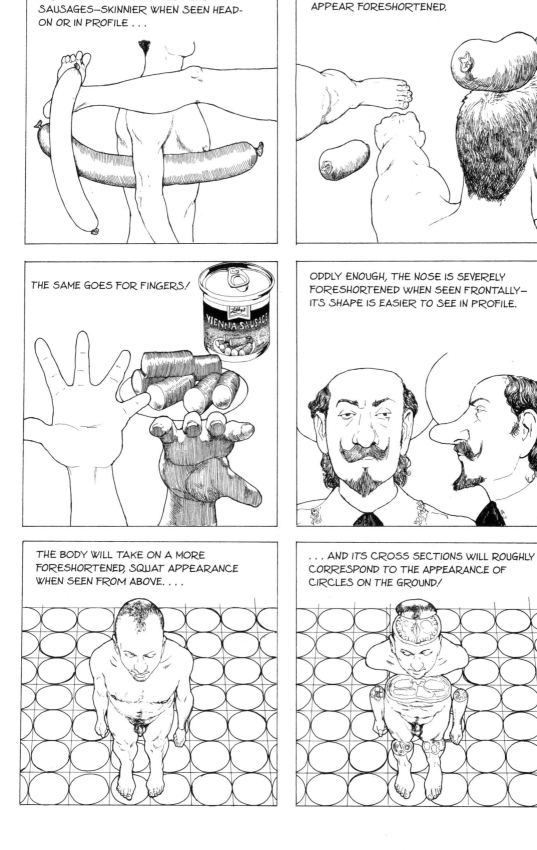

ARMS AND LEGS LOOK A LOT LIKE SAUSAGES—SKINNIER WHEN SEEN HEAD-ON OR IN PROFILE . . .

. . . AND MORE AND MORE ROUNDED AS THEY APPEAR FORESHORTENED.

THE SAME GOES FOR FINGERS!

ODDLY ENOUGH, THE NOSE IS SEVERELY FORESHORTENED WHEN SEEN FRONTALLY— ITS SHAPE IS EASIER TO SEE IN PROFILE.

THE BODY WILL TAKE ON A MORE FORESHORTENED, SQUAT APPEARANCE WHEN SEEN FROM ABOVE. . . .

. . . AND ITS CROSS SECTIONS WILL ROUGHLY CORRESPOND TO THE APPEARANCE OF CIRCLES ON THE GROUND!

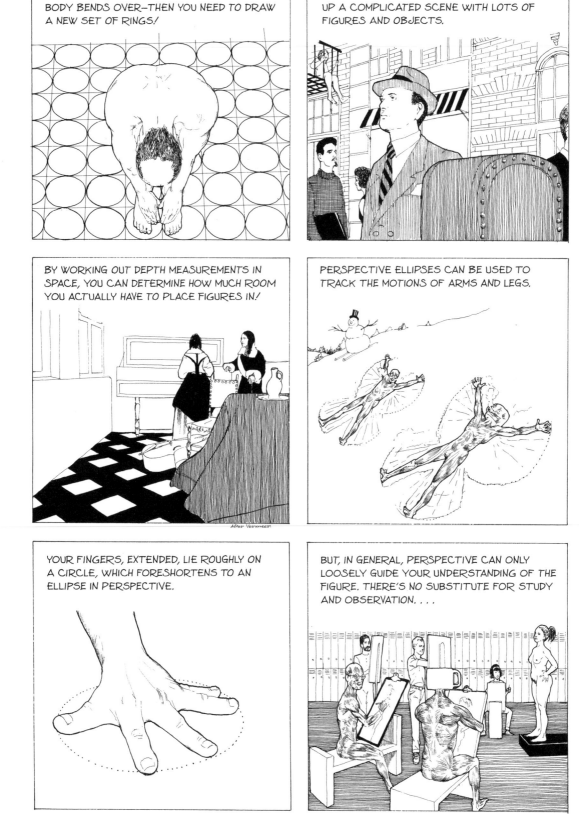

OF COURSE, THIS ALL CHANGES WHEN THE BODY BENDS OVER—THEN YOU NEED TO DRAW A NEW SET OF RINGS!

PERSPECTIVE CAN BE HELPFUL IN SETTING UP A COMPLICATED SCENE WITH LOTS OF FIGURES AND OBJECTS.

BY WORKING OUT DEPTH MEASUREMENTS IN SPACE, YOU CAN DETERMINE HOW MUCH ROOM YOU ACTUALLY HAVE TO PLACE FIGURES IN!

PERSPECTIVE ELLIPSES CAN BE USED TO TRACK THE MOTIONS OF ARMS AND LEGS.

YOUR FINGERS, EXTENDED, LIE ROUGHLY ON A CIRCLE, WHICH FORESHORTENS TO AN ELLIPSE IN PERSPECTIVE.

BUT, IN GENERAL, PERSPECTIVE CAN ONLY LOOSELY GUIDE YOUR UNDERSTANDING OF THE FIGURE. THERE'S NO SUBSTITUTE FOR STUDY AND OBSERVATION. . . .

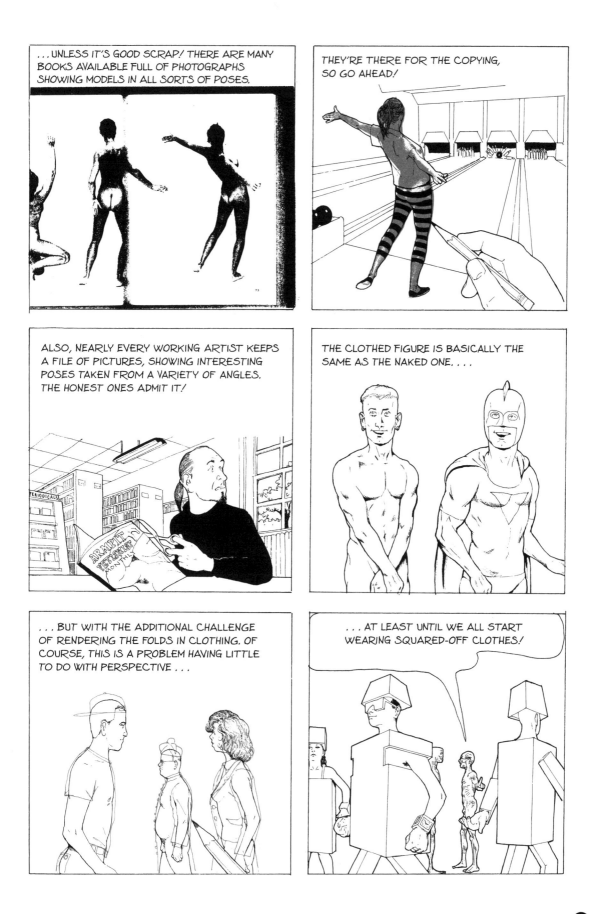

...UNLESS IT'S GOOD SCRAP! THERE ARE MANY BOOKS AVAILABLE FULL OF PHOTOGRAPHS SHOWING MODELS IN ALL SORTS OF POSES.

THEY'RE THERE FOR THE COPYING, SO GO AHEAD!

ALSO, NEARLY EVERY WORKING ARTIST KEEPS A FILE OF PICTURES, SHOWING INTERESTING POSES TAKEN FROM A VARIETY OF ANGLES. THE HONEST ONES ADMIT IT!

THE CLOTHED FIGURE IS BASICALLY THE SAME AS THE NAKED ONE. . . .

...BUT WITH THE ADDITIONAL CHALLENGE OF RENDERING THE FOLDS IN CLOTHING. OF COURSE, THIS IS A PROBLEM HAVING LITTLE TO DO WITH PERSPECTIVE . . .

. . . AT LEAST UNTIL WE ALL START WEARING SQUARED-OFF CLOTHES!

CHAPTER ELEVEN

SHORTCUTS TO PERSPECTIVE

I enjoy the work of constructing perspective, but I'm weird. I think most artists would be happy for their pictures to be correctly in perspective, but dread what they see as the tedious labor of setting it up. And, of course, many working artists simply don't have the time. For them, I have provided a few hints for saving time, and also drawing space, while still arriving at a plausible result. I have also included a number of perspective grids that provide a loose framework of monkey bars extending into space. With a little imagination, these can be used as the basis for sketches for any scene you need to draw, interior or exterior, with no need for any construction at all.

While I certainly hope this book helps many artists learn to construct perspective for themselves, I will also be content if artists value it as a book of perspective grids with a long, long set of instructions.

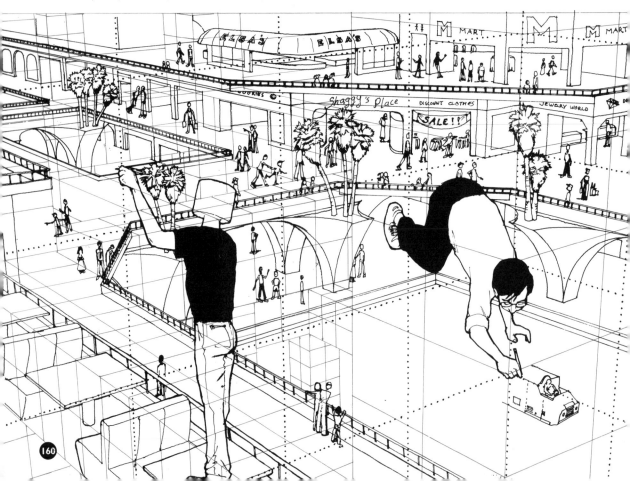

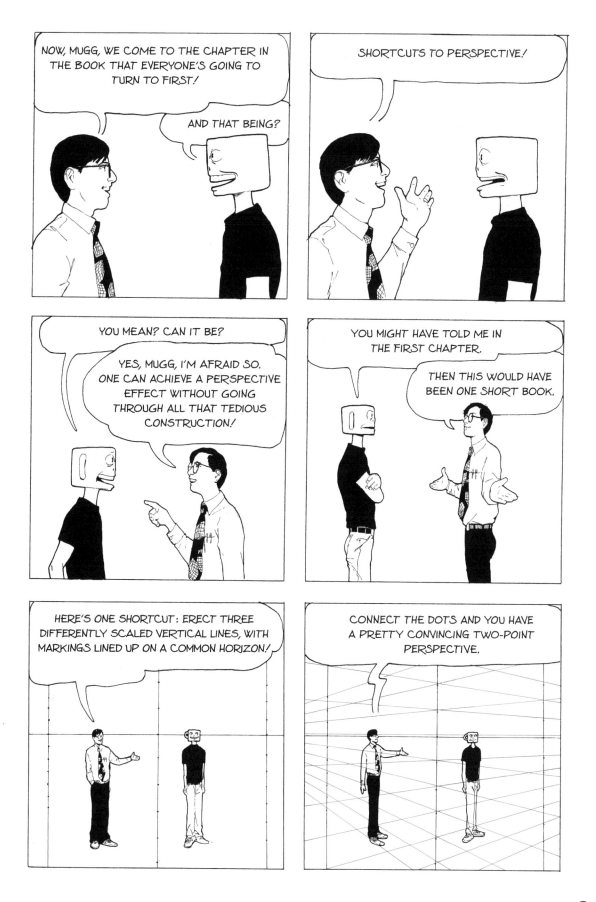

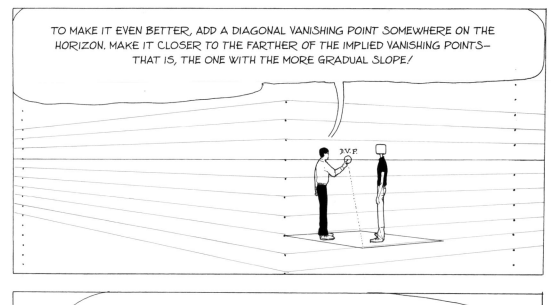

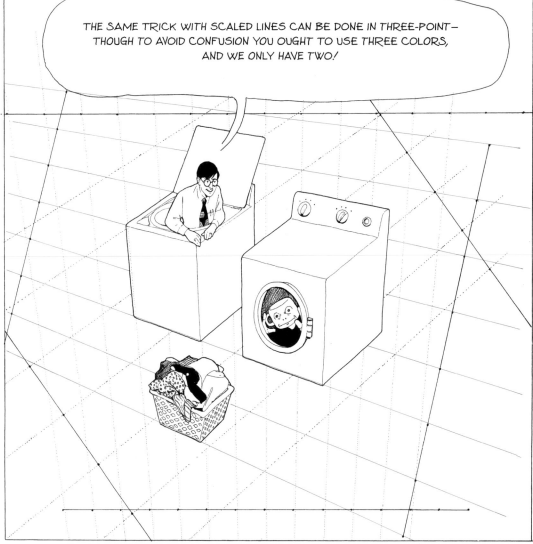

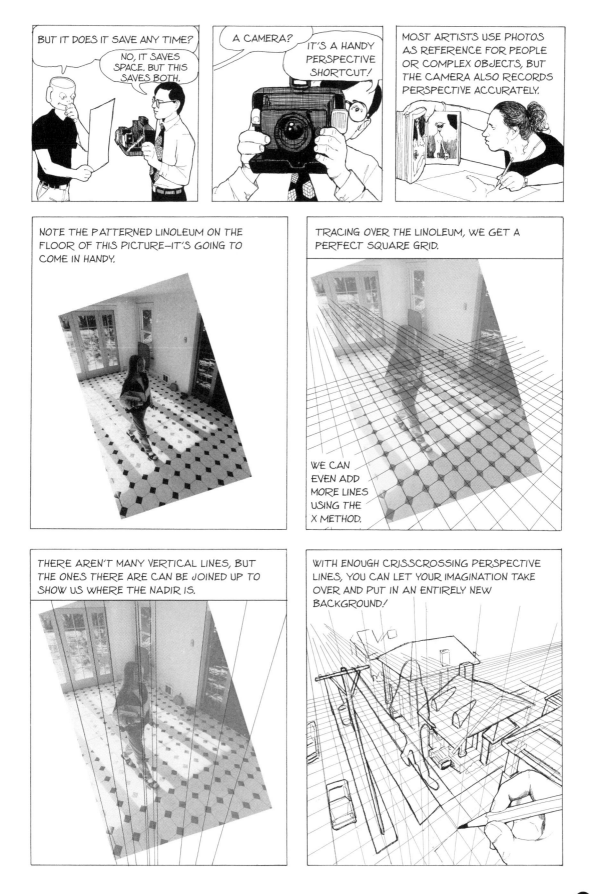

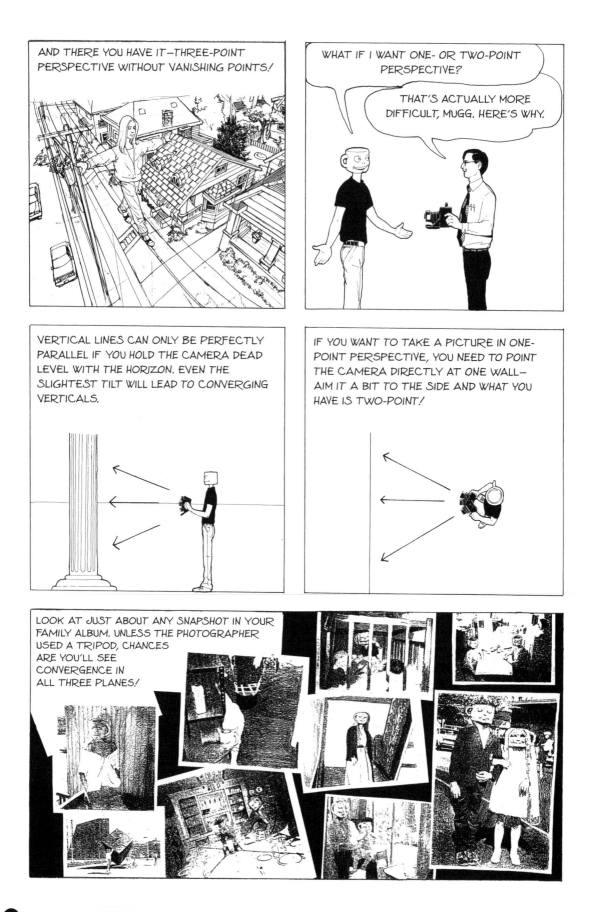

AND THERE YOU HAVE IT—THREE-POINT PERSPECTIVE WITHOUT VANISHING POINTS!

WHAT IF I WANT ONE- OR TWO-POINT PERSPECTIVE?

THAT'S ACTUALLY MORE DIFFICULT, MUGG. HERE'S WHY.

VERTICAL LINES CAN ONLY BE PERFECTLY PARALLEL IF YOU HOLD THE CAMERA DEAD LEVEL WITH THE HORIZON. EVEN THE SLIGHTEST TILT WILL LEAD TO CONVERGING VERTICALS.

IF YOU WANT TO TAKE A PICTURE IN ONE-POINT PERSPECTIVE, YOU NEED TO POINT THE CAMERA DIRECTLY AT ONE WALL— AIM IT A BIT TO THE SIDE AND WHAT YOU HAVE IS TWO-POINT!

LOOK AT JUST ABOUT ANY SNAPSHOT IN YOUR FAMILY ALBUM. UNLESS THE PHOTOGRAPHER USED A TRIPOD, CHANCES ARE YOU'LL SEE CONVERGENCE IN ALL THREE PLANES!

BUT I'VE SAVED THE BEST CHEAT FOR LAST, MUGG.

AND WHAT WOULD THAT BE?

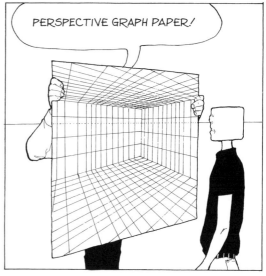

PERSPECTIVE GRAPH PAPER!

HEY, THIS LOOKS LIKE THE STUFF, DAVID! SHOW ME HOW TO USE IT!

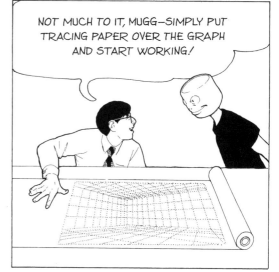

NOT MUCH TO IT, MUGG—SIMPLY PUT TRACING PAPER OVER THE GRAPH AND START WORKING!

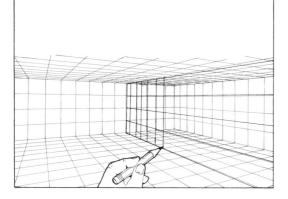

NOT THAT IT'S A TOTAL CINCH—FOR ONE THING, THE "BOX" THEY PROVIDE MAY NOT BE EXACTLY THE SHAPE YOU'D LIKE—SO BE PREPARED TO ADD WALLS, IF YOU HAVE TO!

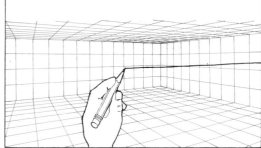

WITHOUT VANISHING POINTS, YOU NEED TO GUESS AT THE DIRECTION OF ANY LINE NOT ALREADY ON THE GRAPH. IF A LINE YOU ADD BY EYE DOESN'T CROSS ANY LINE GOING IN THE SAME DIRECTION, IT'S PROBABLY OK.

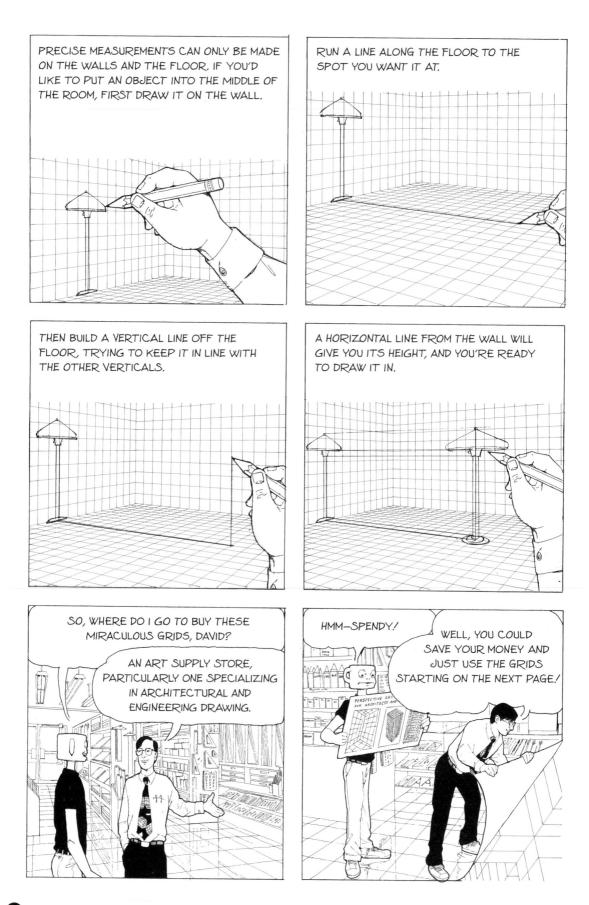

PRECISE MEASUREMENTS CAN ONLY BE MADE ON THE WALLS AND THE FLOOR. IF YOU'D LIKE TO PUT AN OBJECT INTO THE MIDDLE OF THE ROOM, FIRST DRAW IT ON THE WALL.

RUN A LINE ALONG THE FLOOR TO THE SPOT YOU WANT IT AT.

THEN BUILD A VERTICAL LINE OFF THE FLOOR, TRYING TO KEEP IT IN LINE WITH THE OTHER VERTICALS.

A HORIZONTAL LINE FROM THE WALL WILL GIVE YOU ITS HEIGHT, AND YOU'RE READY TO DRAW IT IN.

SO, WHERE DO I GO TO BUY THESE MIRACULOUS GRIDS, DAVID?

AN ART SUPPLY STORE, PARTICULARLY ONE SPECIALIZING IN ARCHITECTURAL AND ENGINEERING DRAWING.

HMM—SPENDY!

WELL, YOU COULD SAVE YOUR MONEY AND JUST USE THE GRIDS STARTING ON THE NEXT PAGE!

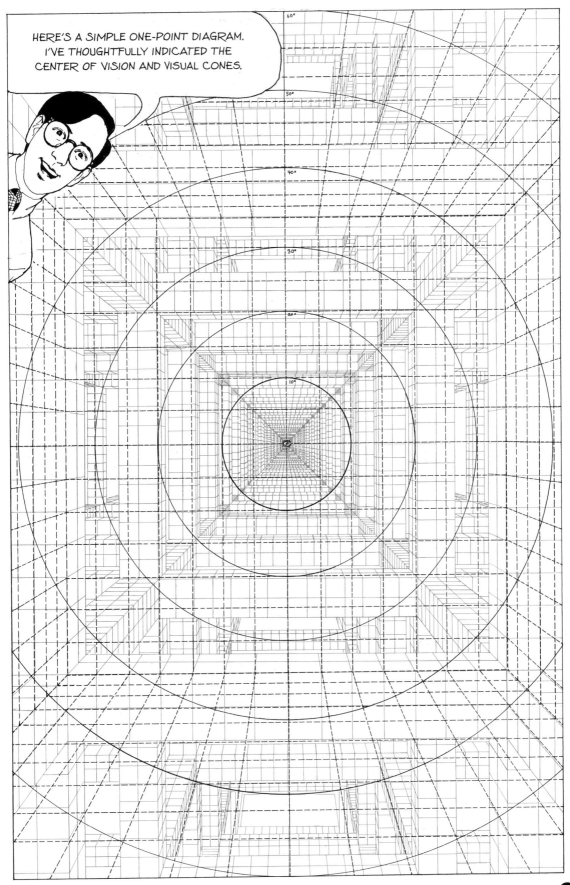

HERE'S A 45° TWO-POINT.

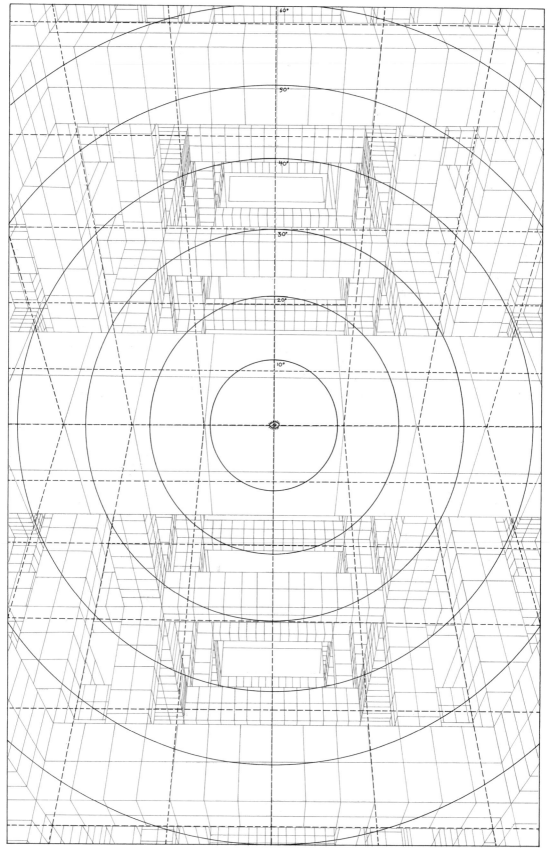

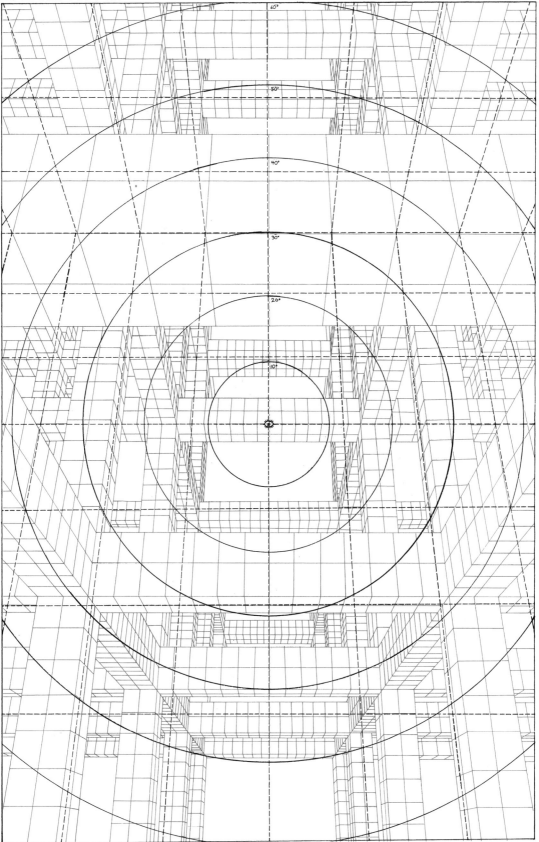

AND . . . WHAT THE HELL—5°/85°.

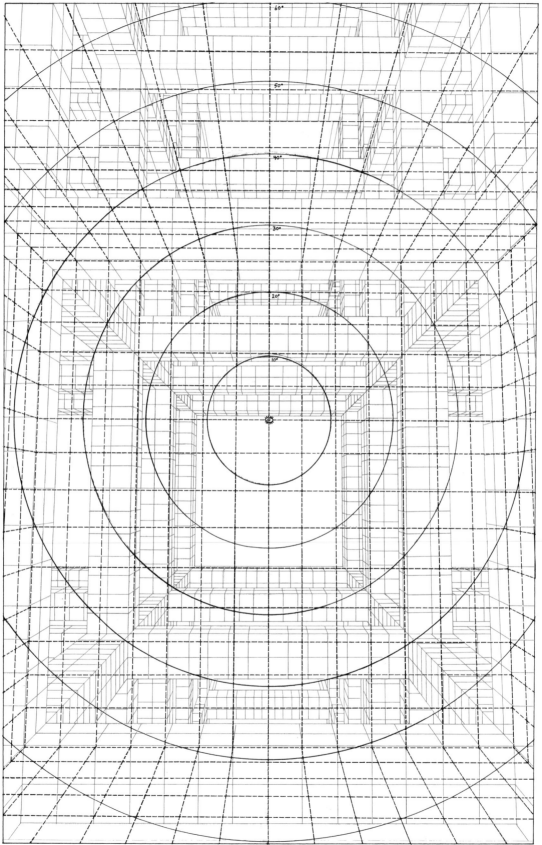

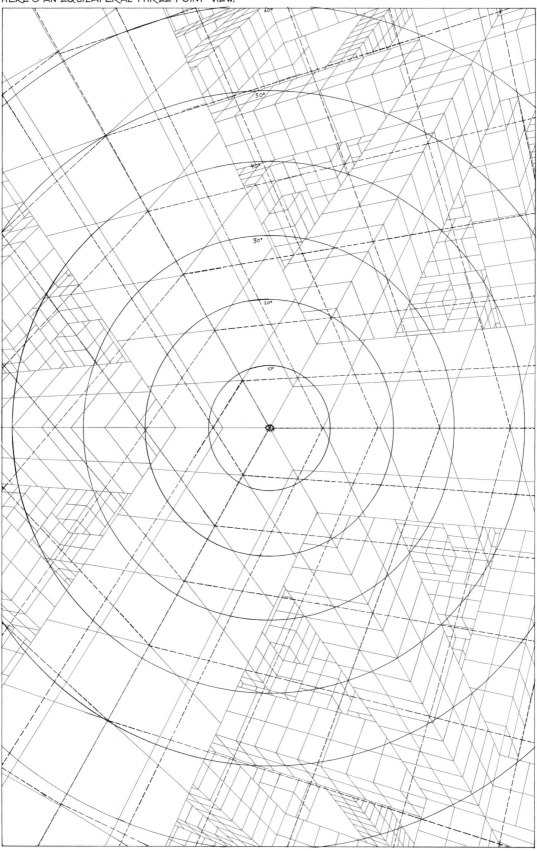

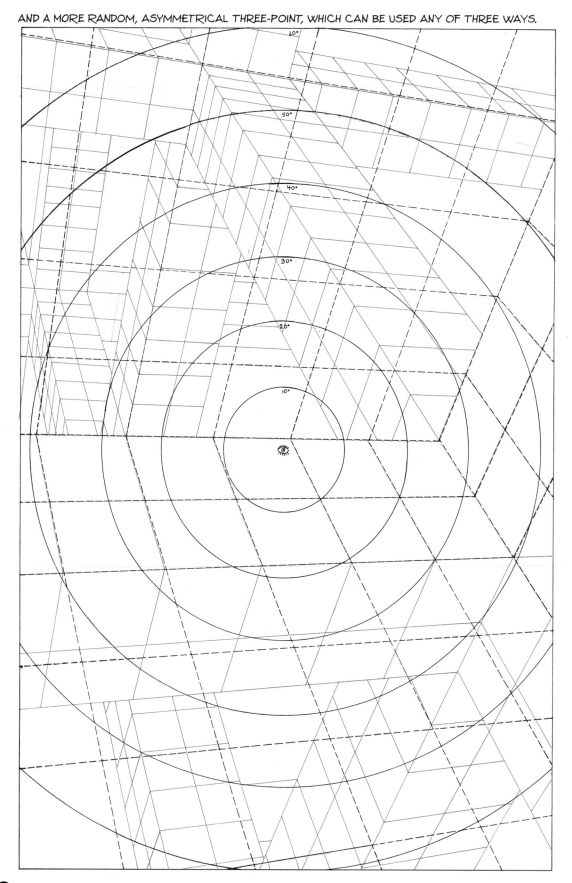

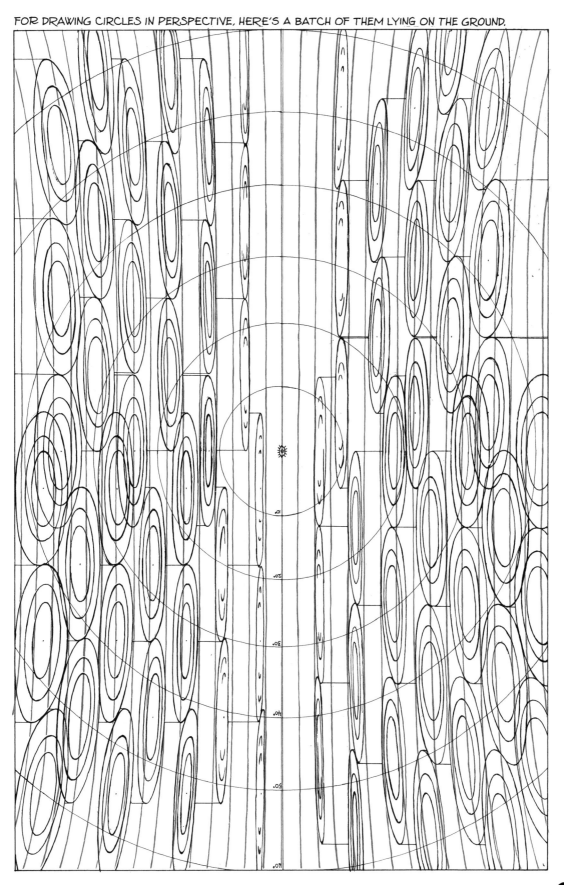